IMAGES
of America

PEMBROKE

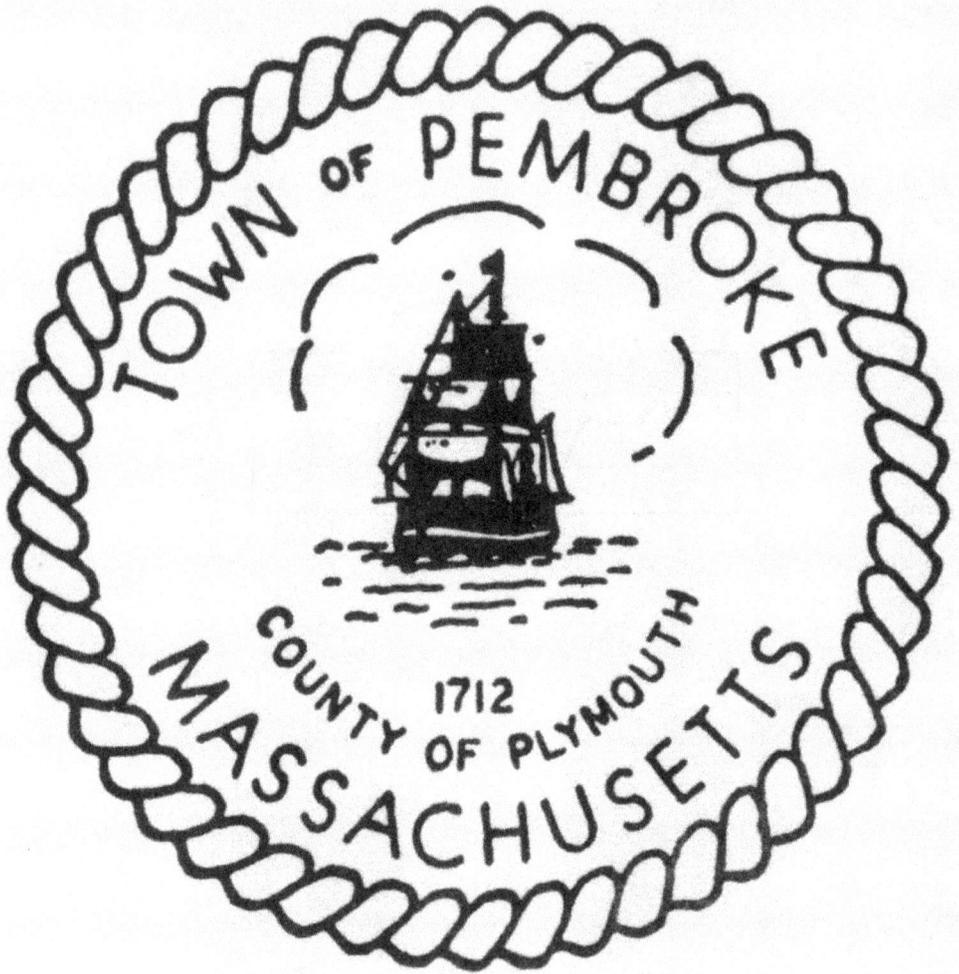

In 1962, at the time of Pembroke's 250th anniversary, a committee of three, Alice Hayes, Frank Downing, and Melvin Shepherd Sr., was chosen to submit ideas for a town seal to the annual town meeting. A design rendered by Everett Reed was chosen from a number of entries and was unanimously approved by the townspeople. The seal depicts the ship *Maria*, built on the North River at Pembroke's Brick Kiln Shipyard by Ichabod Thomas in 1782. She was in service for 90 years.

On the cover: Memorial Day exercises held in local cemeteries were part of the life of the Grand Army of the Republic (GAR). The GAR, made up of Union Civil War veterans, sponsored the Sons of Union Veterans who also participated in the solemn ceremonies. In this picture, members of the GAR are located on the right and the Sons of Union Veterans, the young men in the light-colored pants, are on the left. (Courtesy of the Pembroke Historical Society.)

IMAGES
of America

PEMBROKE

Karen Cross Proctor

ARCADIA
PUBLISHING

Published by Arcadia Publishing
Charleston SC, Chicago IL, Portsmouth NH, San Francisco CA

Library of Congress Catalog Card Number: 2008924454

For all general information contact Arcadia Publishing at:
Telephone 843-853-2070
Fax 843-853-0044
E-mail sales@arcadiapublishing.com
For customer service and orders:
Toll-Free 1-888-313-2665

Visit us on the Internet at www.arcadiapublishing.com

CONTENTS

ACKNOWLEDGMENTS

A project such as this is only as good as those who came before us and who had the foresight to collect, identify, and preserve the information and images here presented. Harry Litchfield, Sarah Bosworth, Susan Smith, William Bryant, Alton and Elliot Ford, and photographer/publisher George Edward Lewis, among so many others, have made it possible for future generations of Pembroke residents and historians to glimpse into the past and be inspired to continue their legacy of preservation. I would also like to thank John Proctor, Nancy Ford, and Jim Hannon for their patience and help. The archival images and some files are courtesy of the Pembroke Historical Society. All other pictures are courtesy of John Proctor. To the best of current knowledge, the information contained in this book is as accurate as possible. Research is ongoing.

INTRODUCTION

Before man walked along the pond's shores and hunted in the forests, there were the herring. Led by inexplicable forces of nature, instinctively, the alewives swam each spring from the ocean to spawn at the ponds where they were born. Yearly cycle followed yearly cycle, and eventually the ponds teemed with the life-giving food. Native Americans, drawn to the area each spring and summer, settled and fished the waterways. The native name for the area was Mattakeesett, meaning "place of much fish."

About 20 years after the first Europeans arrived in the New World and settled at Plymouth, a burgeoning population caused the descendants of the Pilgrims to move north and west of their original settlement. English land grants provided settlers large tracts of land in Duxbury, Scituate, and Marshfield, of which the lands at Mattakeesett were originally a part. The Europeans may have been in Mattakeesett as early as 1640. Robert Barker and Dolor Davis, along with a guide, came up the North River in a canoe from Scituate and, while exploring one of the river's many tributaries, came to the area of today's Herring Run. Barker brought his family to the area and built a garrison at what is today the corner of Barker and High Streets.

The village of Mattakeesett grew, and the settlers, a deeply religious people by nature and by law, traveled many miles to worship at the parent settlements. Not long after the year 1700, Mattakeesett became large enough to support its own parish. In 1712, the Town of Pembroke was incorporated.

The town continued to grow and by the mid-19th century had unofficially divided into several neighborhoods—Bryantville, Center Pembroke, Crookertown, East Pembroke, Fosterville, High Street, North Pembroke, and West Elm Street. The neighborhoods were loosely defined by their local one-room schools and the families who supported them.

While largely an agrarian community, the North River provided the opportunity for several shipyards to prosper. The climate was ideal for growing cranberries, a crop still grown in Pembroke, but on a much smaller scale than in years past.

One

BRYANTVILLE

For almost 150 years, a section of West Pembroke has been known as Bryantville. It is said that it was named for Martin Bryant, a resident who was prominent in local and town business.

Bryant was born on May 7, 1798, in Pembroke. He attended a dirt-floor one-room schoolhouse located on Plymouth Street, where the teacher taught reading, writing, and arithmetic for a salary of 50¢ per week plus room and board. In 1821, he married Sophia Reed of Pembroke. He eventually earned enough money as a foundryman to purchase a farm and store owned by Samuel Briggs.

In 1831, the area then known as West Pembroke had not changed much since Bryant's boyhood days. There was one store and two churches, but private residences were few and far between.

Bryant reopened his newly acquired store. He also introduced the business of braiding straw by providing the straw and buying the braided product, which he then sold to Foxboro hatmakers. For over 30 years, his house served as the village tavern where boarders could spend the night for 37.5¢, including supper and breakfast. To afford easy access to his store, he built Union Street as far as Plymouth Street. To encourage building, he sold house lots from his farm. By 1842, a blacksmith shop, a carpentry shop, a better schoolhouse, and another store were opened. It was during this period that the area began to be called Bryantville, as a tribute to Bryant's enterprise and public spirit.

Bryant continued to introduce local improvements. He organized a group of small companies known as "proprietors," who were responsible for the development of Mount Pleasant Cemetery. Eventually Bryant went back to the regular business of farming. It is believed that he laid out one of the finest cultivated cranberry bogs in the immediate area. Bryant died in 1871, leaving behind a legacy that is Bryantville.

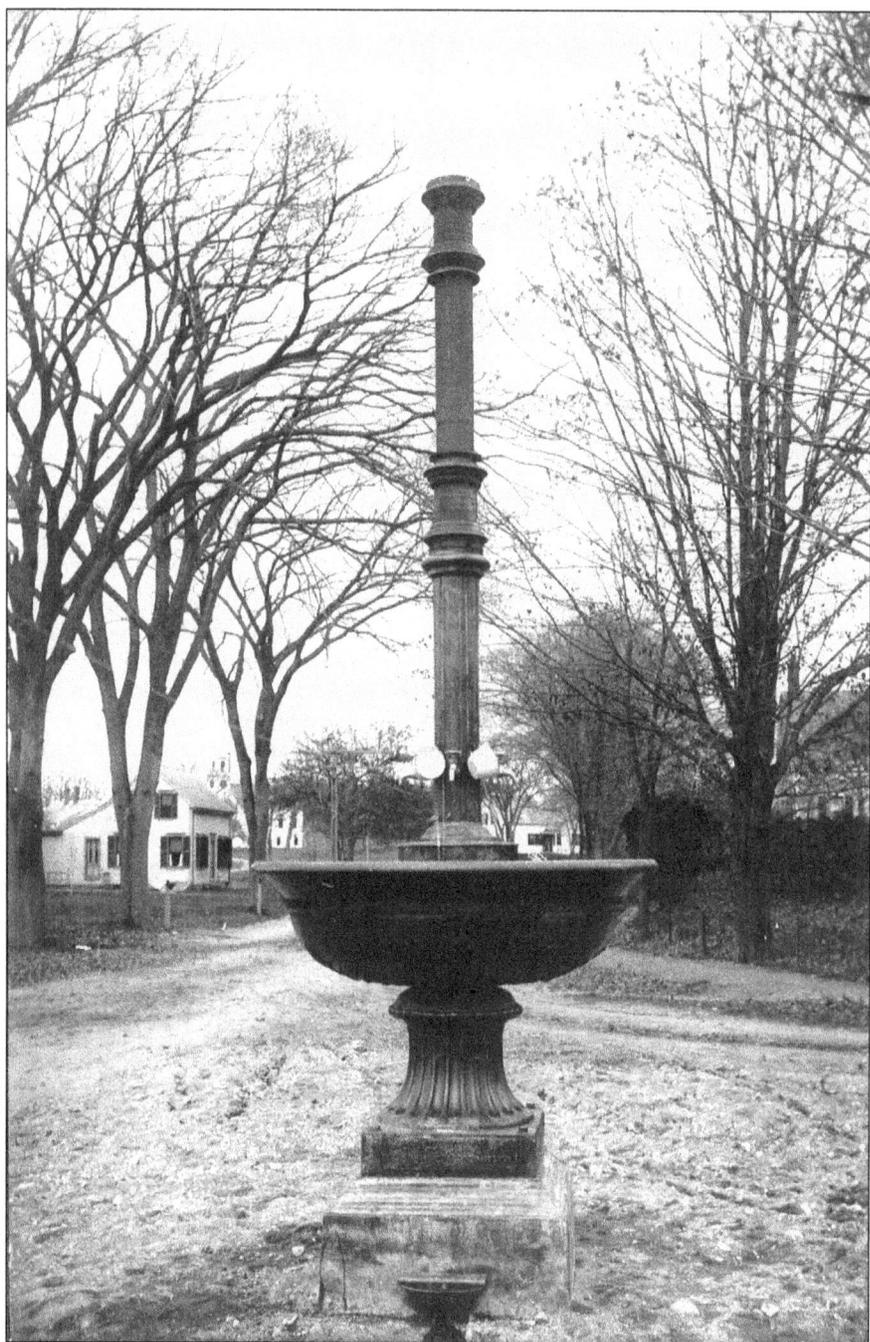

The Bryantville Fountain was made of bronze and was presented to the Town of Pembroke by the South Hanson Women's Christian Temperance Union. The entire structure was 14 feet high. It was moved several times, minus the tall shaft with its white globe—once behind Porter's store in Center Pembroke where it was used as a goldfish pool, and later to the Herring Run where the Grange kept it filled with flowers. Finally it was placed in front of the Pembroke Historical Society Museum Building and is still used as a planter. The shaft and globe have never been located.

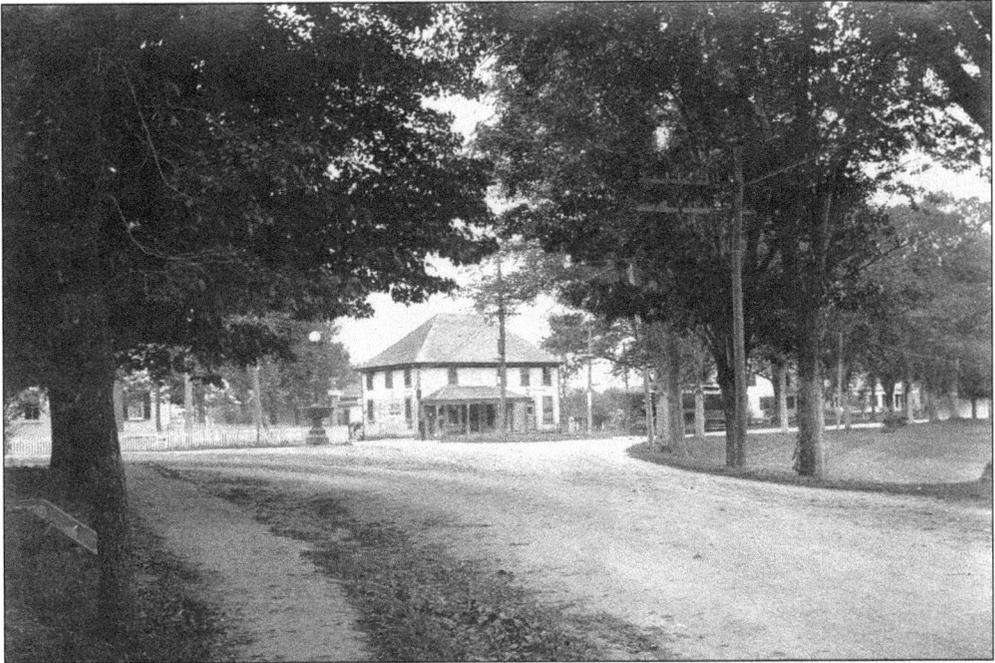

This is Bryantville Corners showing the Bryant family store. The white picket fence on the left marks the property line of Martin Bryant's home. To afford easy access to the store, Bryant built Union Street between his home and his store, as far as Plymouth Street. By 1842, a blacksmith shop, carpentry shop, and better schoolhouse were opened. It was during this period that the area began to be called Bryantville, as a tribute to Bryant's enterprise and public spirit. The picture above was taken from Mattakeesett Street. The Bryantville Fountain appears to the left of the store. Bryantville Corners in winter (below) was taken from School Street looking toward Hanson. The store is on the left; the fountain is on the right behind the horses.

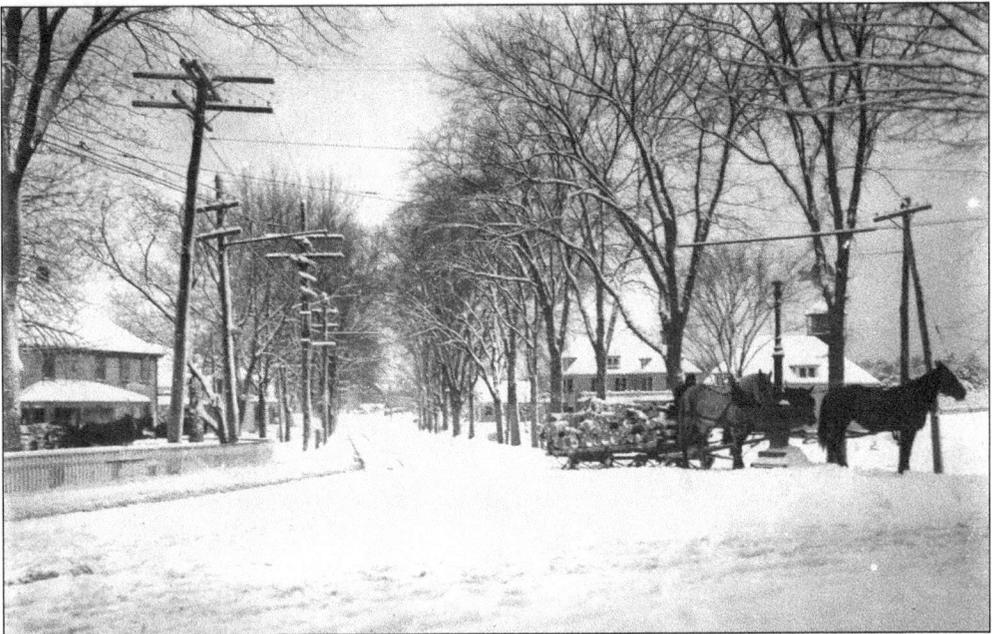

This picture of School Street (above) was taken looking east from Bryantville Corners. The old Bryantville Post Office is seen on the right. It was attached to Howard's Store, later known as Lang's Store. The post office was originally established in 1876 with William H. H. Bryant as its first postmaster. A better view of the old Bryantville Post Office (below) also shows Howard's Store. Channing Howard was postmaster from 1901 until 1922. The post office was a good place to meet one's neighbors and exchange local news and probably a good bit of gossip. The only person identified in this picture is Harold Clark on the far left.

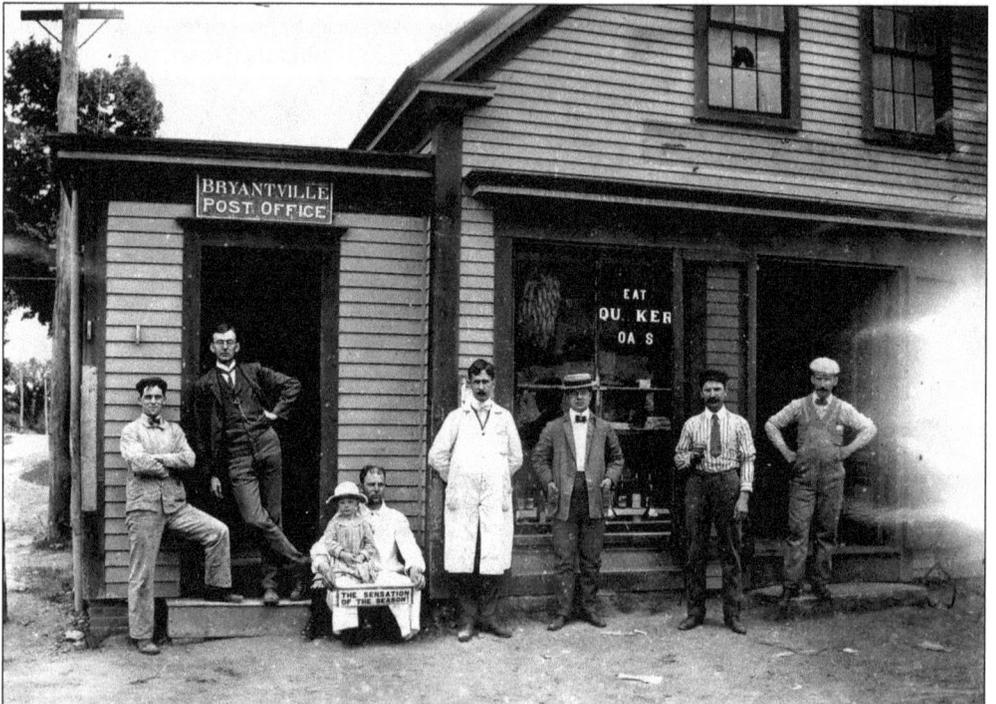

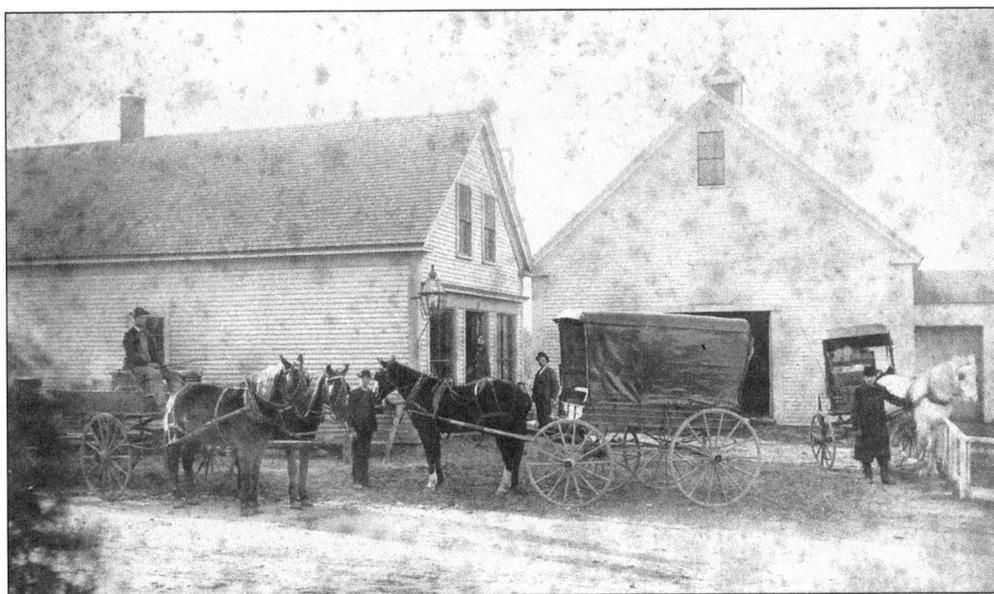

This was E. T. Clark's Store in Bryantville in 1885. It was later known as Howard's Store, and then Lang's Store. Pictured here from the left are Clarence Ford (driving the two horse hitch), Fred Cushing, Maretta Clark and Harold in the doorway, George Clark, E. T. Clark, and Howard, next to the white horse.

This home on School Street in Bryantville was the home of Clinton Elwood Crowell, who was born on Cape Cod and married Maud Beal of Pembroke in 1897. He was a carriage painter at that time. Around 1910, he moved to Middleboro and tried his hand at cranberry growing. Apparently that occupation did not pay off for him, because by 1920 he was back in Bryantville working in a grocery store.

On the corner of School and Union Streets stood the home of Martin Bryant, as seen in the photograph above. He was born on May 7, 1798, in Pembroke. He attended the one-room schoolhouse located on Plymouth Street. In 1821, he married Sophia Reed of Pembroke. He eventually earned enough money as a foundryman to purchase the farm and store owned by Samuel Briggs where Bryant was to spend the rest of his life. The store was enlarged, and a meeting hall was added. He died in 1871. Bryant's son W. H. H. Bryant was operating the store in 1886 (below) when this picture was taken.

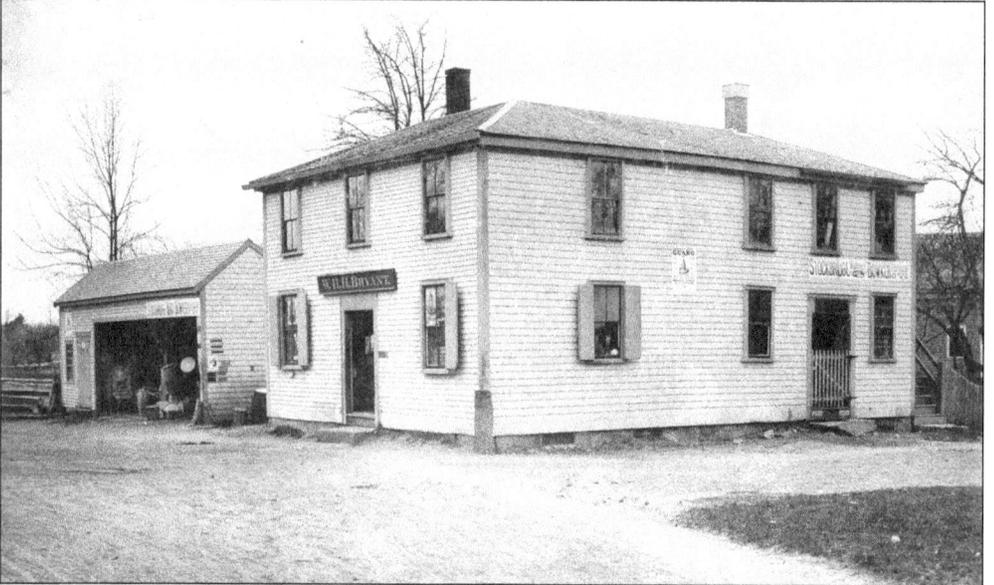

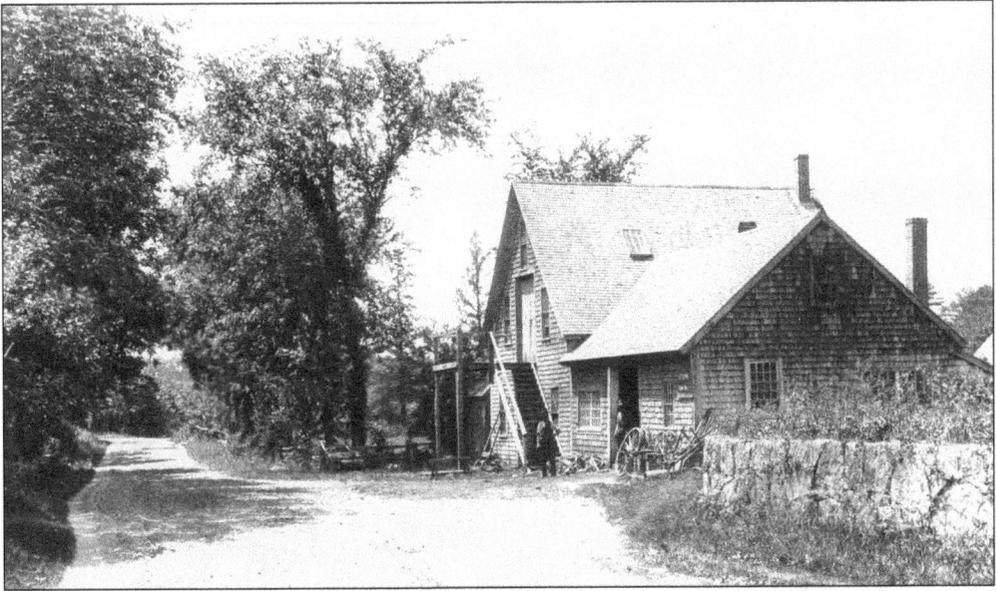

The blacksmith shop of Ellery Merritt was located on Union Street between the Bryantville Corners and Plymouth Street. This picture, looking down Union Street away from Bryantville Corners, was taken in 1890. The Cobb Library was built to the right of this building 10 years after this picture was taken.

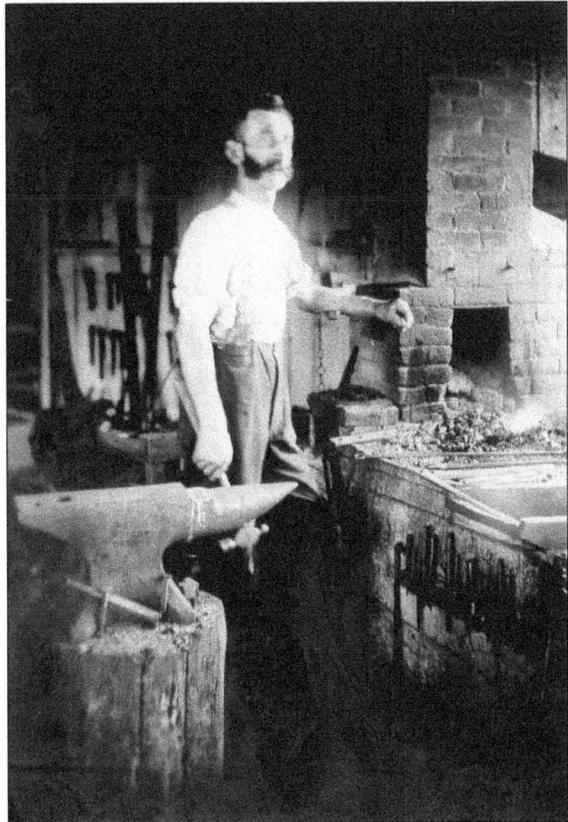

Ellery was the second generation of the Merritt family working in the blacksmith trade in Pembroke. Ellery, born in 1848, was the son of Frank, who owned a blacksmith shop on High Street. Ellery and his wife, Harriet, had a son, Arthur, who also worked as a blacksmith in Bryantville for a time.

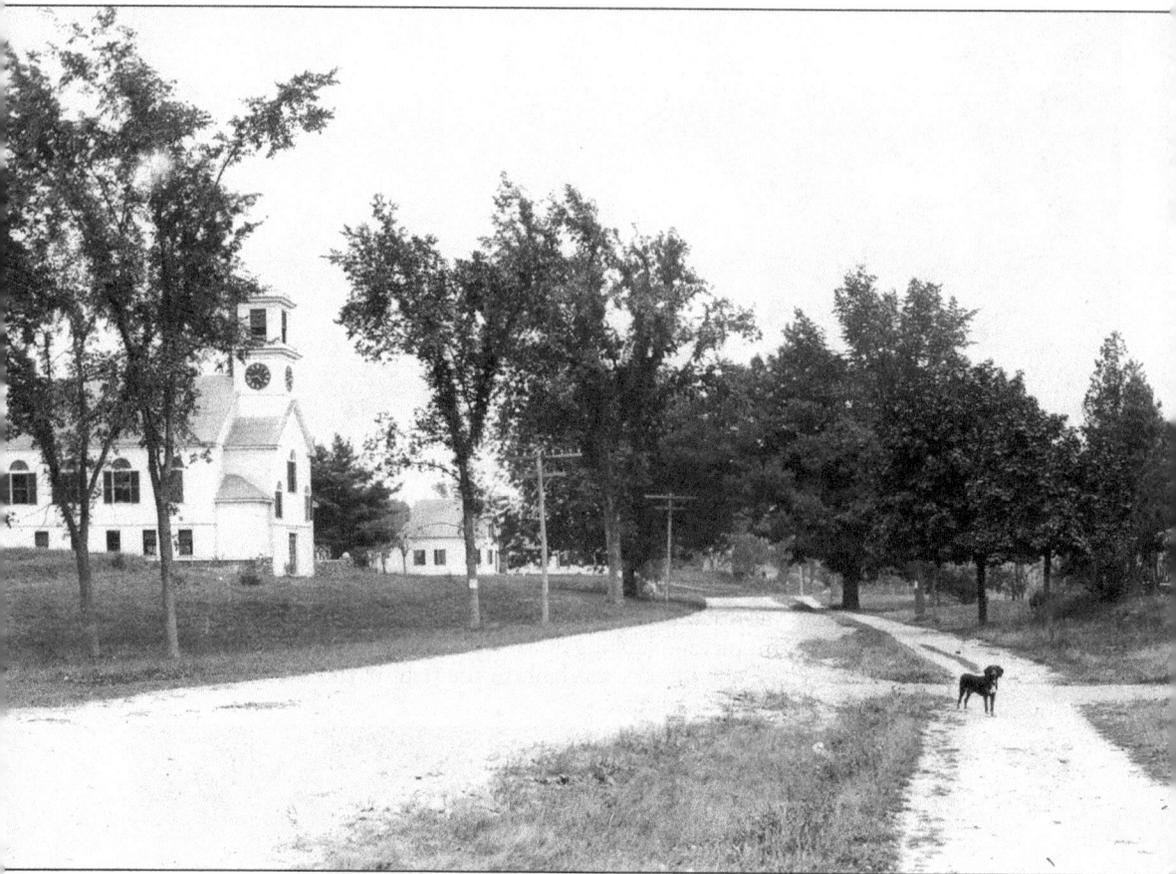

By 1826, the town of Pembroke, and Bryantville in particular, had an organized Methodist society with the Reverend William Stone as pastor. Soon a meetinghouse became a necessity. A 32-by-29-foot building was constructed on Mattakeesett Street at a cost of $925. On June 19, 1828, the little church was dedicated. In 1872, many improvements were made, including the addition of a tower. A bell was given to the church by Greenleaf Kilbrith and John Foster at a cost of $450. A benefactor of the Bryantville area, Martin Bryant donated $100 toward a clock. The interior of the church was painted, and carpet was laid down. An organ was purchased partly with funds raised by a fair held by the Ladies' Aid. The Methodist church remains one of the most recognizable structures in Bryantville.

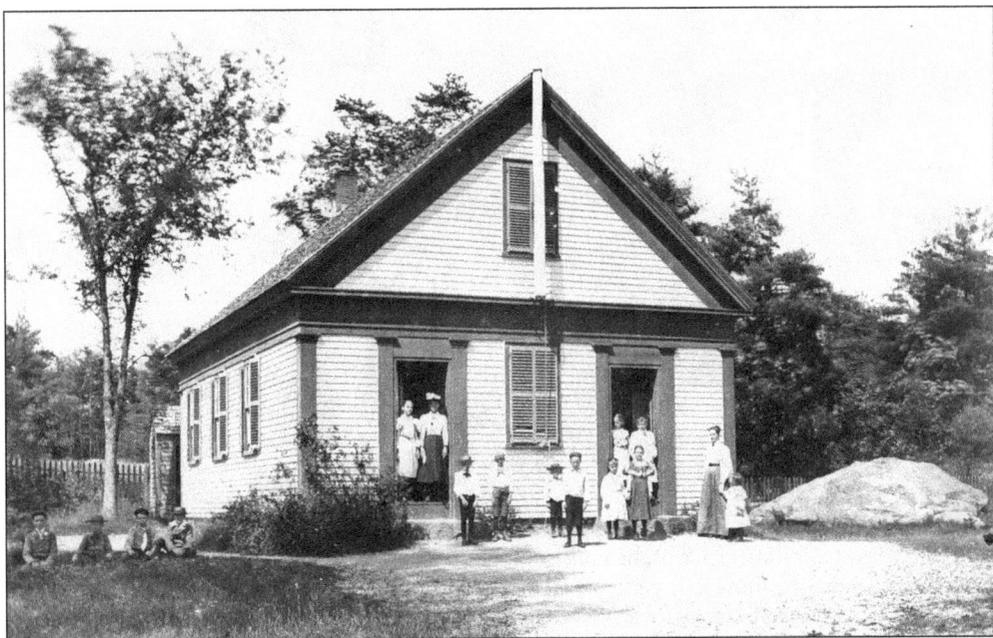

The Bryantville School (district schoolhouse No. 6) was originally built in 1847 and was located at the corner of Union and Plymouth Streets. It was a one-room school building that housed all eight grades. In 1911, another schoolhouse was built, and the Bryantville school building was moved to Pembroke Center where it served as an office and eventually as the Pembroke Historical Society.

Joseph Thomas Fish, or "Jo Tom" as he was known, was born in Pembroke in 1824. In 1868, he married Sarah Stephens. He was a shoemaker. Upon his death in 1904, his obituary in the *Bryantville News* read, "He was a familiar figure on the streets, especially in the summer, and many have enjoyed his droll remarks." He spent his last years at the Pembroke almshouse in feeble health.

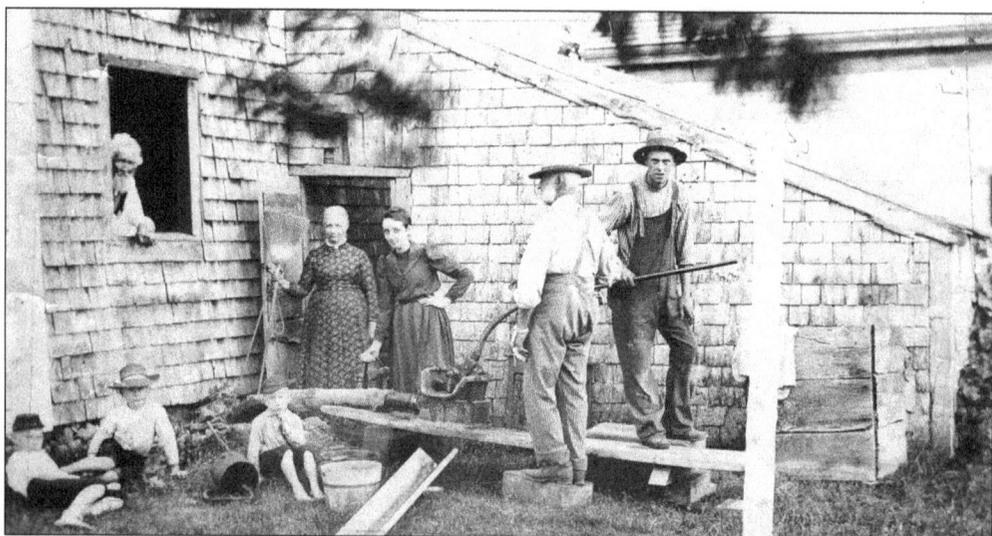

The picture above is illustrative of the multigenerational family typical of 19th-century Pembroke. This picture seems to show four generations of the Keene family. They appear to be reshingling a building. The women are identified as Cornelia E. R. Keene (left) and her daughter Marion (Keene) Lewis (right). With his back to the camera is probably Daniel Keene. The elderly man (far left) could be Caleb Lapham (father of Cornelia). Cornelia (Lapham) Keene (below) sits in front of the fire for this picture taken by her son-in-law George Edward Lewis, Bryantville photographer and publisher. Cornelia was born in 1840 in Pembroke and married Daniel Keene in 1858.

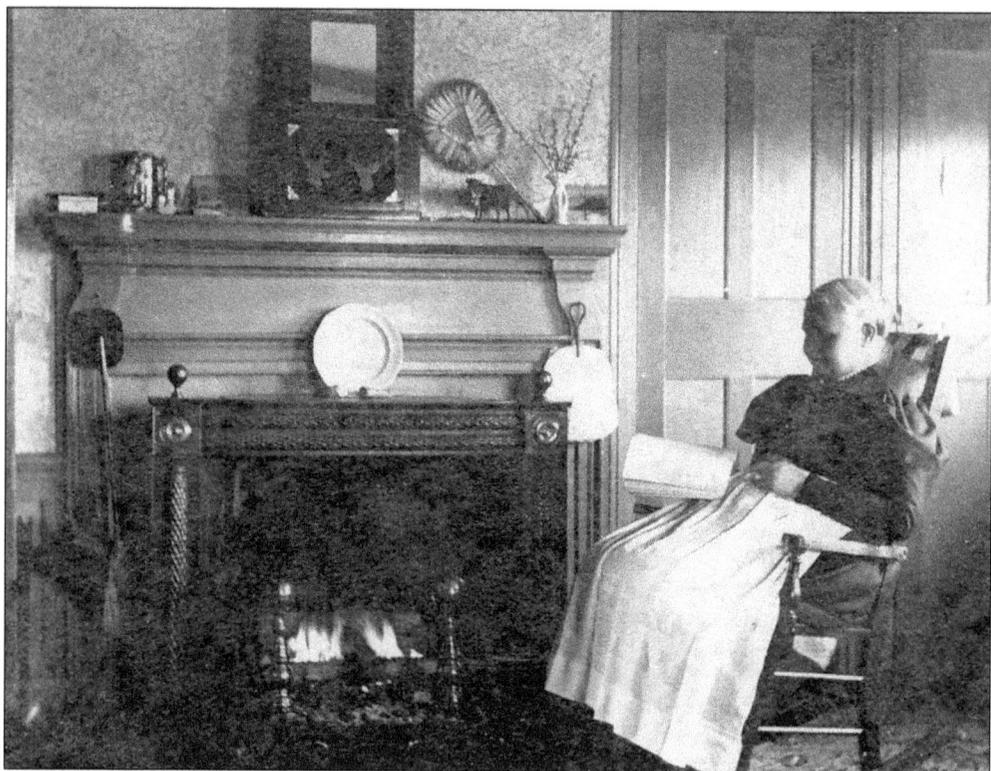

In 1884, George Edward Lewis moved to Pembroke from Franconia, New Hampshire, with his parents, George B. and Helen Lewis. He married Marion Louise Keene in 1892 in Pembroke (at right) and settled in the house (below) on Plymouth Street. George Edward was the publisher of the *Bryantville News*. His print shop was located at Bryantville Square. He was also a photographer of some merit. His pictures, taken at the end of the 19th and the beginning of the 20th centuries, were donated to the Pembroke Historical Society and make up a large portion of this book. Besides publishing and photography, George Edward Lewis was also the inventor of the Lewis Banjo. The banjo was manufactured in the 1890s by the John C. Haynes Company of Boston and had an unusual one-piece rim construction. It sold for between $30 and $112.50, depending on the grade.

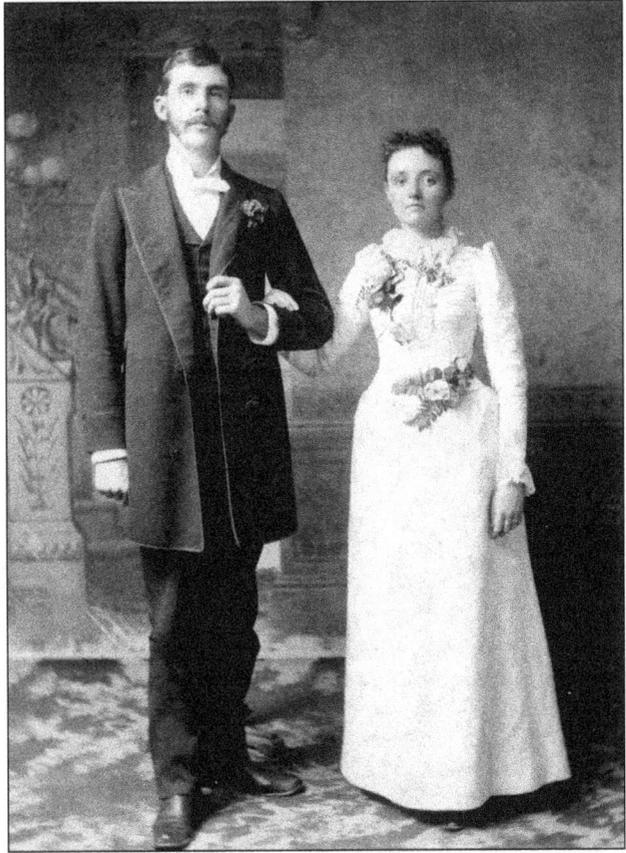

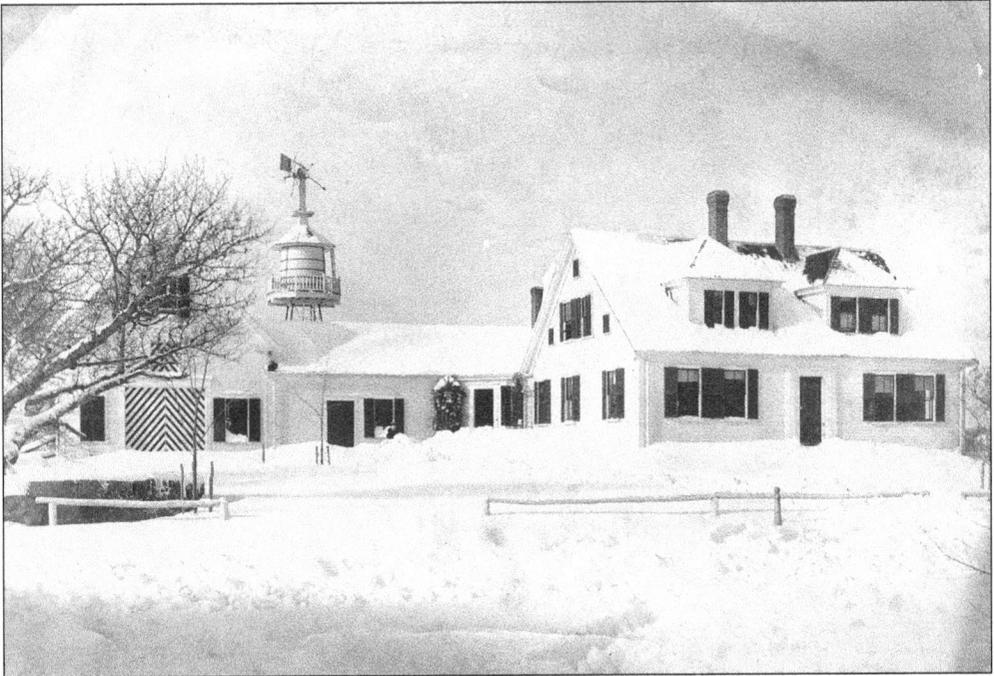

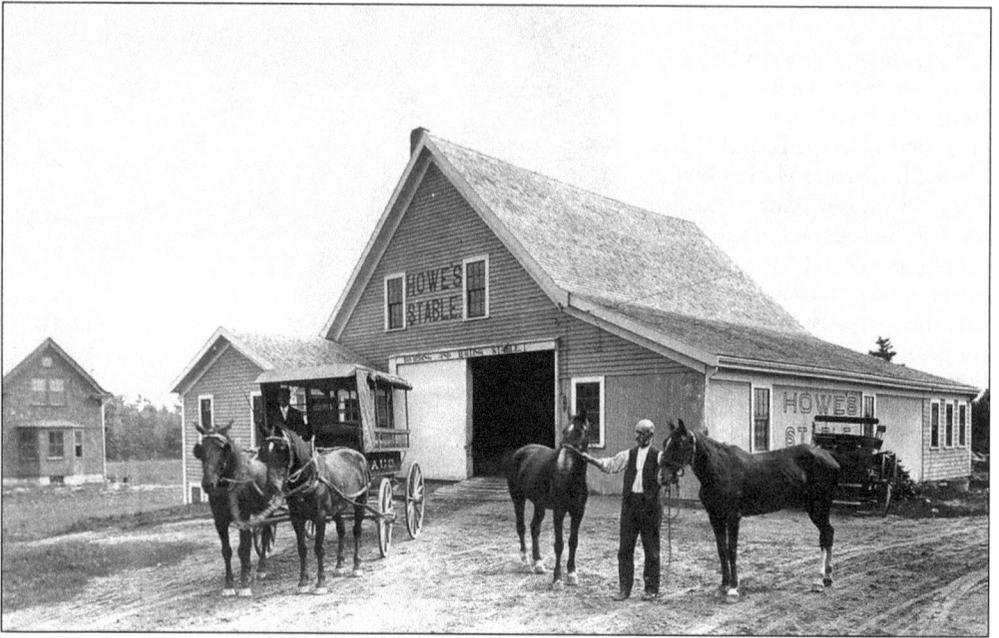

Howe's Stable was located on School Street (Route 27) in Bryantville. In the picture above are owner Lewis B. Howe holding the horse and his son Henry E. Howe sitting in the coach. The business later became known as Howe's Stable and Garage (below) to accommodate the advent of motorcars to the area. It was located across from the early-20th-century amusement park Mayflower Grove, which opened in 1900, making it convenient for anyone traveling to the park by horse or by car, both of which could be unreliable at times. The business burned on November 13, 1913.

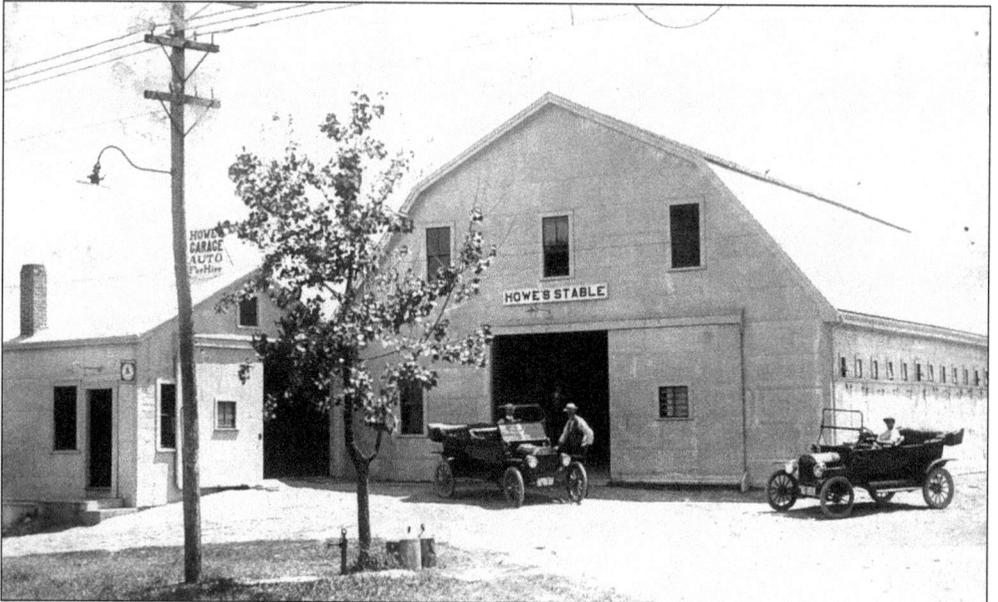

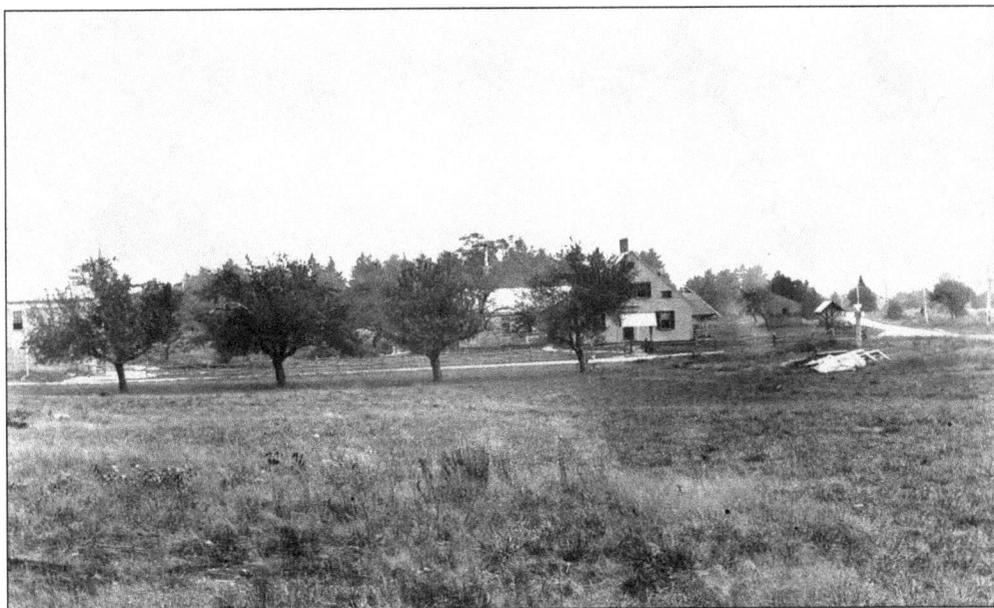

This home on the corner of Plymouth and Elmer Streets was known as the Harvey Bryant Place. Harvey was born in Pembroke in 1793. He married Lydia Wright in 1824. He was another member of the Bryantville family who spent his life in the neighborhood that bears his family's name. After Harvey's death, the home passed to his son John Wright Bryant. John died in 1909, and sometime after that, the house burned down.

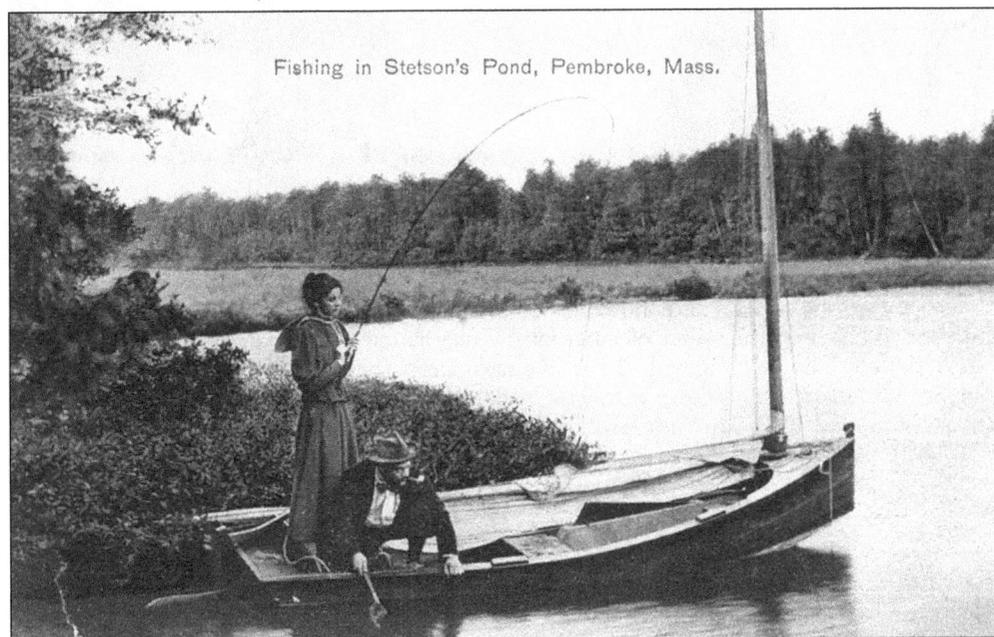

Fishing in Stetson's Pond, Pembroke, Mass.

Stetson Pond, in the southwestern corner of Pembroke, is close to the borders of Halifax and Hanson. An 1831 map of Pembroke shows the Zenas Stetson home near the pond, and judging from the large number of Stetsons in Pembroke before 1850, it probably gets its name from this extended family. From this picture, it is clear that Stetson Pond has long been a great fishing hole.

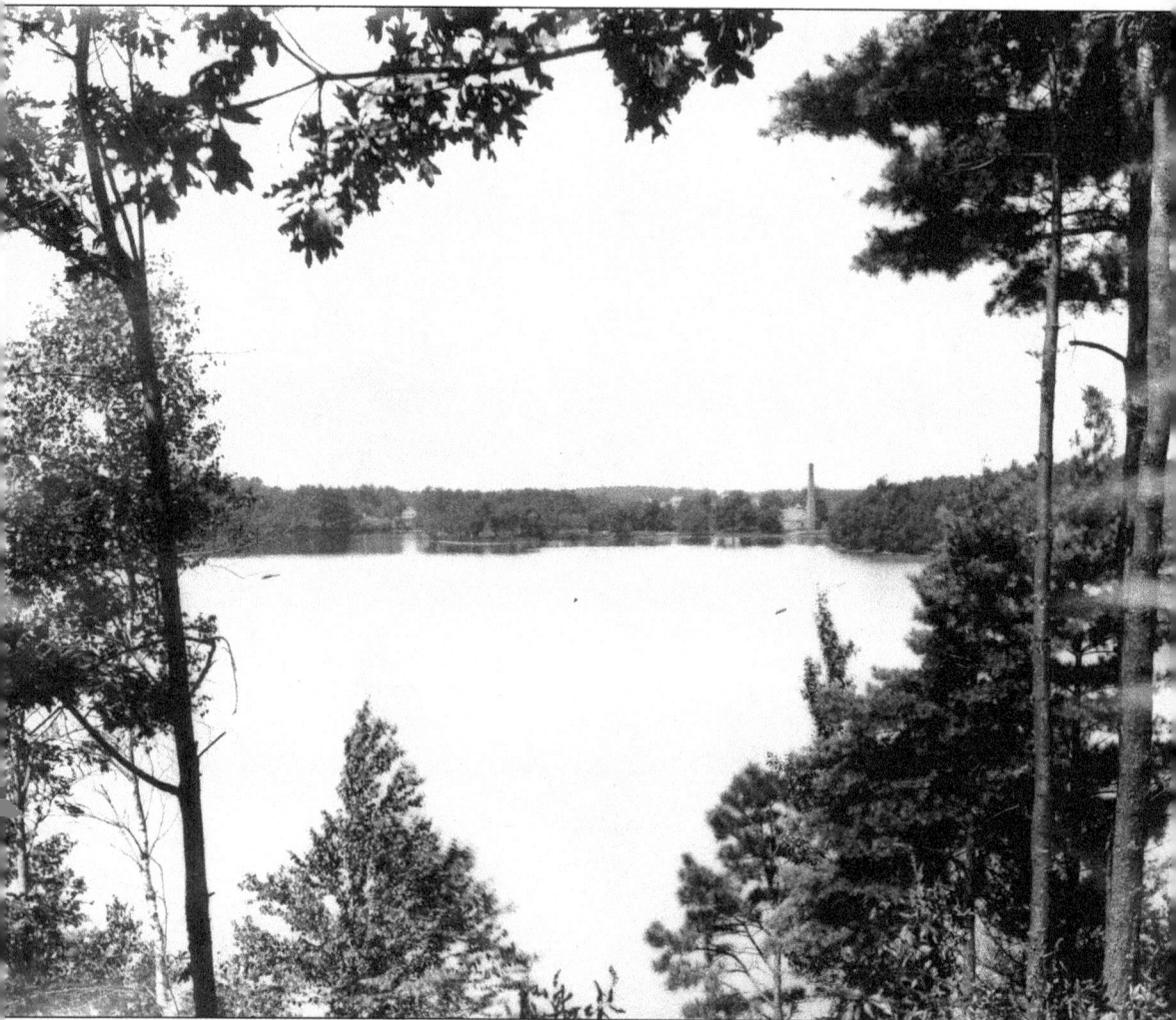

Big Sandy, or Great Sandy Bottom Pond, as it is also known, is shown here from the Gorham Street (Bryantville) side. The pond encompasses about 110 acres with almost 12,000 feet of shoreline. It has been the source of water for the nearby towns of Abington and Rockland for over 100 years. The building with the smokestack across the pond is the Abington-Rockland pumping station located in Fosterville. The pumping station was built in 1886, and this picture was taken around 1890. The smokestack has become one of the most recognizable features in many pictures of the local area.

In 1881, Dr. Orlando Charles (at right) settled in Bryantville, in the home at the corner of Mattakeesett and School Streets (below). He was born in Fryeburg, Maine, in 1856 and graduated from Bowdoin Medical College just before coming to Pembroke. He was married to Mary Elizabeth Chandler of Fryeburg. He practiced medicine in Pembroke until 1922, the year his wife died. After that, he moved back to Fryeburg and lived with his brother. The house seemed well suited to the needs of Pembroke physicians as it was next occupied by Dr. J. Edmund Brown. The home was later remodeled by another Pembroke doctor and his wife, John and Florence Angley.

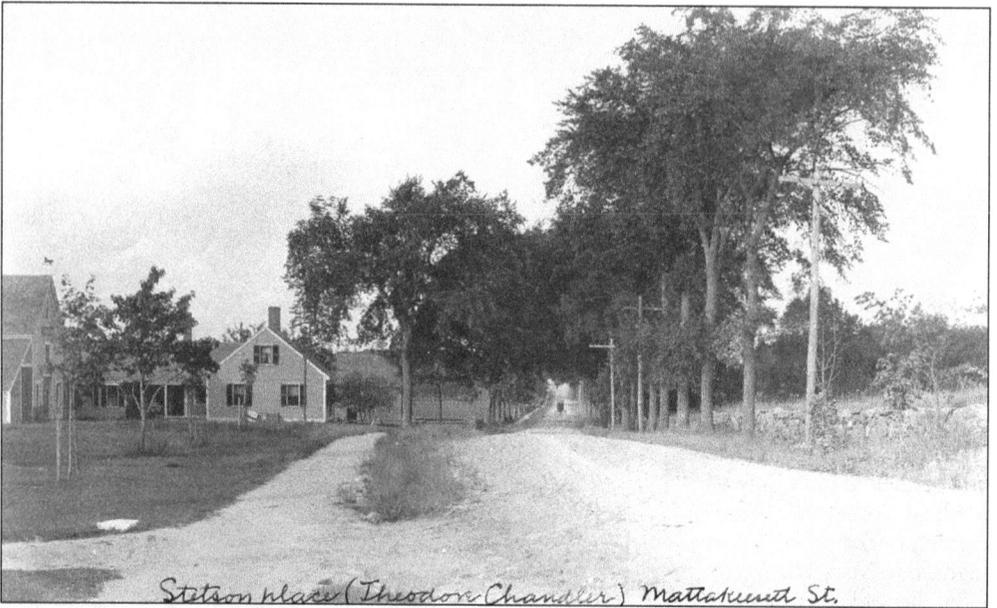

Stetson place (Theodore Chandler) Mattakeesett St.

This house, on Mattakeesett Street, was built by Micah Foster before 1790. It was located across the street from the Mount Pleasant Cemetery. The home was known as the Stetson House and was also owned by Theodore Chandler. It was the home of David H. Foster before he built his house just down the road in Fosterville. It burned in 1918.

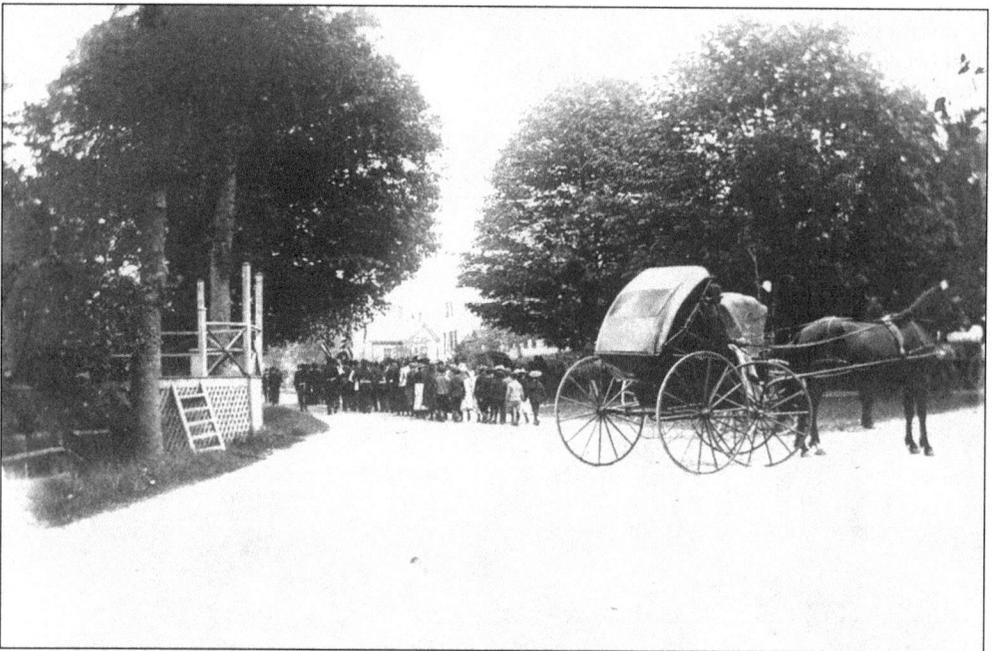

This gathering of Bryantville residents occurred on May 30, 1892. It was in honor of the ceremonies commemorating Memorial Day. These observances were very important to those who fought in the Civil War (a mere 30 years earlier) and those who lost loved ones. It is possible to make out the Sons of Union Veterans (SUV) amid the crowd.

George Edward Lewis, Pembroke photographer, travelled around town in the late 19th and early 20th centuries photographing major events, places of interest, local homes and buildings, and everyday residents doing their daily work. These two pictures of unidentified Bryantville citizens speak to the truly rural character of Pembroke and its neighborhoods. While these pictures were taken in the Bryantville neighborhood, scenes like these played themselves out in most of the other neighborhoods on a daily basis. A strong work ethic and a strong back were the main requirements for these gentlemen to put food on their families' tables.

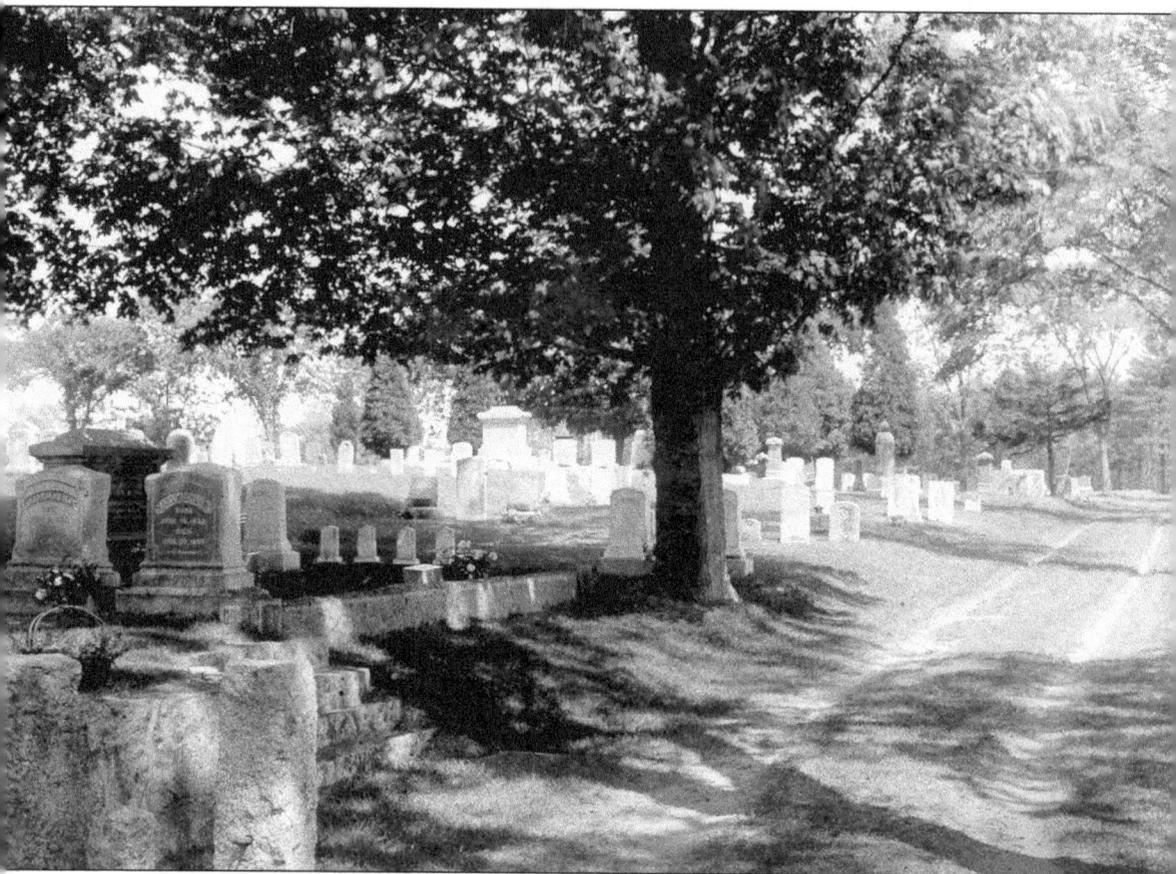

Mount Pleasant Cemetery is one of many legacies left behind by Martin Bryant, benefactor and namesake of the Bryantville neighborhood. In 1842, Bryant organized a group of small companies known as "proprietors," who were responsible for the development of the cemetery. Within 30 years, the proprietors had received their money back plus 1 percent per year interest. The first interment in Mount Pleasant Cemetery was in 1842, but there are several older stones for those individuals removed from other burial locations and reburied here. Members of the Bryant family and several of the Fosters, for whom the neighborhood of Fosterville is named, are buried here.

Two

CENTER PEMBROKE

It is possible that the location of the town center was a result of intersecting trails created by the Native Americans as they traveled in search of food. A trail known as Mattakeesett Way, which ran from Furnace Pond to the ocean, intersected the Bay Path near the spot of the Herring Run and the early Barker garrison. Pockets of settlers sprang up around the garrison and elsewhere depending on the availability of freshwater and farmland. In 1708, when the center of Colonial community life, the church, needed to expand out of Sabbaday Orchard near Mountain Avenue, the congregants moved to a high spot not too far from their original meeting place and more central to the homes of their growing congregation and built a more permanent structure. In January 1716, the town voted that "a school be kept half a year annually in ye middle of said town by ye meeting house."

Most New England towns, especially those whose roots are firmly established in an agricultural economy, had some tract of land near the town center called the town common. The name comes from the fact that the land was under the jurisdiction of the town and therefore belonged to all the residents in common. Every acre of a family's property was precious to them and usually used for the raising for food, especially corn and hay for winter use. Cattle usually ran at large and foraged for themselves from early spring until late autumn. The common land provided the farmers a place to graze their animals without using up valuable cultivated acreage. A pound to corral wayward animals was also built. Quite naturally, the common also became an intersecting point for the roads that were the direct routes to the homes of the early settlers of Pembroke, who would come to check on their livestock. The Pembroke Center neighborhood was established.

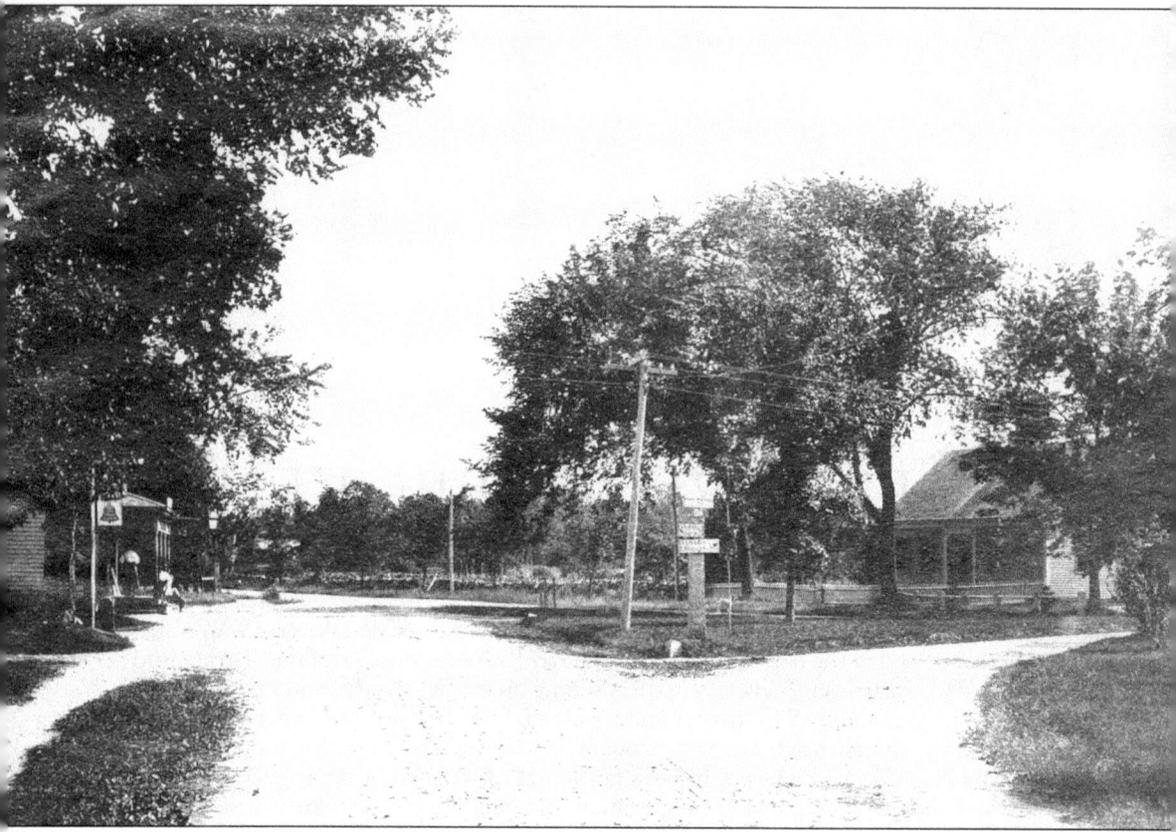

The Elisha Josselyn house, on the right, once stood as pictured here at the intersection of Center and Mattakeesett Streets. It was later moved farther down Center Street to make way for the construction of the Pembroke Center Plaza. The home was owned by several generations of Josselyns, a practice very common in many families. The country store, or general store, on the left dated back to the early part of the 19th century. Owned first by Isaac Jennings and called the Union Store, it was later operated by Joseph Shepherd and James Wilkenson. Eventually it was purchased by Ira Porter and then Kenneth Henrich. The building burned down in 1974.

This is the intersection of Center Street and Mattakeesett Street, looking north. The Elisha Josselyn House is on the left, and the Old Union Store is on the right. Looking in this direction, the Burton Homestead is also seen near the center of the picture.

This home is known historically as the Elisha Josselyn House. It was probably built about the time of Elisha's marriage to Abigail Standish in 1835. It was originally located at the corner of Mattakeesett and Center Streets but was moved farther down Center Street in 1966 to make room for the Pembroke Center Plaza.

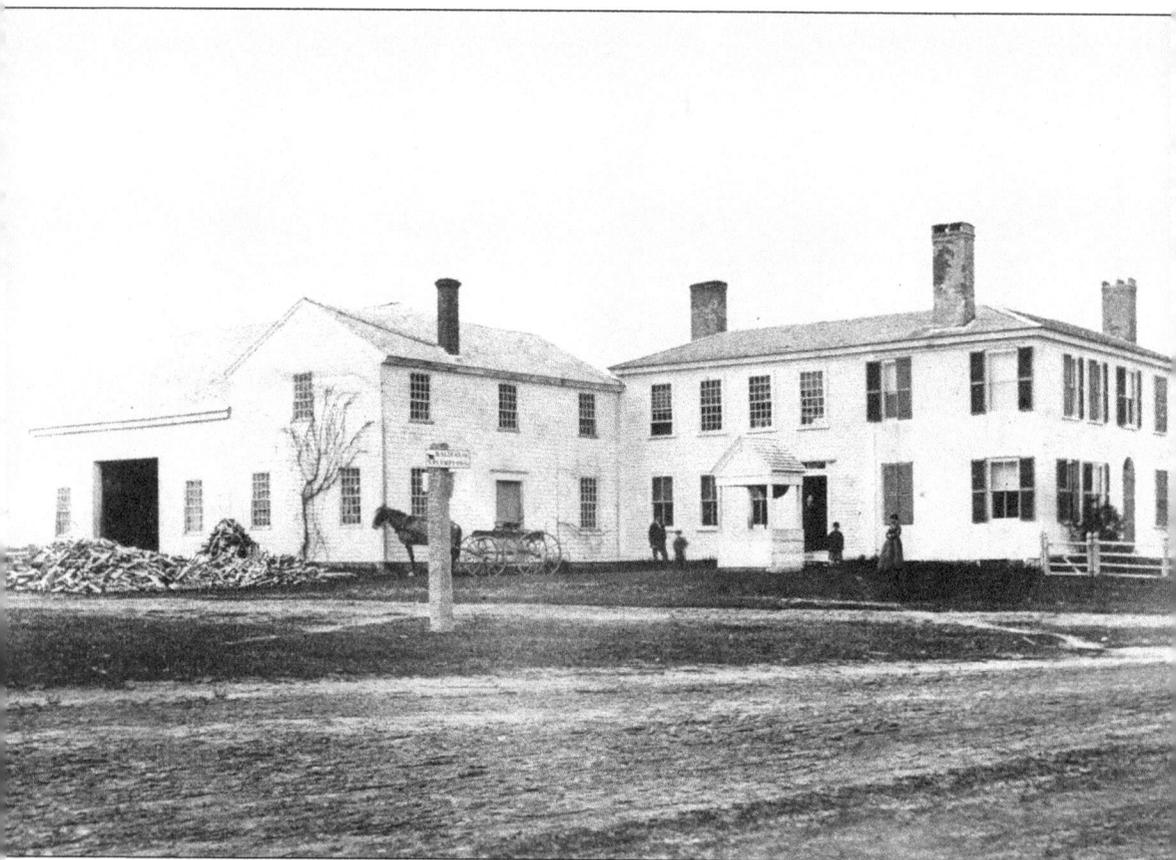

Known historically as the Burton Homestead, records are murky as to whether any of the original homestead remains today. It is thought that the original structure, built by Thomas Burton and his wife, Alice (Wadsworth) Burton, was the ell (now gone) and that what remains today was actually built by Elisha Keen Josselyn around 1808. Over the years, the building has been a general store and the public library, which was housed there in one room from 1878 until about 1890 when the rent charged by then owner J. Riley Josselyn went up to $10 per year. It has also been a private home, retail offices, and a bank.

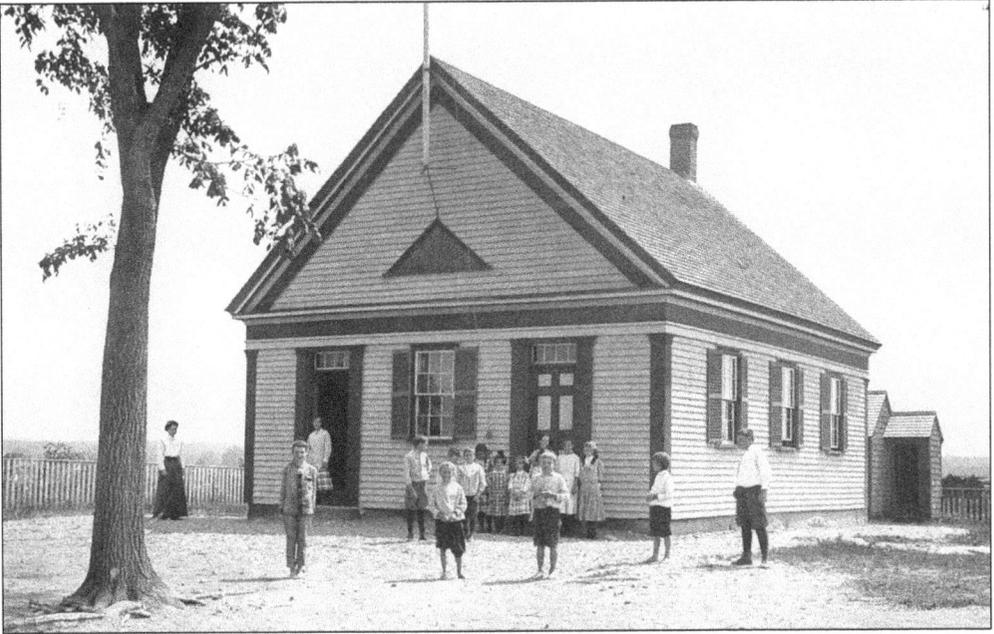

The first local schools came into being through a law passed by the Colony of Massachusetts Bay in 1647. It stated that every town of 50 households or more had to maintain a free public school and appoint a teacher for all those wishing to learn to read and write. Pembroke tried schools in several locations but eventually settled on eight district schools. The Center School was school district No. 5.

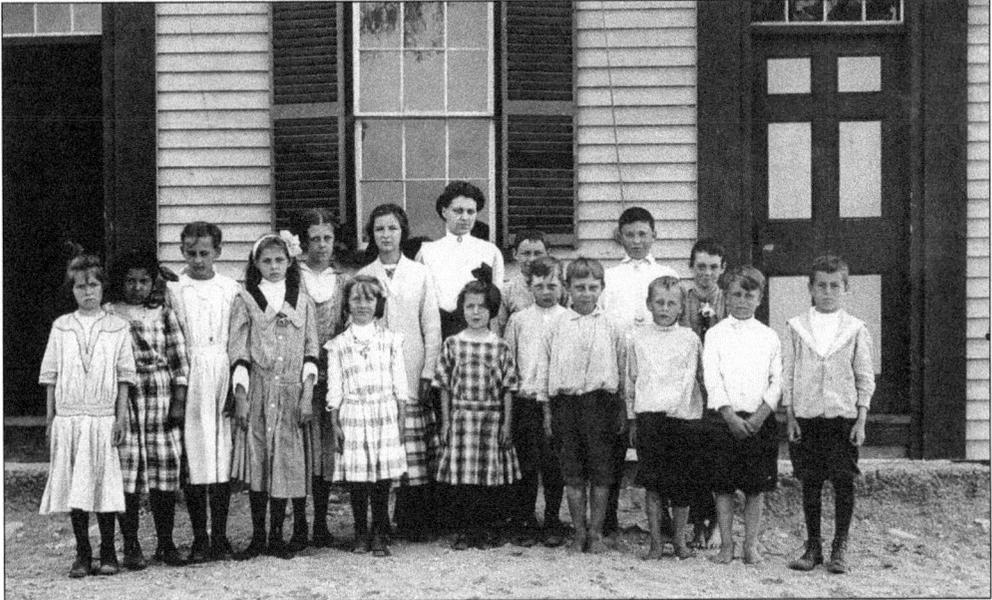

It is thought that this picture of the Pembroke Center school district No. 5 scholars was taken about 1910. Pictured are, from left to right, Velma Hoxie, Abbie Hyatt, Mabel Hyatt, Florence Hoxie, Hazel Hopkins, Celia Olson, Emily Shepherd, teacher Grace McDowell, Erymantrude Potter, Alton Ford, Gail Anderson, Amos Soleski, Russell Brown, Emil Wessa, Frank Whitmarsh, Hannes Wessa, and Maynard Potter.

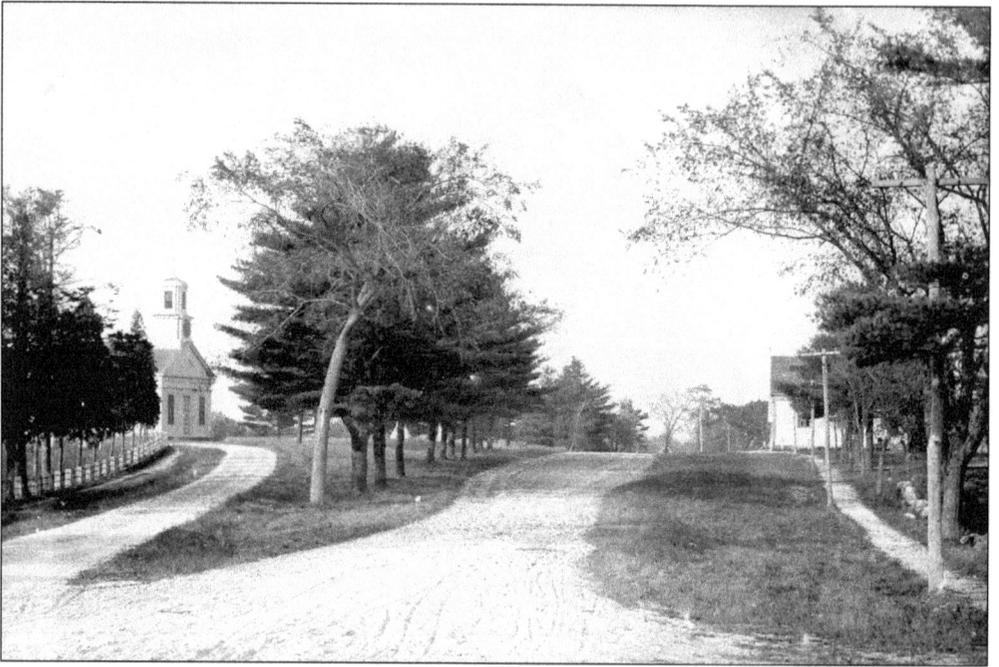

Taken in the 1890s, the picture above shows a normally tranquil and bucolic scene in downtown Pembroke at the intersection of Center Street and Curve Street. Looking down Center Street, the Center Cemetery, Curve Street, and First Church are on the left, the town hall is on the right. The grassy, tree-lined area between the two streets is today's Pembroke Memorial Park. The picture below shows a traffic jam in downtown Pembroke, an event that occurred on many Sunday mornings as residents headed to and from Sunday services. One wonders if there were parking problems even back then. The dirt roads must have made for many dusty congregations.

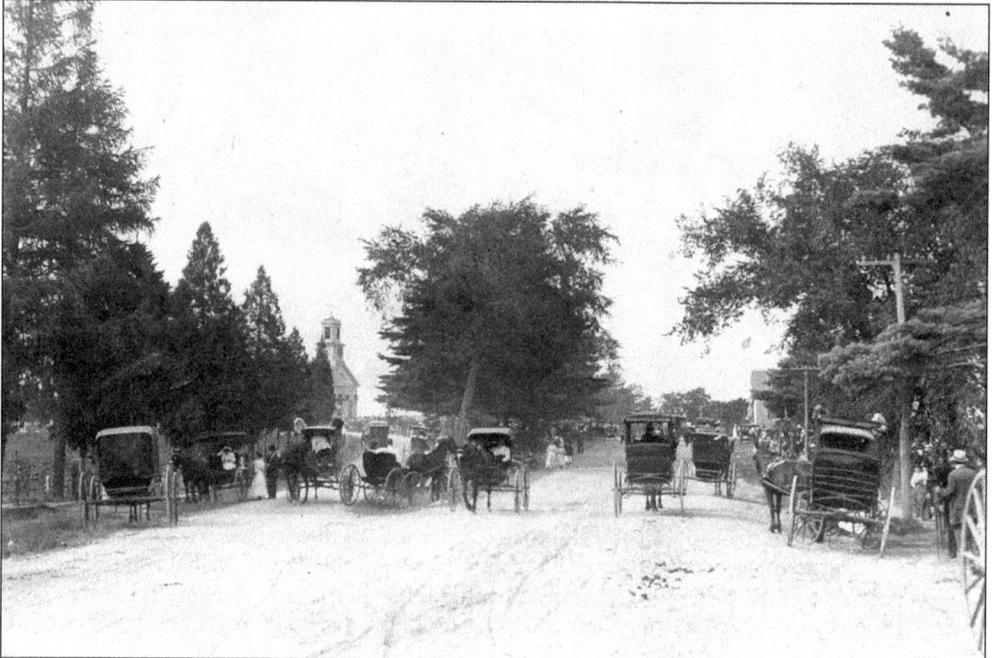

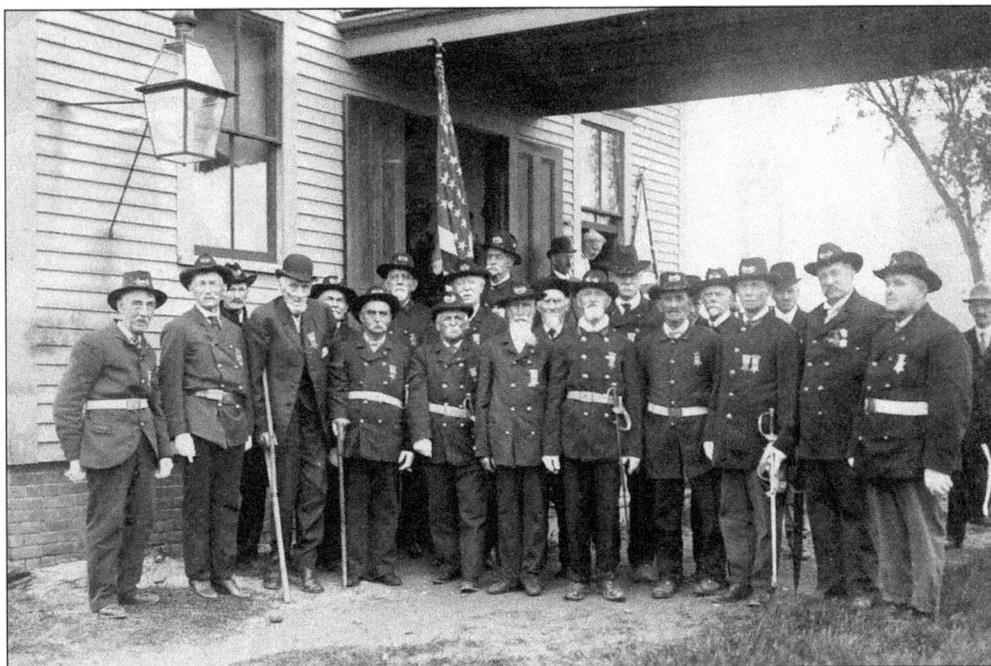

After the Civil War, veterans grouped together to form the Grand Army of the Republic (GAR) chapters or posts (above). In 1869, Pembroke veterans formed the Joseph E. Simmons Post, named after a Pembroke soldier who had died at Second Manassas. Pictured here, among others, are veterans with familiar Pembroke names like Presby, Poole, Magoun, Sampson, Farnsworth, Phillips, Collamore, Damon, Gaskins, Halliday, Ford, Hatch, Drake, Mann, Tappan, and Morton. A patriotic group of women who called themselves the Grand Army Sewing Circle provided assistance to the Joseph E. Simmons Post until 1881, when they formed the official Joseph E. Simmons Women's Relief Corps (below). They met in the town hall and over the Lewis store, but in 1895, they decided to build their own structure, which they shared with the men's group.

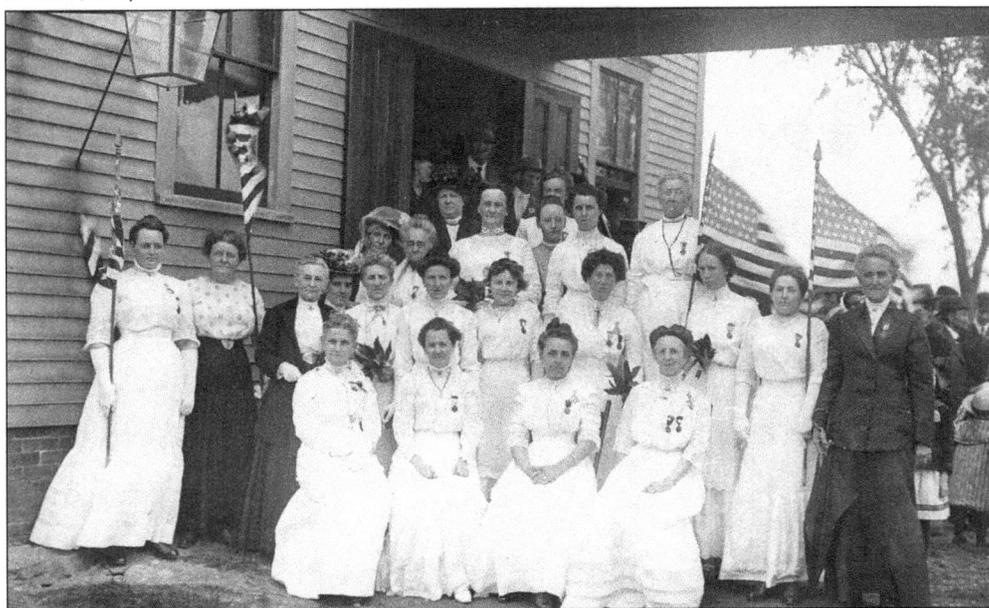

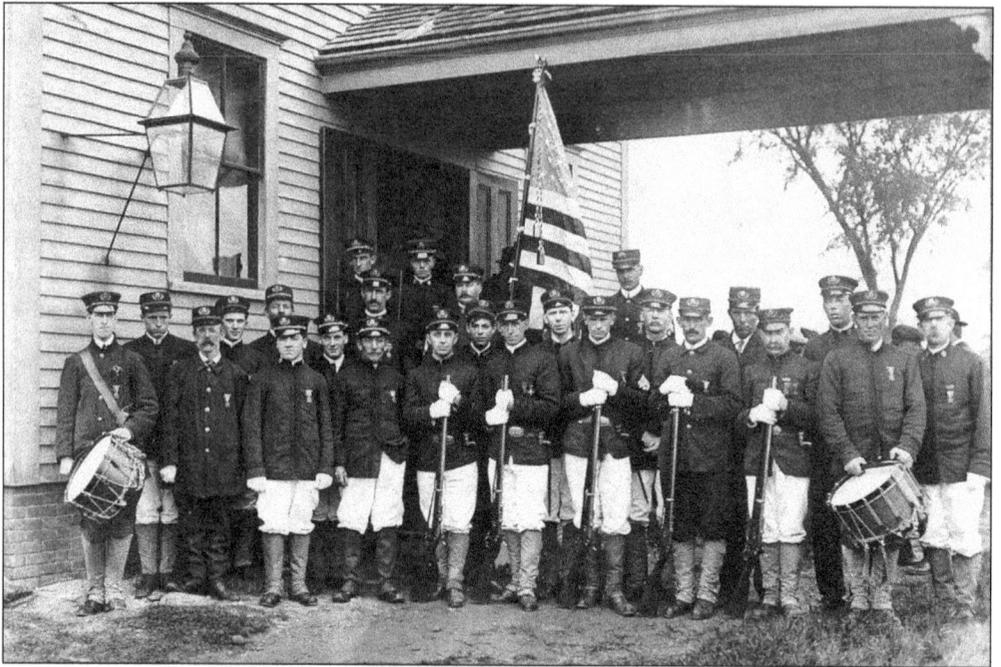

In 1881, the GAR established the SUV (above) to carry on its traditions and memories. Members of the Charles C. Clark Camp of Pembroke's SUV are Dan Ewell, Oren Crossley, Herbert Gerrish, Edward Roberts, George Mann, Samuel Sawyer, Elliott Magoun, Alpheus W. Ford, John Jones, Charles Howe, Harry I. Josselyn, Edward Turner, Francis Crafts, Walter Ford, Paul Gassett, Wendell Howard, Charles Crossley, Edgar Thayer, Charles Gassett, James Smith, Foster Hatch, Barton Rogers, Chester Keene, Oren Gassett, and Frank Whitcomb. An important part of being a member of the GAR or the SUV was the annual Memorial Day exercises, held historically on May 30 every year. Below are the two groups marching in their Memorial Day parade, a solemn occasion in which the town honored its war dead.

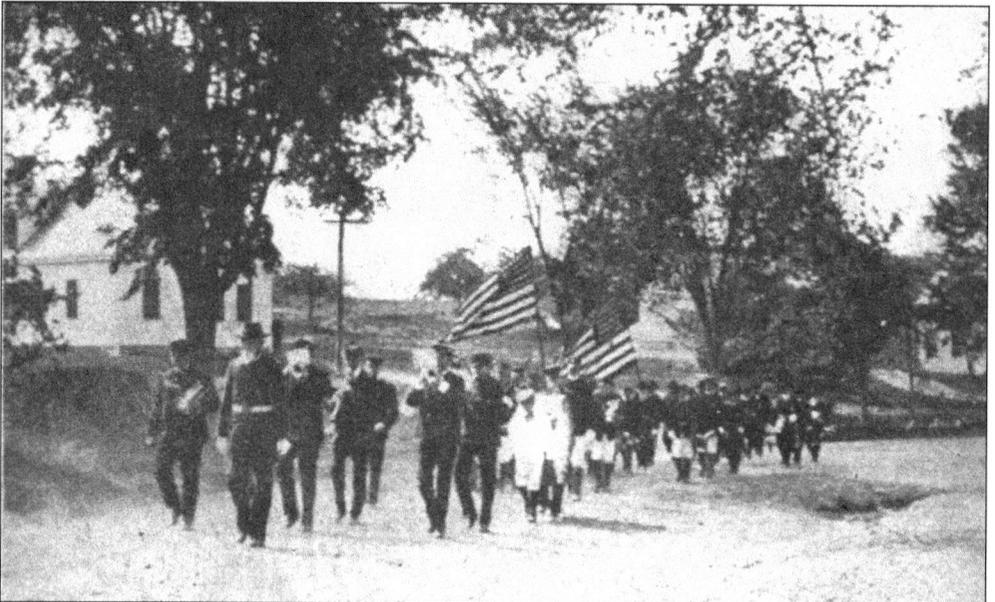

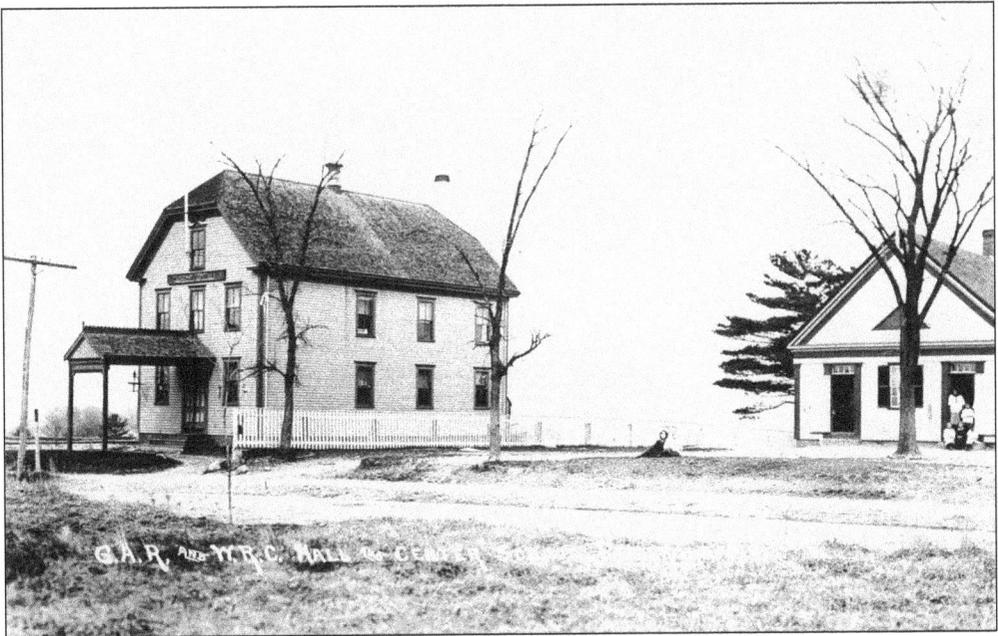

Several years after the Women's Relief Corp was established, members decided to build a hall for themselves and their GAR comrades. After conferring with the men, they decided that the project should fall on the women as none of the men wanted the responsibility. The men would "render all the assistance they could." The building was dedicated in 1896, and the women invited their GAR comrades to share the hall.

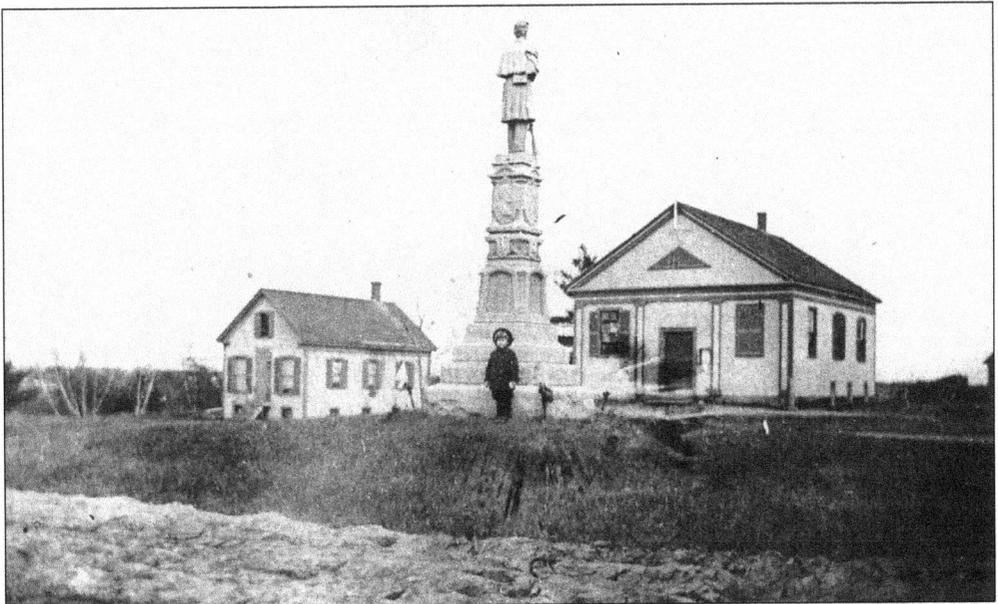

In 1889, the monument erected in Pembroke Center, honoring those who served in the Civil War, was dedicated. It was cast in white bronze or refined zinc by the Monumental White Bronze Company of Bridgeport at a cost of $950 for the bronze monument and $106 for the Hallowell granite base. In the picture, the town hall is on the right and the First Parish Sewing Circle is on the left.

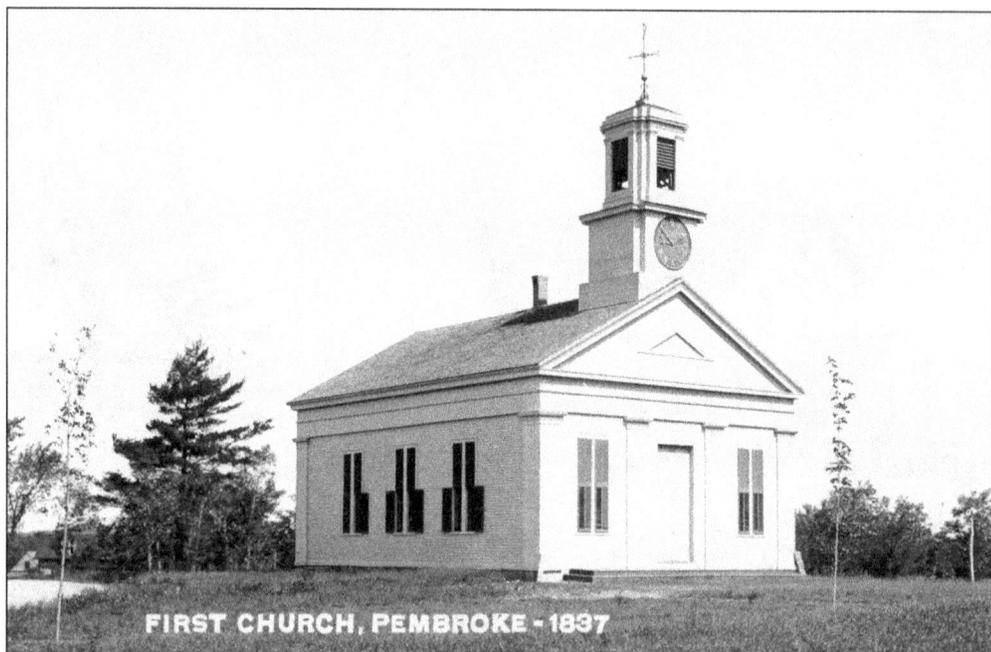

FIRST CHURCH, PEMBROKE - 1837

Although the First Church in Pembroke was formally established in 1712, this building (the third meetinghouse on the site) was built in 1837. It was designed by noted architect Alexander Parris, a Pembroke resident. Parris also designed Quincy Market and the Charlestown Navy Yard in Boston, among other notable buildings.

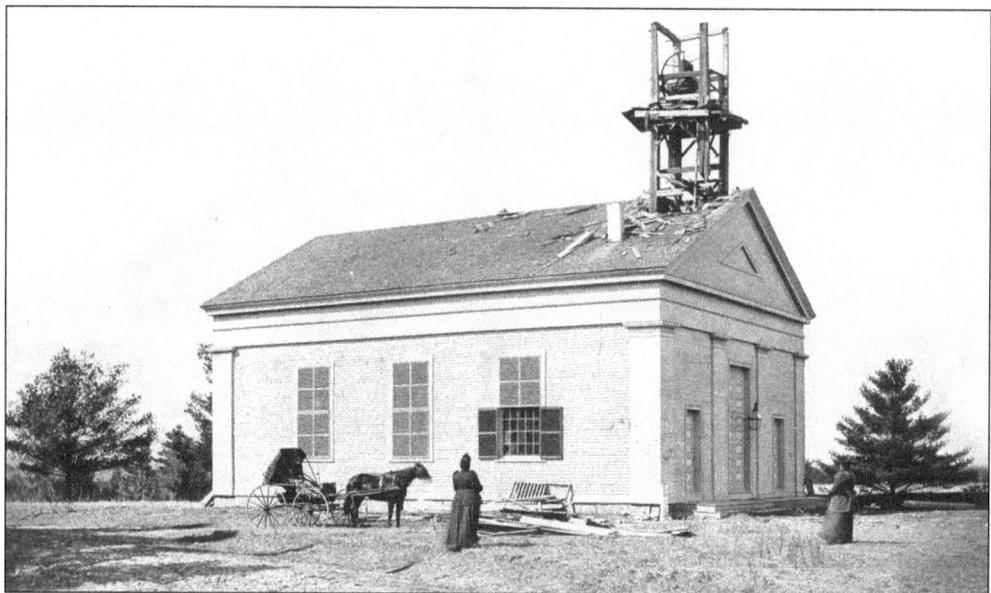

On April 8, 1893, the clock tower on the First Church in Pembroke was struck by lightning, which destroyed the belfry and scattered the parts of the clock in all directions. Repair seemed impossible, but Henry Baker, clock caretaker, managed to locate all the parts and was able to reconstruct the clock.

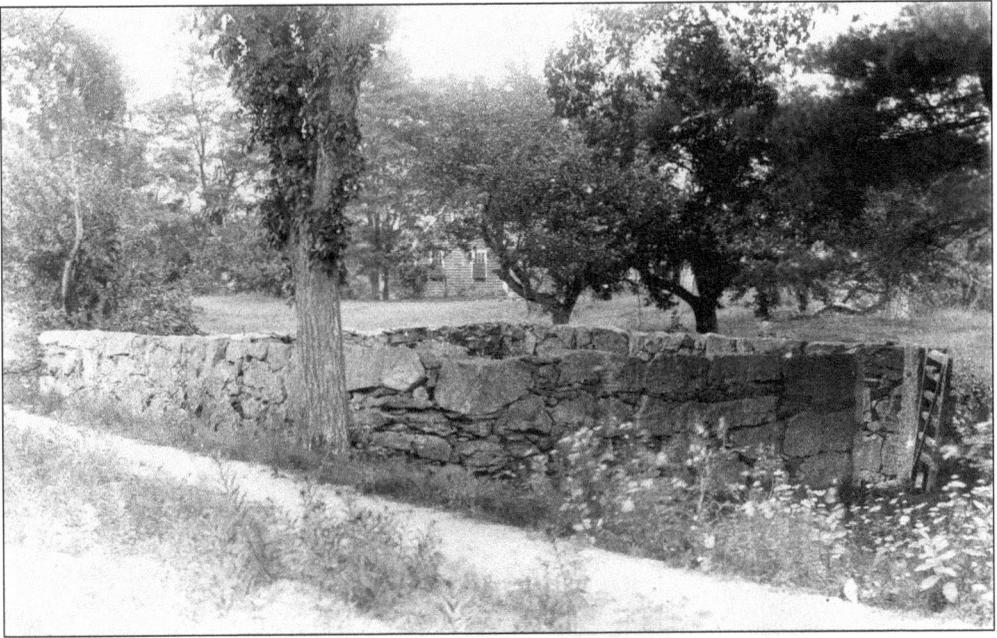

The town pound (above) is one of only 12 remaining in New England, according to *Yankee Magazine*. It served as a detention facility for stray animals during the time when the town common was used as a communal foraging area for all the farms in town. While the original location and date of the first wooden pound is unknown, the current pound was built in 1824 and was the same size as the old one—20 feet on all sides, located "near the old one." A plaque (at right), erected on the structure after its 1909 restoration, proclaims, "The Ox Knoweth His Owner" from the biblical book of Isaiah.

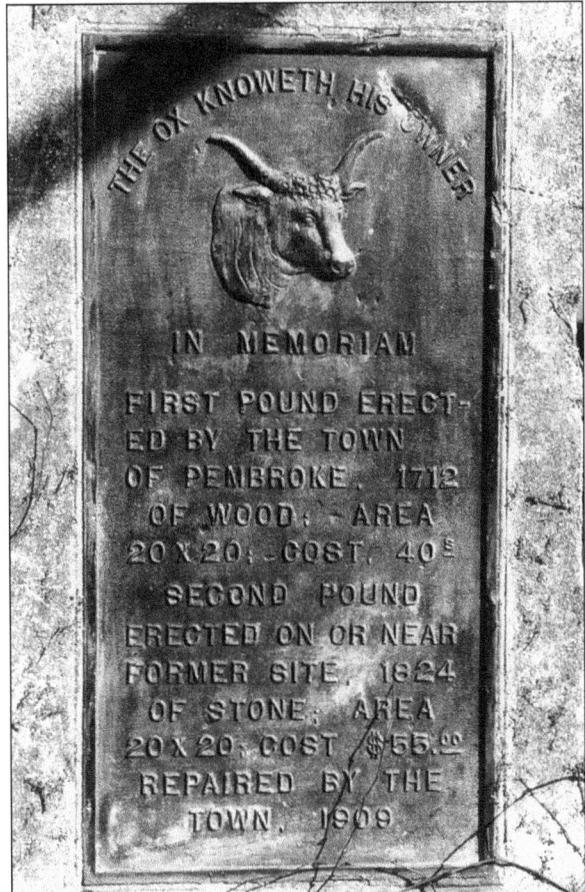

THE OX KNOWETH HIS OWNER

IN MEMORIAM

FIRST POUND ERECTED BY THE TOWN OF PEMBROKE, 1712 OF WOOD; AREA 20 X 20; COST 40$ SECOND POUND ERECTED ON OR NEAR FORMER SITE, 1824 OF STONE; AREA 20 X 20; COST $55.00 REPAIRED BY THE TOWN, 1909

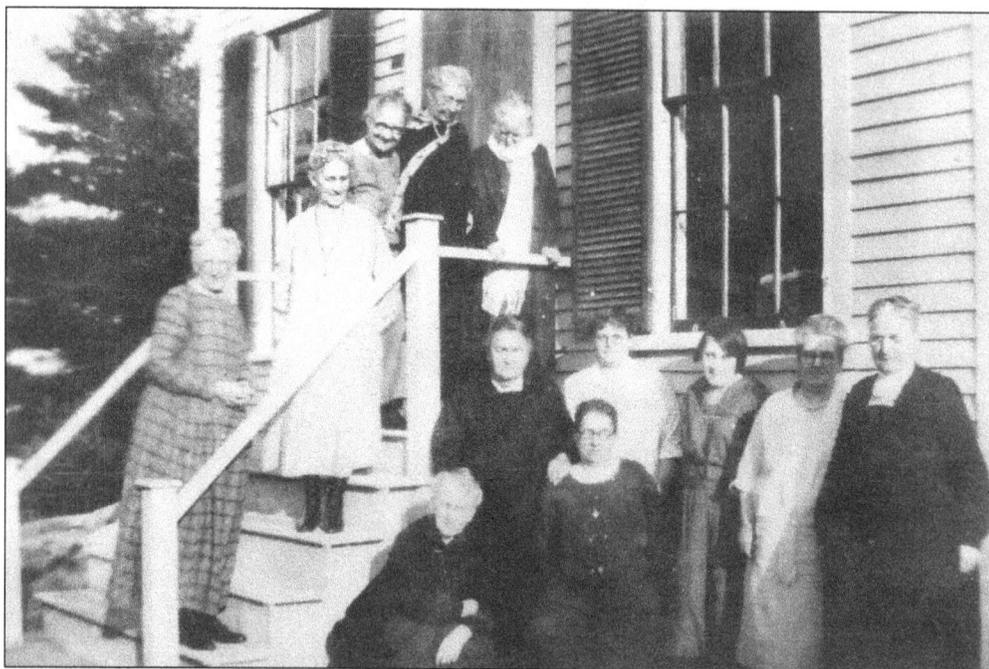

The Pembroke Ladies Sewing Circle, established in 1845 by a group of First Church women, was interested in performing charitable works. In 1851, the name changed to Sewing Circle of the First Parish in Pembroke. Seen here on the steps are, from left to right, Abbie Oldham, Phoebe Baker, Mrs. Miller, Carrie Thayer, and Nellie Bates. Seated from left to right are Alice Litchfield and Annie Anderson; standing are Deborah Ramsdell, Eva Orne, Dorothea Ford, Besse Porter, and Mary Addie Oldham.

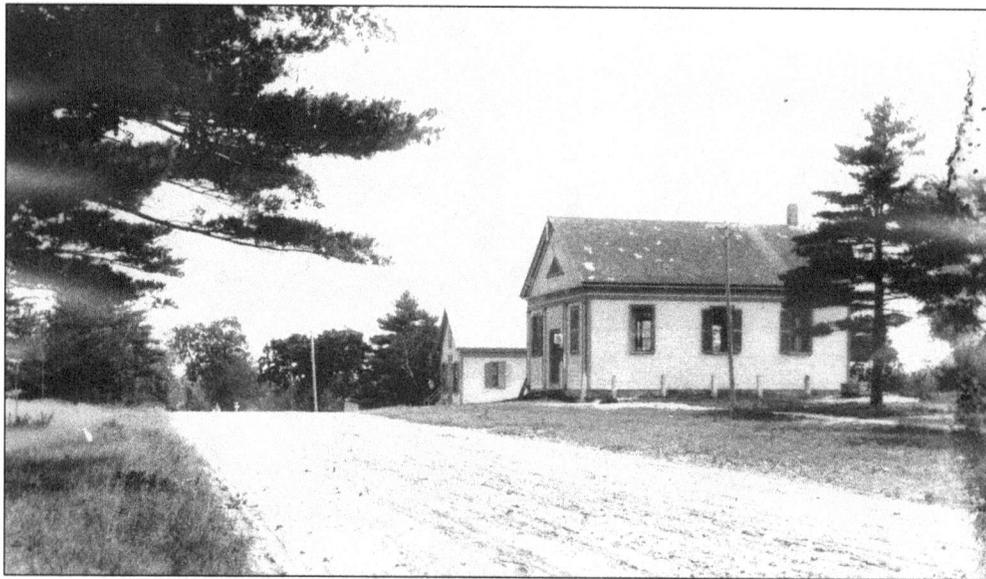

In 1837, Pembroke built its first town hall (in the foreground) on the present site of the Pembroke Historical Society Museum. In 1932, it was moved to the present location, where it was renovated and columns were added to the original structure. On February 21, 1978, a fire destroyed the newer wing of the town hall and heavily damaged the original section.

38

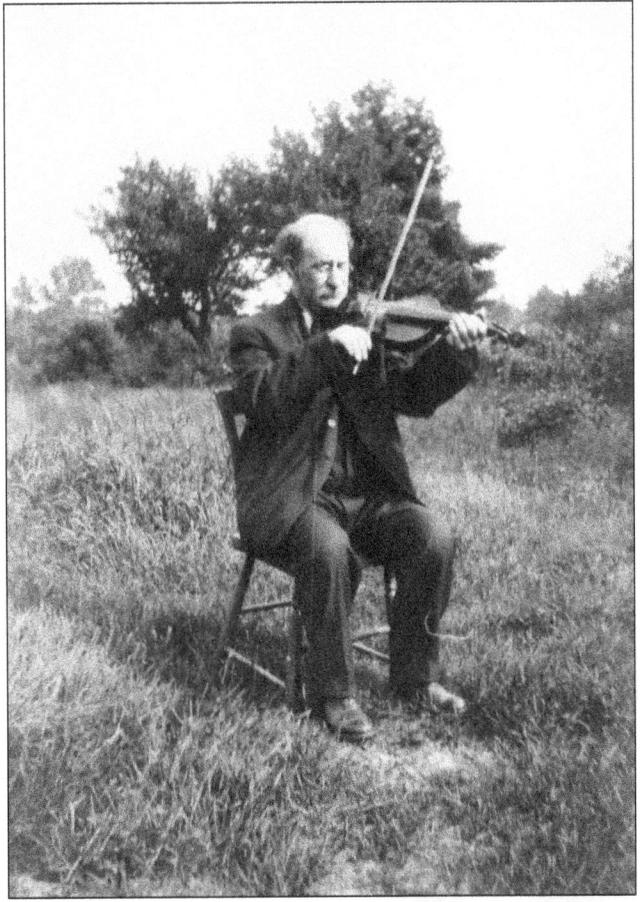

Fred White (at right) was born about 1850, the son of Lucius and Sarah White. Fred was a blacksmith by trade with a shop (below) on Center Street at the site of today's center fire station. As a hobby, Fred made violins. He was deaf as a result of measles but was able to feel vibrations of his violins through his jawbone. It is thought that he made between 70 and 80 violins before he died in 1928. He claimed that his violins were mostly designed after those made by Stradivari, but some were similar to those made by Guarneri. Ironically, the home burned down in 1975.

The land known historically as the Little's Estate at the end of Little's Avenue was probably built on by Robert Barker Jr. around 1710. Barker sold the farm to Joshua Cushing, who sold it to Isaac Little in 1725. In 1788, the residence was intentionally burned to the ground by Wealtha (Winsor) Little, the wife of Isaac Little III (grandson of the first Isaac). The present house was built by Isaac and Wealtha soon after on the same spot as the old house to Wealtha's specific instructions. Isaac was later to point out that his wife had deprived herself of the right to "find fault with her field of operation."

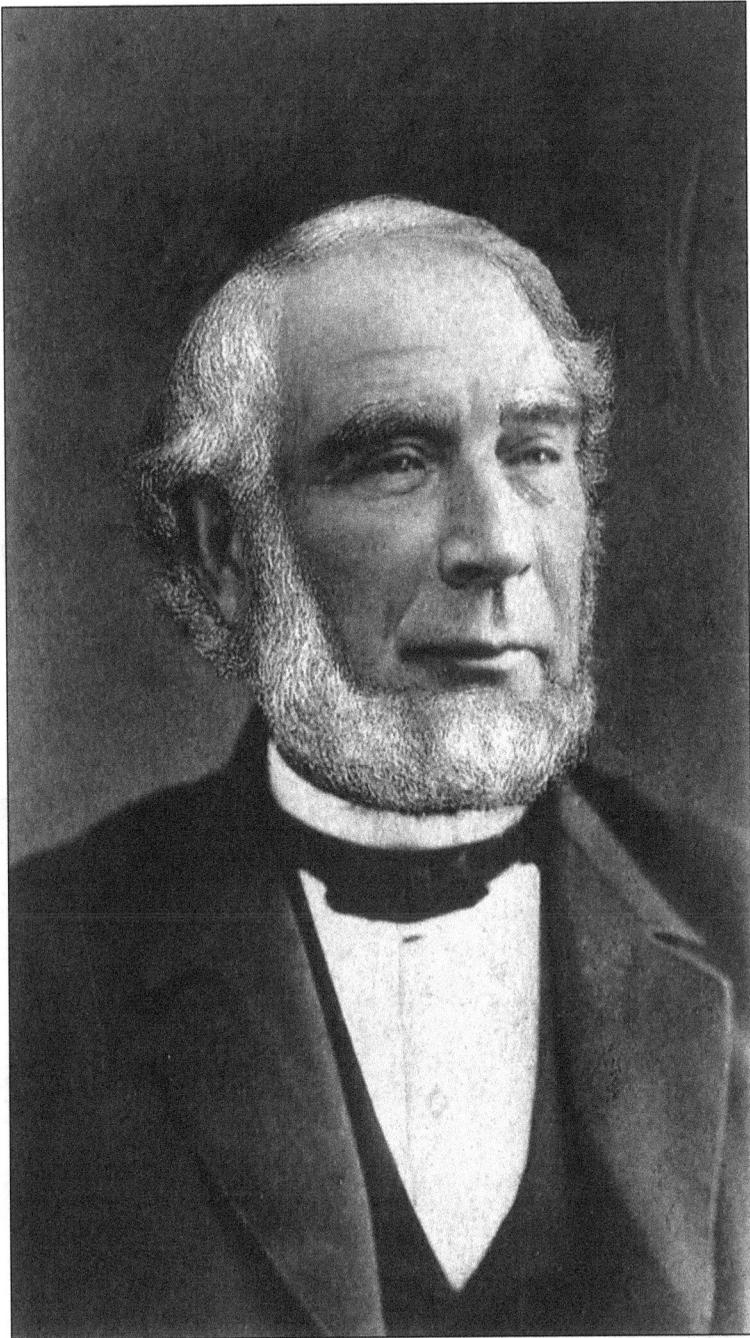

Capt. Otis Little was born in Pembroke in 1809, the son of Isaac and Wealtha (Winsor) Little. He succeeded several generations of the Little family to live in the estate on the road that bears the family name. Otis earned the title of captain through his command in the Massachusetts militia, having been appointed as an ensign by Levi Lincoln, governor of Massachusetts, in 1832. He married Betsey Haskins of Scituate in 1838. He was a mason by trade. Betsey Little died in Pembroke in 1893. Otis died in Boston in 1895. Both are buried in the Pembroke Center Cemetery.

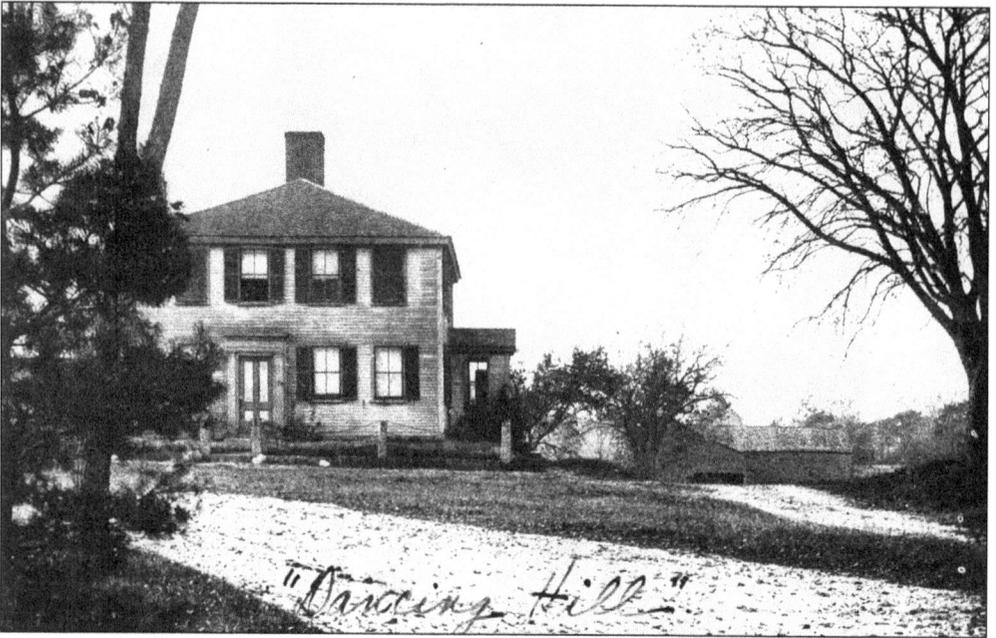

"Dancing Hill"

The land at the east end of Allen Street was once known as Dancing Hill by the Native Americans who performed tribal dances there. Around 1800, Morrill Allen, fifth minister of the First Church, built a substantial farm on the lane that bears his name. Besides his ministerial duties, he wrote frequently for several 19th-century agricultural publications before his death in 1870. The home eventually burned to the ground.

This was the home of Nathan and Lucy (Osborne) Simmons. Both Nathan and Lucy were born in Pembroke and were married here in 1834. It was known as the Lucy Simmons Place, probably because Lucy outlived her husband by 23 years. The home was located on Center Street between Elliott Avenue and Kilcommons Drive. It burned in the mid-1920s.

Lucius White (at right) was born in Hanson in 1827. He was the son of Welcome White of Hanson and Urania Howland (Fish) White of Pembroke. The family was descended from Pilgrim Peregrine White and was in Pembroke early. One ancestor worked as an iron molder at the Colonial furnace on Furnace Pond. In 1849, Lucius married Sarah Tripp in Hanson. The couple lived in this house (below) on Oldham Street near Pembroke Center, where they raised three children, Frederick, Edward, and Aroline. Lucius worked at various times as an iron founder, a shoemaker, and a farmer. Sarah died in 1902, and Lucius died in 1911.

Originally the Martin Osborne House, this home was built about 1790. It became known historically as the Ford Place, after the family of Joseph Ford and was located on the site of the present Pembroke Center Post Office. The home was moved to Barker Street. Elliott Avenue, which runs between the fire station and the post office, was named after one of the descendants of Joseph, Elliott Ford.

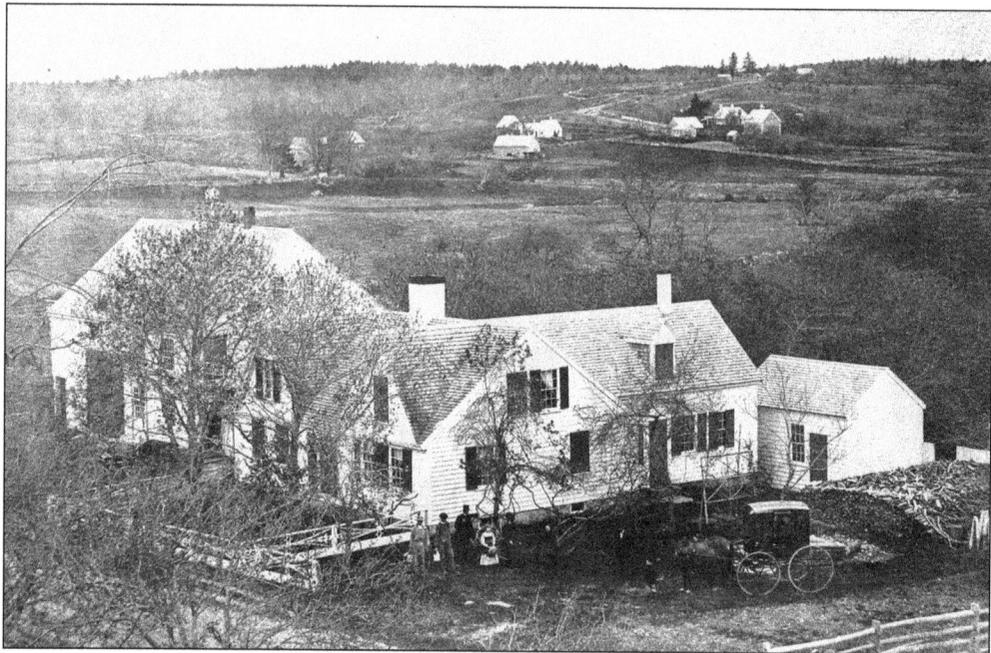

The Josiah Bishop House on Oldham Street was built about the time he married Sarah Crooker in 1736. The couple raised three sons and three daughters in the home. The home left family hands in 1832, when the wife of Josiah Bishop's great-grandson sold the property to Seth Jones. Jones family heirs owned the property until 1977. Note West Elm Street in the distance.

Although known as the George Ryder Place, this home first belonged to Michael and Eliza (Bartlett) Howland. It was located on Center Street across from Mountain Avenue. Michael was a shoe fitter and lived in Pembroke his entire life. The house burned in the 1920s and was replaced by the home where Tommy and Jeanette Reading ran their produce stand. It is now the site of adult housing.

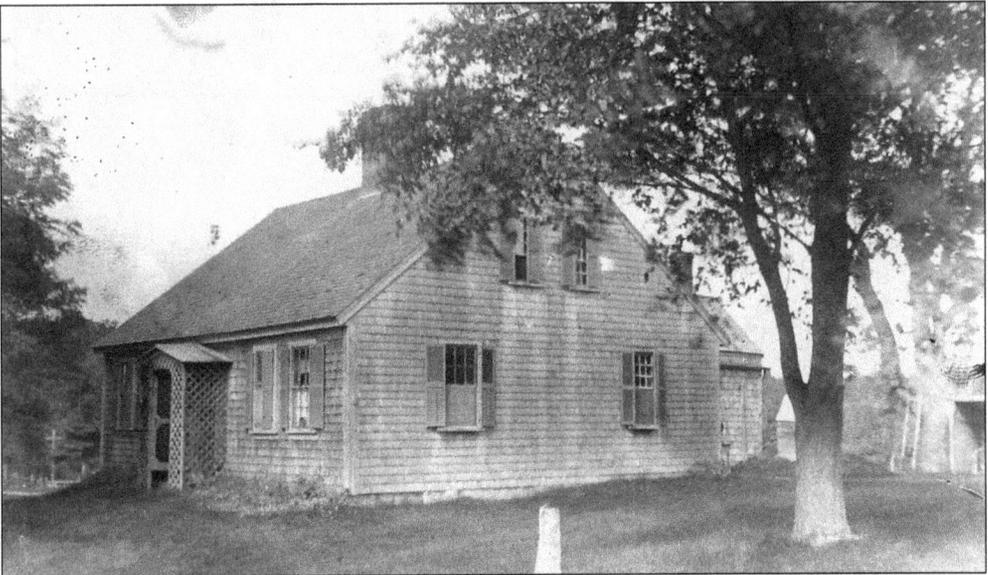

Known as the Homestead Farm, this home on Mountain Avenue was built about 1775 and probably first owned by Martin Ford. There are two legends about this house—one says there are Acadian children buried on the grounds. Another says that one of the owners married a Native American girl named Marsha, and whenever the wind blew the upstairs doors shut, later owners would say, "There's Marsha at it again."

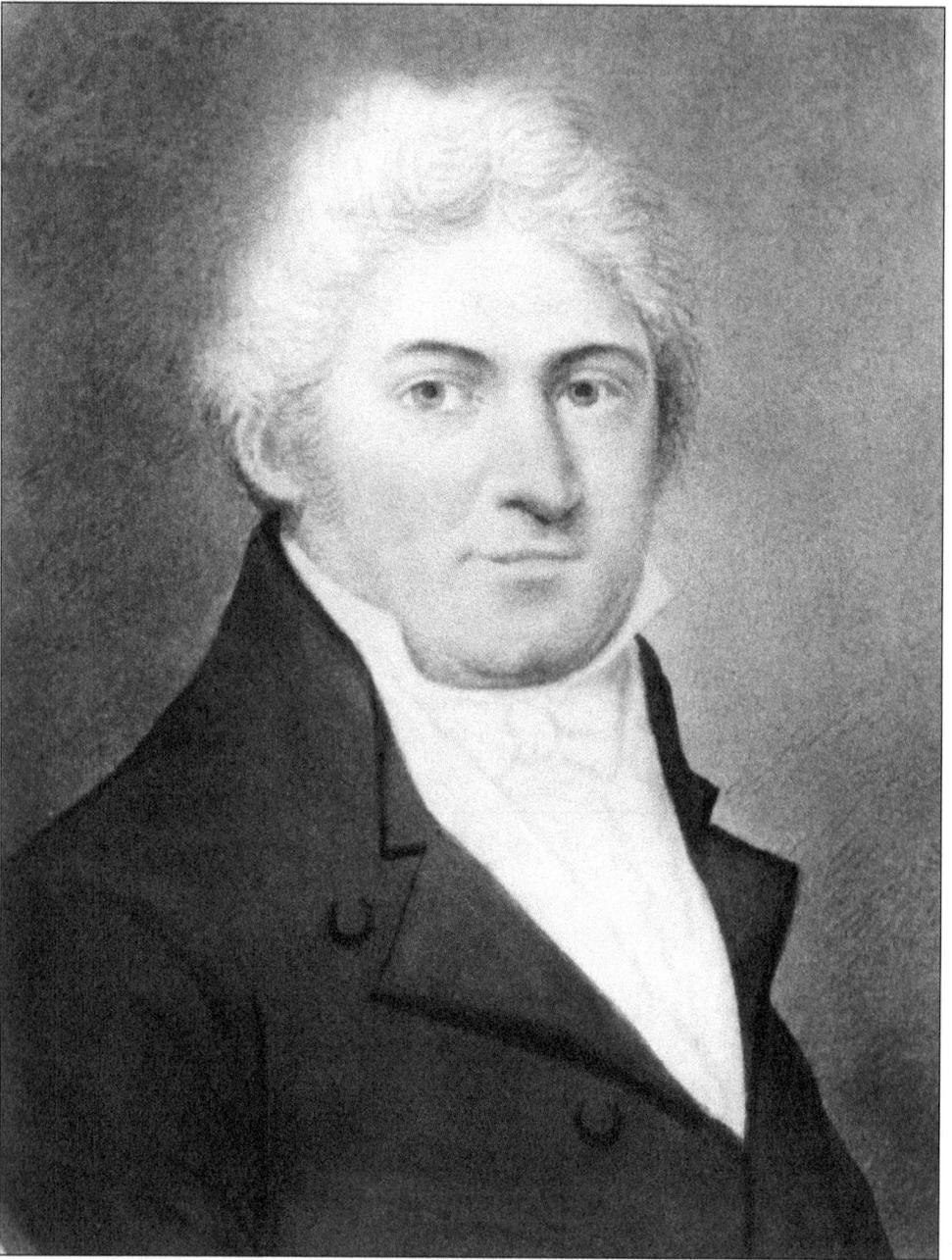

The Reverend Kilborn Whitman, third minister of First Church in Pembroke, was born in Bridgewater in 1765. A graduate of Harvard, he came to Pembroke in 1787 to assist the Reverend Thomas Smith. He married Elizabeth Winslow in Marshfield in 1788. In 1796, he retired from the ministry and began to study law. In 1798, he was admitted to the bar and began to attend all the courts in southeastern Massachusetts. He kept his farm and his office in Pembroke and served as representative, selectman, and moderator for the town. He was a judge in the court of common pleas, the attorney for Plymouth County, and the overseer and advocate for the Mashpee and Herring Pond Native Americans. Reverend Whitman died in Pembroke in 1835 and is buried in Pembroke's Center Cemetery.

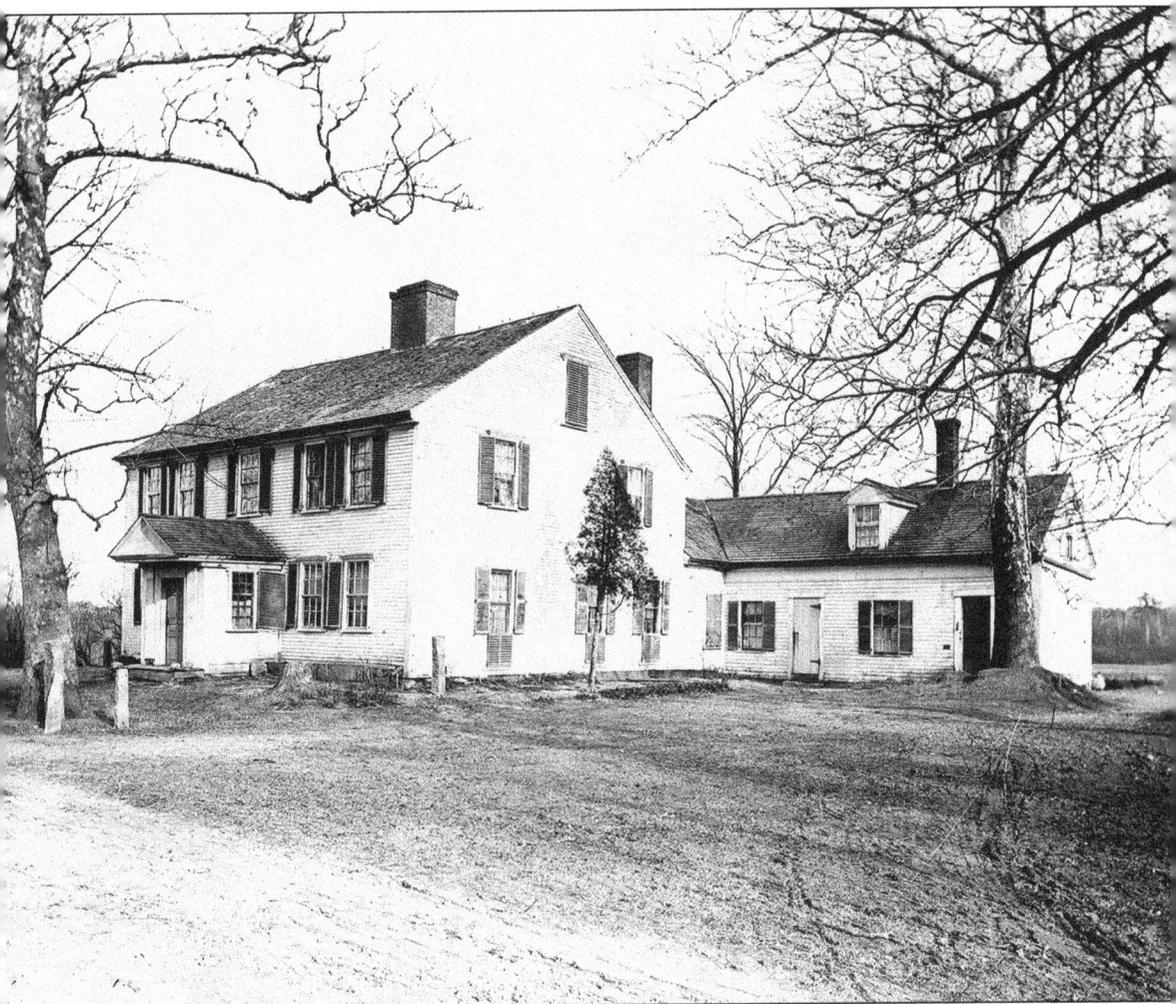

This home on Center Street is known historically as the Judge Kilborn Whitman House. It was built by Abraham Pearce prior to 1700 as a half house. Pearce and his family owned a large grant of land, which at one time covered most of what would become Pembroke Center. Upon the death of Pearce, the house passed to his son John. In 1714, John sold the home to Nehemiah Cushing. The home remained in the hands of Cushing's descendants until it was purchased by Reverend Whitman. After the death of Reverend Whitman and his wife, Elizabeth, the home passed to their son James Hawley Whitman. He died, and the house was owned by Kilborn's daughter, Frances Gay (Whitman) Hersey, who was a widow. After her death in 1899, the home seems to have passed out of the Whitman family.

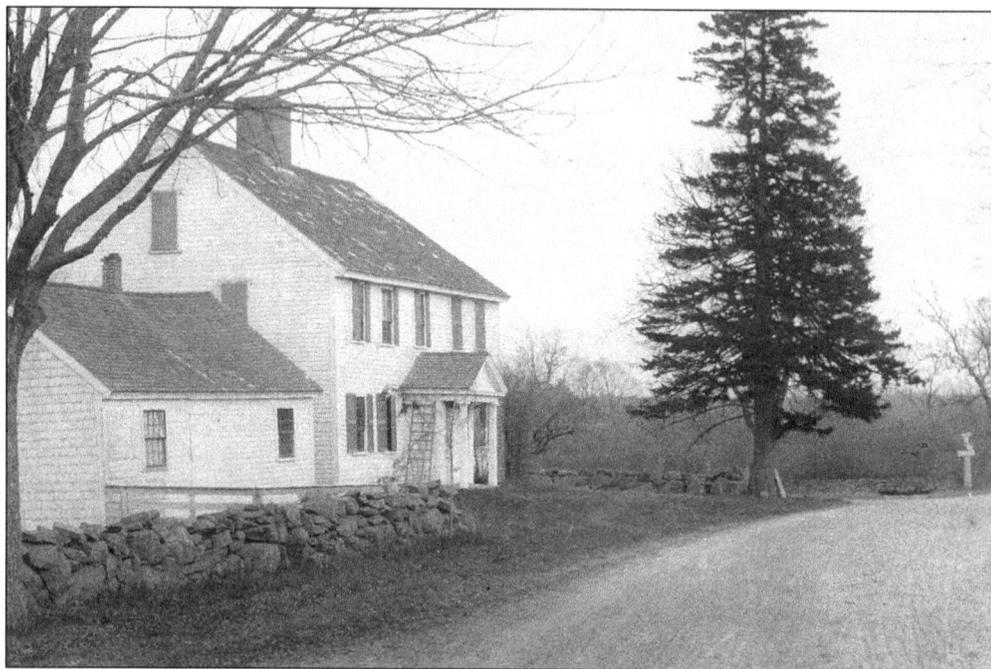

This house, next to the Herring Run, is known historically as the Peter Salmond House. Its exact age is uncertain, but it was owned by Deacon Jacob Mitchell, a blacksmith, in 1720. It was not until 1792 that Peter Salmond, of Scotland and a trader, bought the home. His son Peter lived there next. He was a teacher and later operated a general store in the house's north wing.

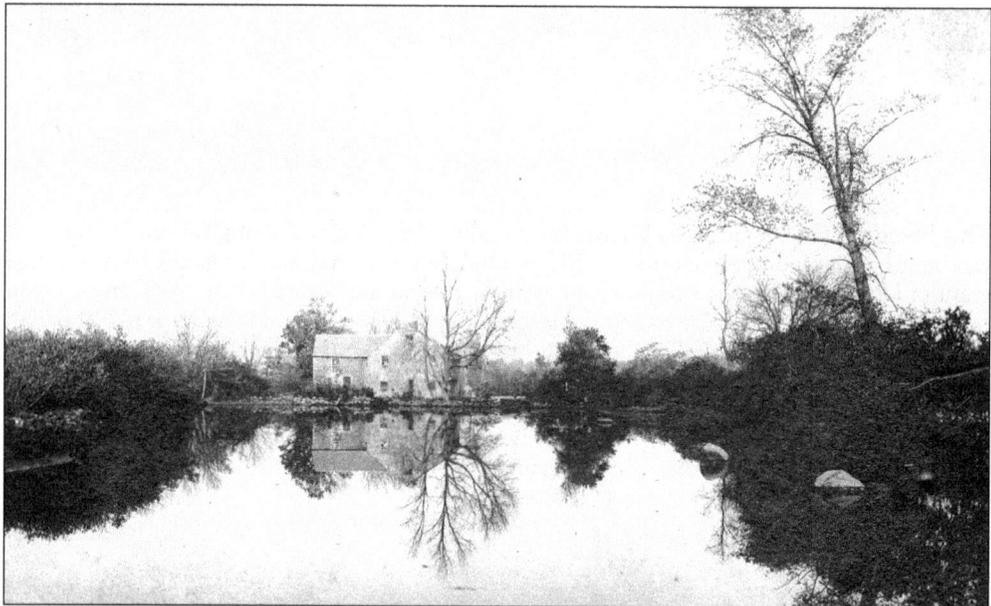

The Herring Brook, which runs between Furnace Pond and the North River, gave birth to a number of local mills. One such mill was a sawmill owned by Lemuel LeFurgey, located on Center Street near the Herring Run. Born on Prince Edward Island in 1837, LeFurgey married Susan Shepherd, daughter of box manufacturer Calvin Shepherd, in 1861. Several generations of LeFurgey and Shepherd descendants continued this industry well into the 20th century.

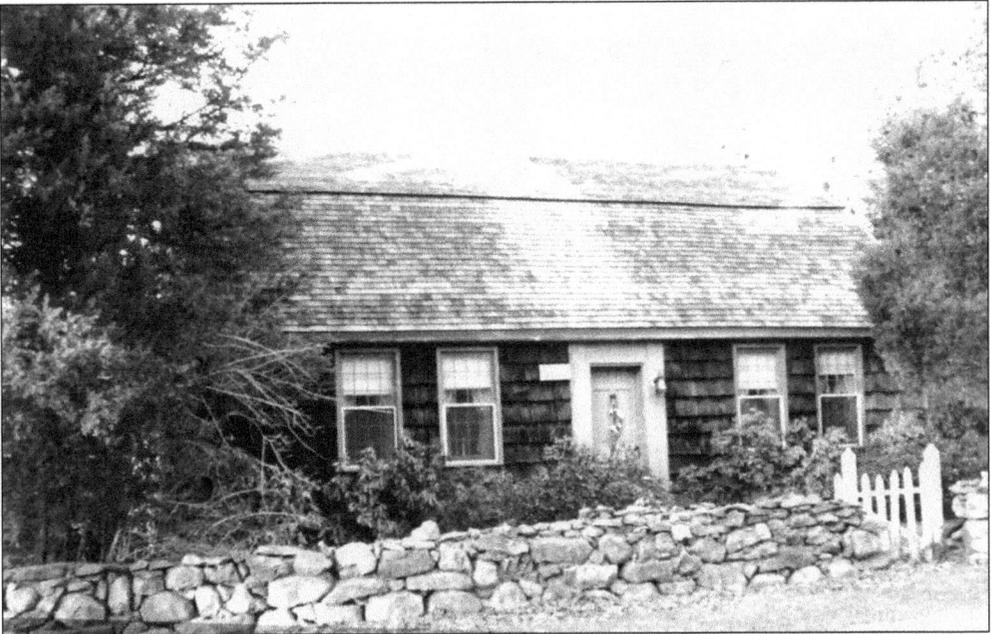

Hudson Bishop probably built this house on Oldham Street around the time of his marriage to Abigail Keen in 1756. The home passed to their son Nathaniel around 1746. It was briefly owned by Josiah Keen about 1760, and in 1761, Nathaniel Stetson took ownership. Nathaniel willed the house to his son John. The house remained in the Stetson family until the 1900s.

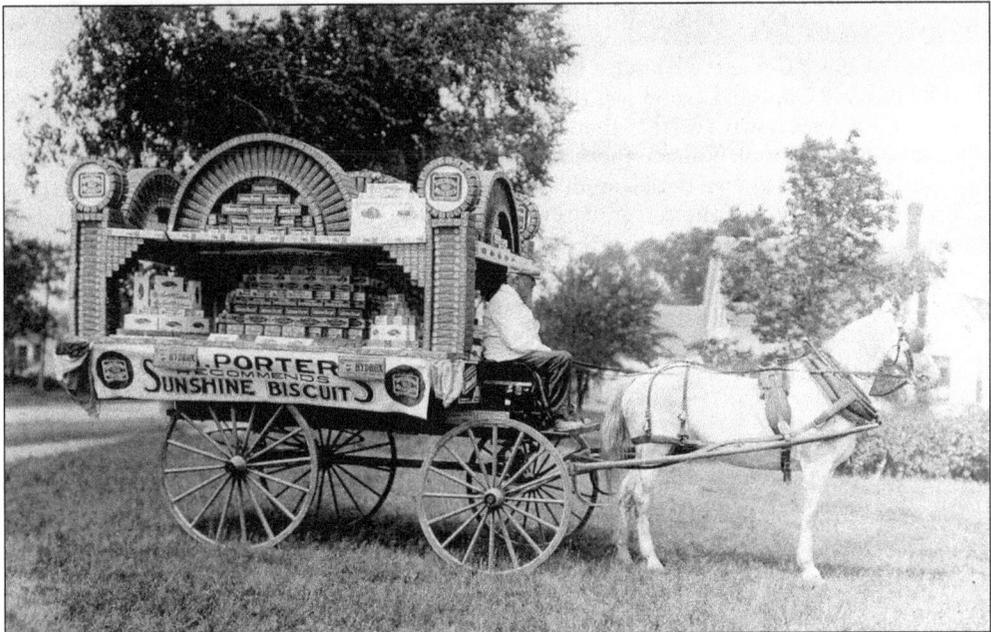

In 1900, Ira F. Porter described himself as a "peddler of wholesale confections." He eventually purchased Isaac Jennings's store in Center Pembroke. Ira and his wife, Bessie, lived in an apartment over the store until 1938, when he sold the business to Kenneth Henrich, a former employee. In 1974, the store, located at the intersection of Center and Mattakeesett Streets, was destroyed by fire.

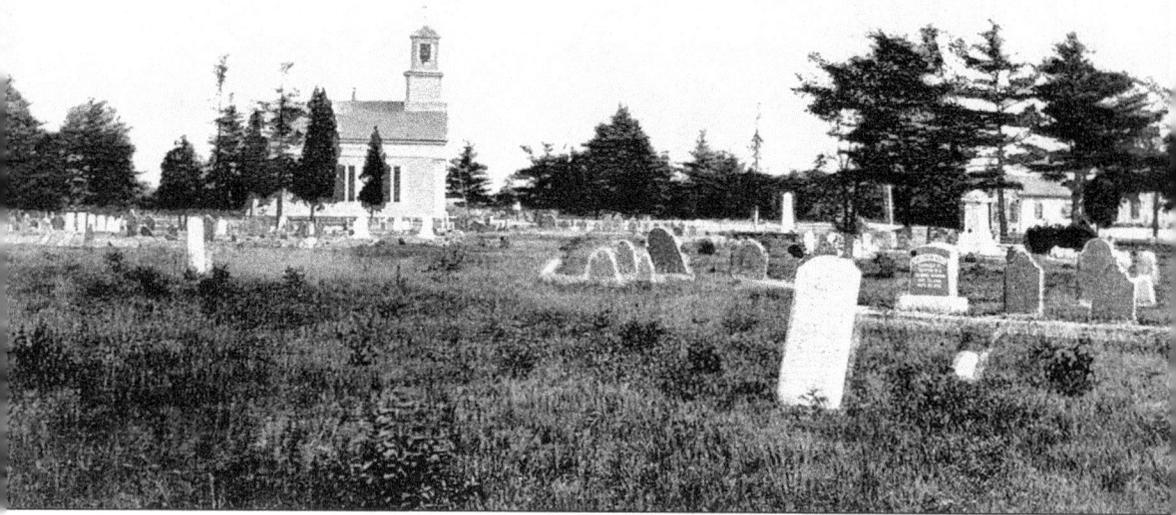

Pembroke's Center Cemetery bounded by Center, Curve, and Oldham Streets is also known as the Old Burying Ground. Legend says that early on, Native Americans of the area were buried here. The earliest known burial is that of Anne, a child of Isaac Thomas who died in 1715. The oldest stone, that of William Tubbs who died in 1718, has lost its inscriptions due to harsh weather. The earliest known burials seem to be in the area of the middle gate, closest to the First Church. Not surprisingly, the cemetery is the final resting place of a number of First Church's ministers. Other names on the stones read like a page straight out of Pembroke's early history.

Three

CROOKERTOWN

The neighborhood known as Crookertown was part of Marshfield Upper Lands. It was settled by the Crooker families of Marshfield. Jonathan Crooker owned a large tract of land with Israel Thomas that extended to the shores of Silver Lake, then known as Jones River Pond.

Jonathan Crooker was born in Marshfield in 1684. He married Sarah Allen in Marshfield in 1714. They raised two children in Pembroke. By 1800, there were six Crooker families in Pembroke. By 1850, there were over 100 births in Pembroke of children with the last name of Crooker. The name had all but died out by that time in Pembroke, however, and the Crookertown neighborhood was home to families with the names of Stetson and Ford, among others.

The heart of the Crookertown neighborhood was located near the intersection of Plain Street and Valley Street. When the town divided itself into eight school districts, the Crookertown School was district school No. 2 and was located at that intersection. This one-room schoolhouse was exactly that—all grades (one through eight) were housed in one room with one teacher. There were typically two doors in the front of the building, one for the boys and one for the girls. There was usually a front hall with coat hooks and shelves for students' lunches. The main room had a small, round stove for heat. There were two outhouses located to the rear, often connected by a long, narrow woodshed. These early schools gave the students a basic education in reading, writing, and arithmetic. Later a little spelling and grammar were added. They would also learn syllables and phonetics.

Today the Crookertown neighborhood has been absorbed by the Hobomock school district, named for the pond in the area.

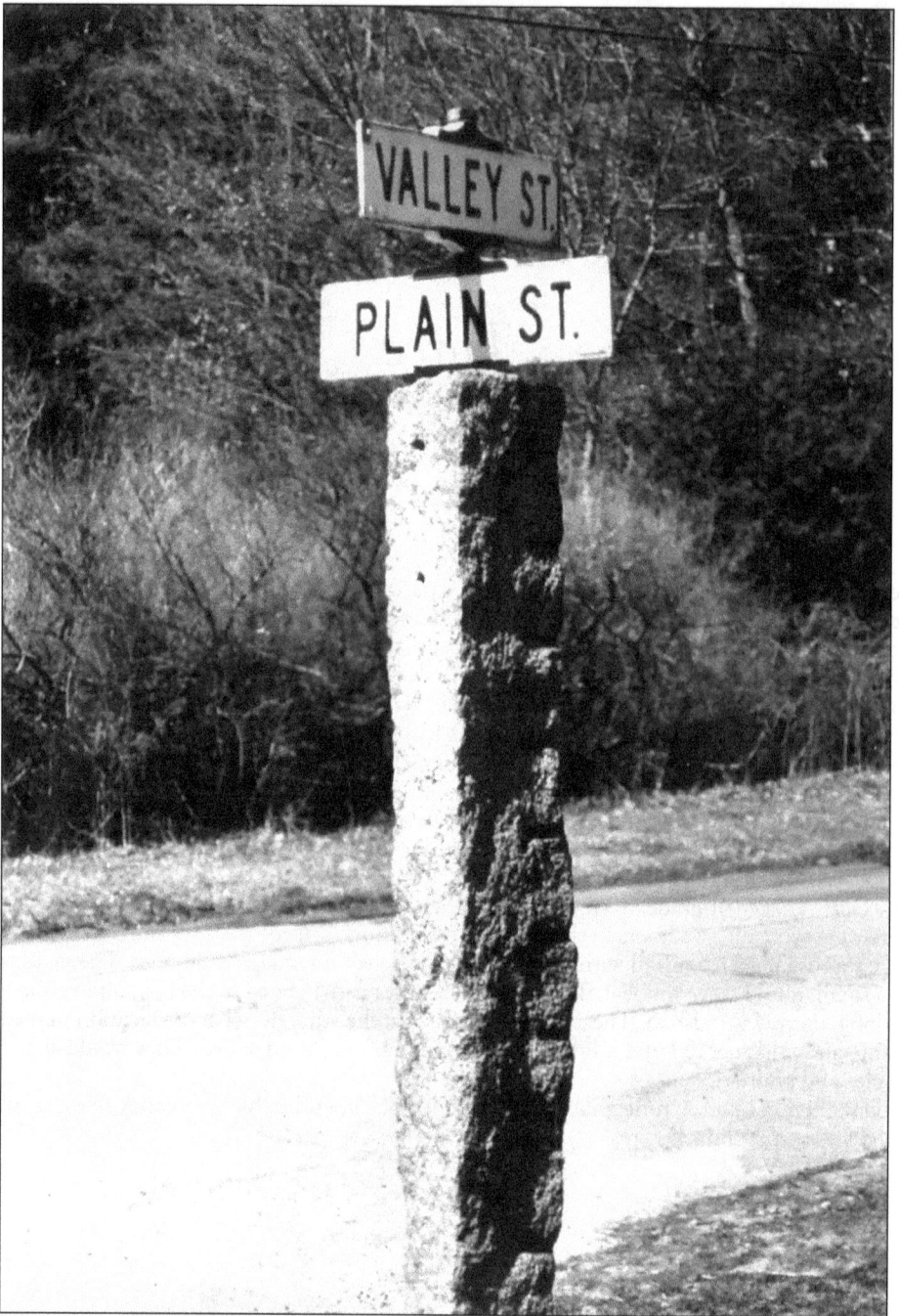

The intersection of Plain Street and Valley Street was considered the heart of the Crookertown neighborhood. This is probably because the Crookertown district school No. 2 was located here. At one time, there were 32 granite signposts scattered throughout the town of Pembroke. According to the 1841 Pembroke town treasurer's report, the posts were set in the ground in the fall of 1841 by Job Beal, a stonecutter and Pembroke native. He was paid $28.70 for his trouble. Martin Ford and John Barker were also involved in the project. Ford was paid $66.56 and Barker $27.55. Today there are only 11 of the original 32 still in existence. (Courtesy of John Proctor.)

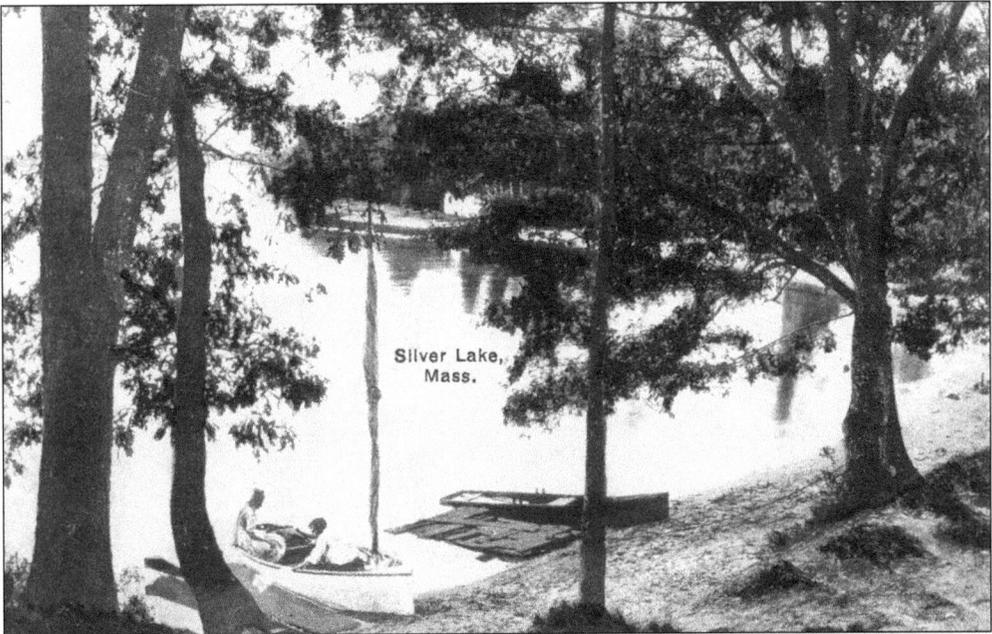

Silver Lake covers about 442 acres near Crookertown as well as part of Halifax and Kingston. Originally called Jones River Pond for the Jones River, a major tributary running from the pond to the sea, it was named for the captain of the *Mayflower*, Christopher Jones. Renamed in the 19th century, it was thought Silver Lake was a better name for the selling of the ice harvested and sold commercially.

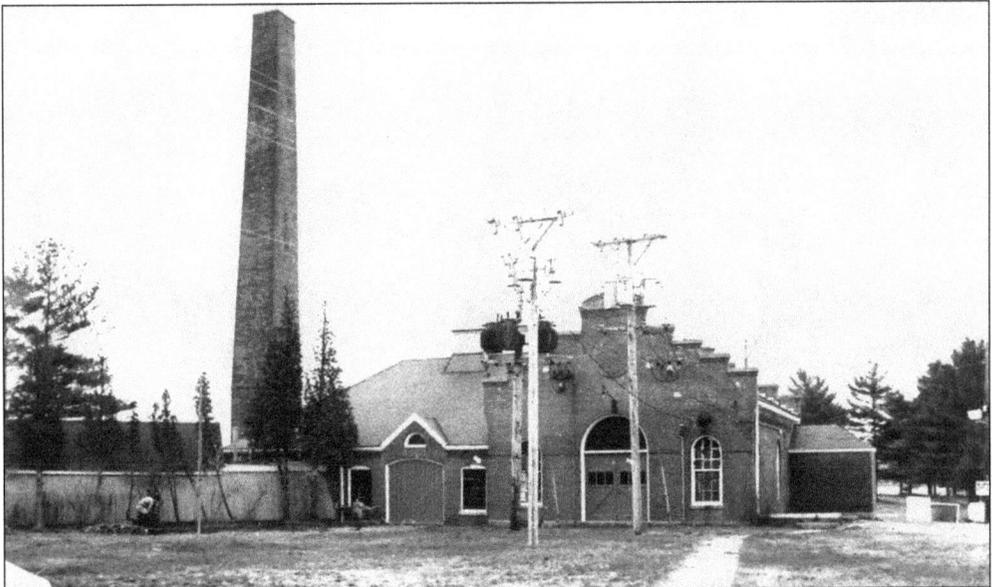

This is the Silver Lake Pumping Station, which was erected in 1899. It was built to serve the city of Brockton with clean, fresh drinking water. It began pumping water to Brockton in 1901. The original building is still standing.

Located on School Street in Crookertown, the house with the nickname "Old Ironsides" was built in 1765. It is a two-story, center chimney home built with wide floorboards and gunstock corner posts. It originally had strap door hinges and a closet in the front hall built in the chimney, for drying herbs. The facts relating to the origin of the nickname may be lost to history.

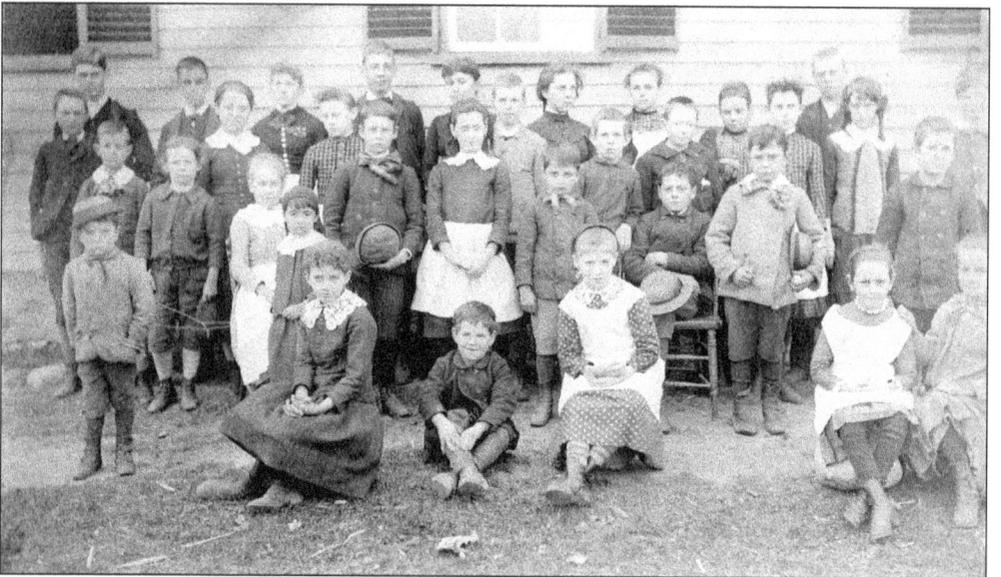

Typical of the schoolchildren of Pembroke in the 1880s, this picture shows the attendees of one of the town's one-room schools (possibly Crookertown district school No. 2). Each one-room schoolhouse (and there were eight district schools) housed grades one through eight. This picture shows the wide variety in the ages of the children.

An 1834 census of scholars for the Crookertown district school No. 2 was taken by Alden Wetherell. He lists himself as "agen of district No. 2." It does not seem that he is the teacher, as he lists himself in the 1850 census as an anchor smith. He may have been the local school board member. It is interesting that William A. Crooker is the only one of that name in the Crookertown school. The Fords clearly outnumber the rest of the families. The ages of the children range from 3 to 15. It is not hard to imagine that with 53 students, the older students probably frequently taught the younger ones. Even so, the teacher clearly had his or her hands full.

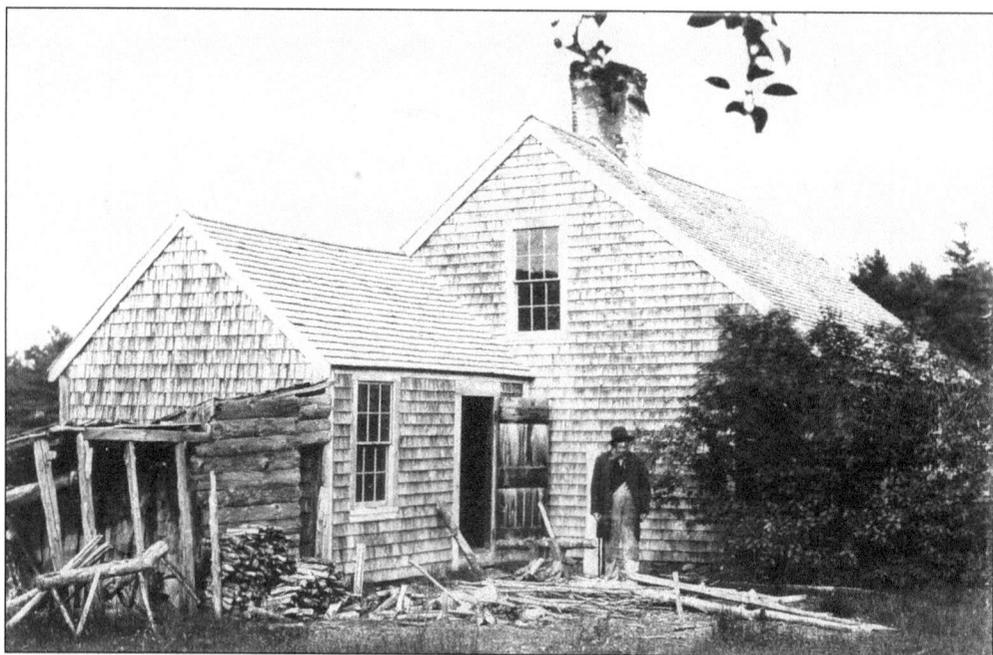

The home of Thomas Jefferson Turner was located on School Street between Tubbs Meadow Brook and Monroe Street and was built prior to 1831. Thomas was born in 1805, the son of Joshua and Hannah Turner. He was married to Mary Bearse of Scituate. Thomas worked as a tack maker until about the age of 75, when he turned to farming. He died in Pembroke in 1894.

Elisha Waterman Tillson was born in Hartford, Maine, in 1804. He married Almira Keith Turner of Pembroke. The couple had nine children. He was a blacksmith. Elisha died in Pembroke in 1888, and his wife died a year later. His son Mercer is credited with making detailed survey maps of the original land grants that became the town of Pembroke.

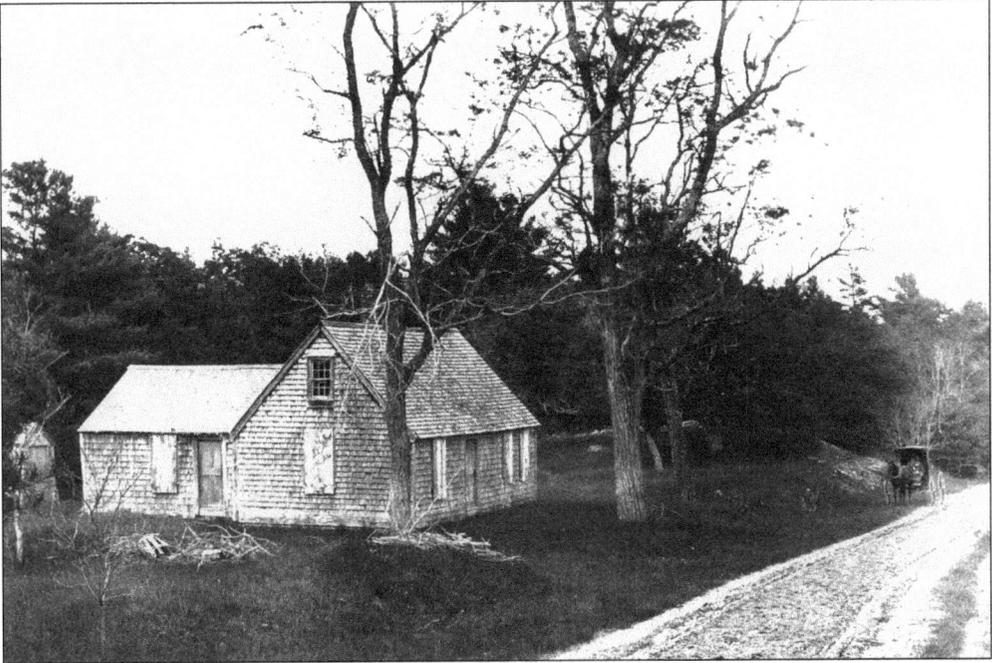

Known locally as the Widow Leavitt Place, this was the home of Laban and Celia Winslow Turner Leavitt on Plain Street. Both were born in Pembroke in the early 1780s. They married in Pembroke in 1806. Laban died in 1819, leaving his widow (hence the name Widow Leavitt Place) with six children all under the age of 14. Celia died in 1856. The house was destroyed by fire sometime after 1893, when this picture was taken.

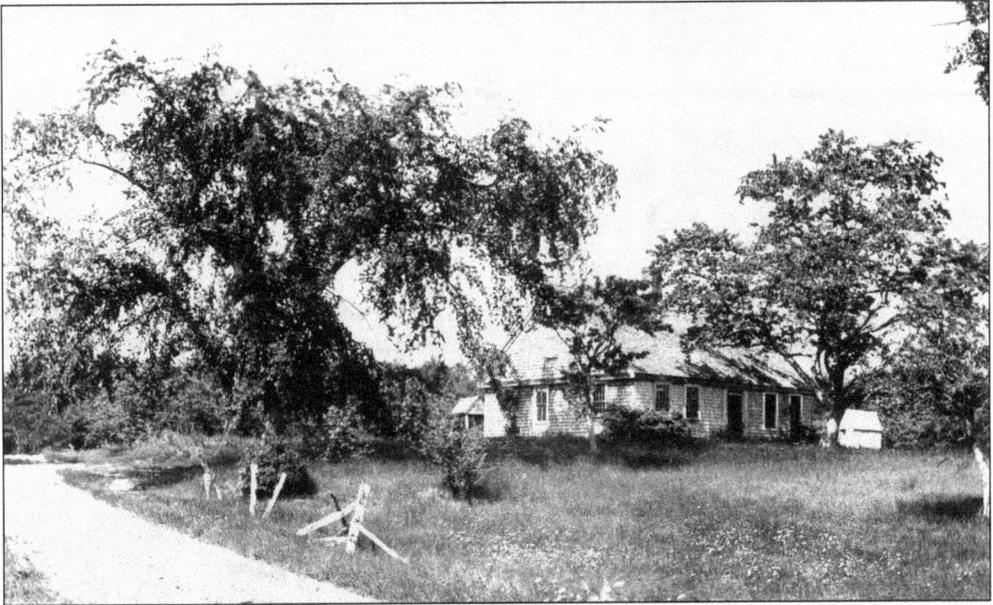

This house, located on School Street, was known historically as the Caleb Lapham House. The Laphams in Pembroke were farmers and iron founders. Pembroke had an iron furnace as early as 1692 on Furnace Pond. The ore that was used came from the local bogs, and the resulting product was known as "bog iron."

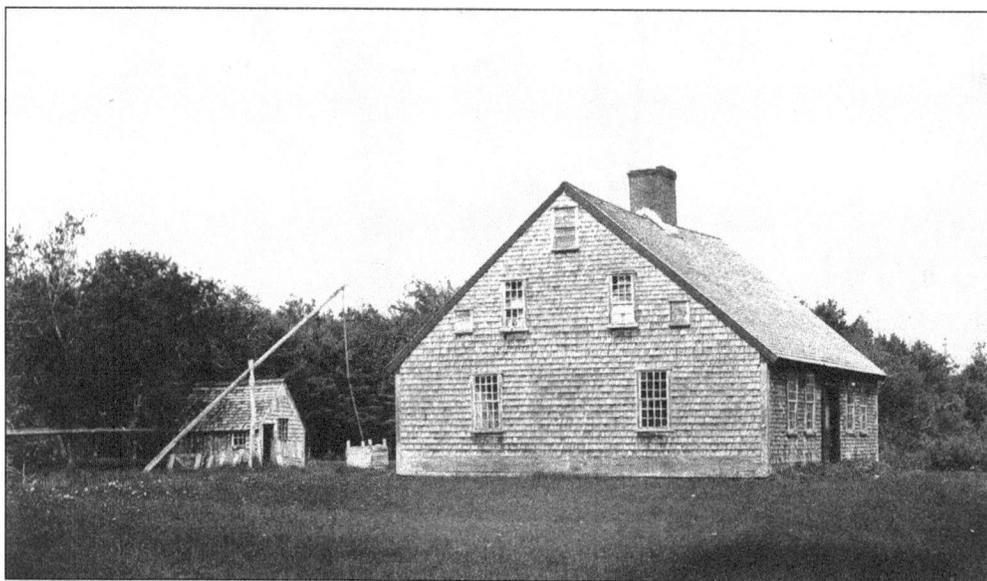

This home, in Crookertown, is historically known as the Charles Stetson House. Charles Stetson was born about 1804, one of 10 children born to Abner Stetson, a lifelong resident of Pembroke, and his wife Polly (McLaughlin) Stetson. The 1850 federal census shows that Charles called himself a furnaceman. Later censuses show that he turned to farming. He died in Pembroke in 1894, unmarried.

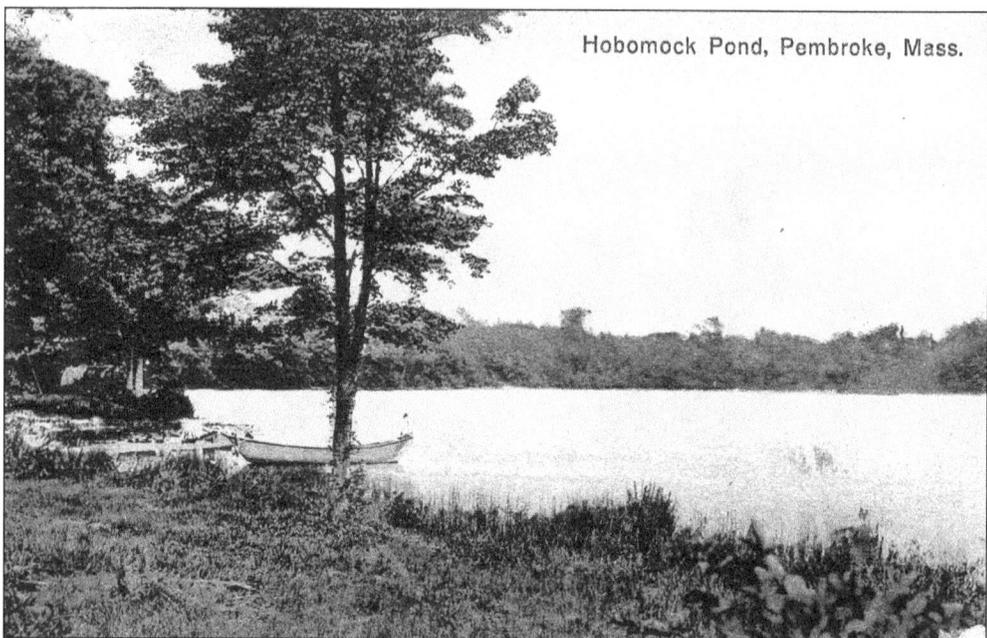

Hobomock Pond, Pembroke, Mass.

Hobomock Pond was named by the Native Americans of the area for the evil spirit who they believed dwelt within its depths. The depth of the spring-fed pond changes considerably with the summer heat or rain. The Native Americans were acute observers of nature and believed the attributes of the pond were caused by their evil spirit Hobomock.

Abigail Chummucks was a Mashpee Indian born between 1809 and 1815. In 1840, she married Joseph Hyatt, a direct descendant of Queen Patience (for whom Queensbrook was named). The couple built a cabin near Hobomock Pond and raised five children. Joseph died in Pembroke in 1884, and Abigail died 10 years later.

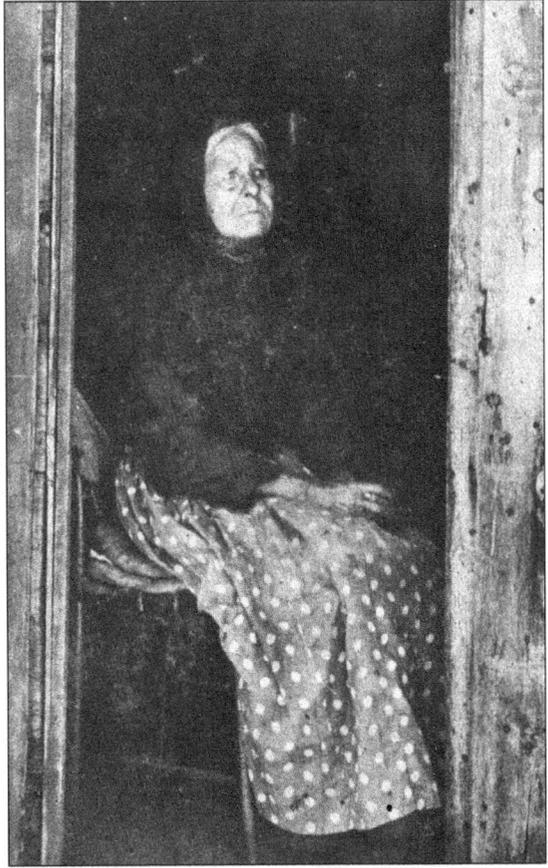

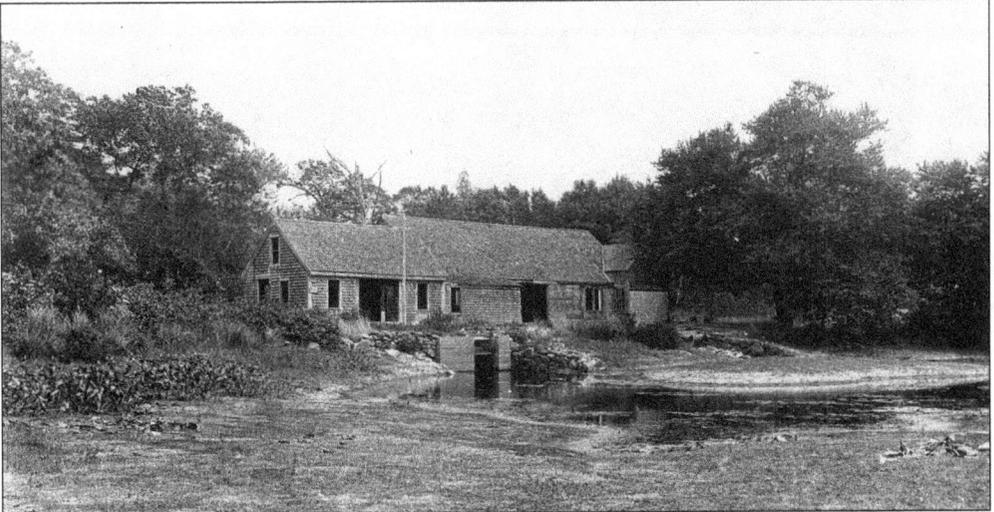

John Foster's upper mill was located off Hobomock Street. It was a lumber mill and a shingle factory. The Herring Brook that runs between Furnace Pond and the North River, Pudding Brook, and other Pembroke streams, made possible a number of local mills. A growing population and burgeoning shipbuilding industry on the North River were eager customers for the goods local mills produced.

The Tubbs Meadow Brook flows into the north end of Silver Lake. It begins near Standish Street, flows toward Monroe Street where it splits, and then the main branch heads off toward Silver Lake. On the way it served a number of cranberry bogs, providing the large amounts of water necessary for cranberry cultivation. Legend says that the Tubbs family ran a mill on the brook that bears their name. There is mention of the Tubbs Meadow Brook in records dating back as early as 1698 according to historic surveyor Mercer Tillson. William and Joseph Tubbs were signers of a petition important in the incorporation of the new town of Pembroke in 1712. It is probable that the stream and meadow were named for one or both of these men and their families. (Courtesy of John Proctor.)

Four

EAST PEMBROKE

On the easternmost edge of Pembroke sits a small group of antique homes interspersed with a few more modern dwellings historically referred to as the village of East Pembroke or the East Neighborhood. It centers around the area of Elm and Taylor Streets. Records do not indicate exactly when East Pembroke was settled, but local historians believe that Josiah Keen was the pioneer settler of this area. Keen received a grant of land from the town of Duxbury and later purchased adjoining land around the Pudding Brook. It seems fairly certain that he was at East Pembroke by 1698. He eventually gave to his three sons, Matthew, Josiah Jr., and Benjamin, tracts of land and any buildings thereon. By 1706, the three brothers owned about 150 acres of land on both sides of the brook, encompassing most of the land on which the village developed.

In time, the families of Howland, Ford, Taylor, Chandler, Pierce, Magoun, Sole, Macfarland, and others settled in East Pembroke.

Isaac Hatch came to East Pembroke and built a mill on the Pudding Brook. The mill was a two-story structure used for making satinet, a kind of cloth made from cotton and wool. He also owned a sawmill.

By 1835, Hatch had closed the satinet mill to concentrate on making shoe and other types of wooden packing boxes. It is said that this was the first factory for making wooden boxes in this part of the country. Business began to decline in the village after 1868, with the completion of the Hanover Branch Railroad. It had been hoped that the railroad would pass through East Pembroke, but this was not to be.

Besides the cluster of homes, the neighborhood had its own district school No. 7 and a store, which for many years supplied the neighborhood with general merchandise.

The section of town known as East Pembroke encompassed the area around Pleasant Street, Taylor Street, West Elm Street, Spring Street, and Congress Street. Taylor Street was referred to in 1767 as "the cartway that goeth from the Country Road to the house of Samuel Taylor." It was also known as "Goose Lane" because of "the large and numerous flocks of geese kept by those who dwelt along its way." (Courtesy of John Proctor.)

This is a picture of Pleasant Street looking south taken around 1900. The photographer was standing near the intersection of Pleasant Street and Spring Street. The Hatch farm is on the left. In the background, on the right, is the Hatch Mill.

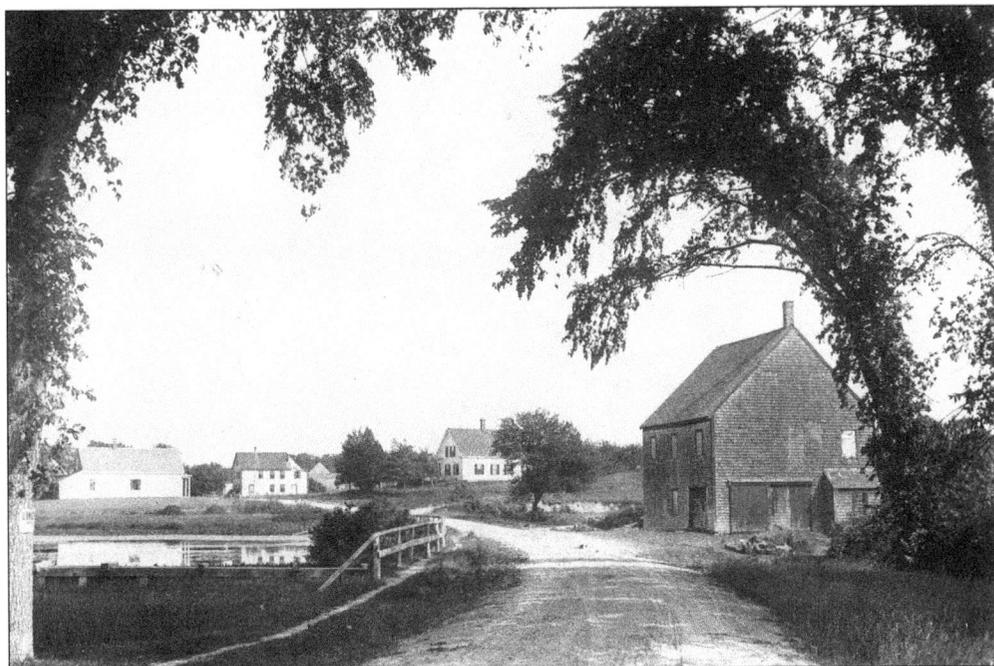

This is the village of East Pembroke, showing the Hatch Mill on the right. About 1813, Isaac Hatch came here and built the mill on Pudding Brook. It made satinet cloth, which was woven from cotton and wool. He employed a number of girls, paying them 50¢ per week plus board. By 1835, he had closed the satinet mill to become one of the first mills in this area to make wooden packing boxes.

This home, owned by George and Maria Hatch, is known as the George Francis Hatch Farm. George was the son of successful mill owner Isaac. He took over the running of the mill after the death of his father. He was an excellent businessman and public-minded citizen who took special interest in Pembroke's schools. In his will, he left money for the establishment of Pembroke's first high school.

Located on Elm Street, this home was probably built by Isaac Randall around the time of his marriage to Joanna Keen in 1812. Isaac was born in Pembroke in 1783. They raised four children in the home. Isaac listed himself as a shoemaker and a cordwainer (someone who makes shoes and other articles out of soft leather).

This house was probably built by Recompense Magoun around 1739. It is located on Elm Street. Magoun was born in 1716 in Pembroke. He married Ruth Crooker in 1742. He died in 1802, and his wife died in 1803. Like so many other ancient houses, this home passed through many generations of the family, from father to son and father to daughter.

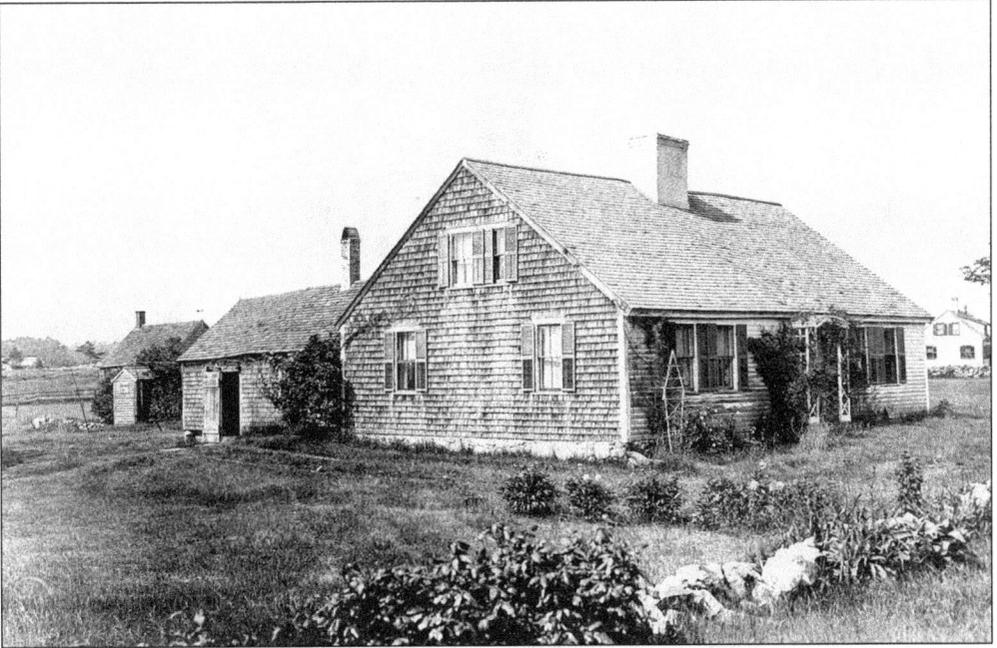

At the foot of the hill on Taylor Street is this home built by James and Lydia (Bradford) Ford. True to custom, it is believed that it was built around the time of their marriage in 1782. It began as a typical half house, with two windows and a door, but was enlarged to a full cape. Four generations of the Ford family, all carpenters, lived in the home.

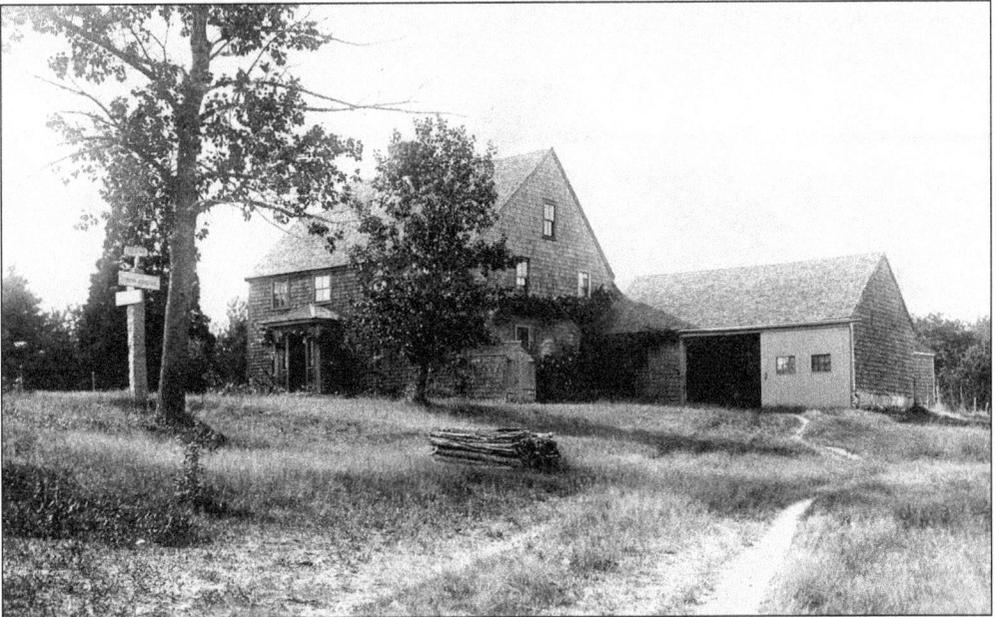

The oldest standing house in East Pembroke is thought to be the Benjamin Keen House on Elm Street. Benjamin married Deborah Howland between 1719 and 1729, and it is believed that the house was built by him around that date. The home is a two-story, solidly built home with a heavy oak frame, well-suited to withstand the ravages of time and the footsteps of almost 300 years worth of occupants.

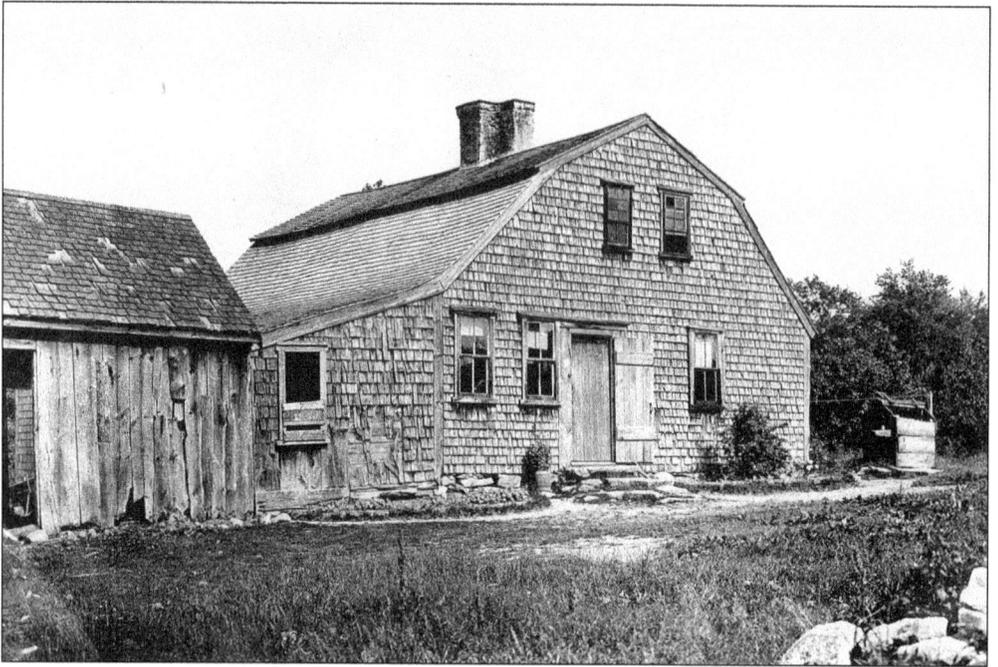

Records are murky, but this home at the corner of Taylor and Elm Streets was probably either built by William Ford in the mid- to late 1600s or Barnabas Ford around 1710. About 1797, Elcy Okeman operated a store here selling molasses and snuff. With failing health, Okeman was cared for by Olive Churchill, who in 1823 received the home as payment for her services. It was known locally as the "Old Churchill Place."

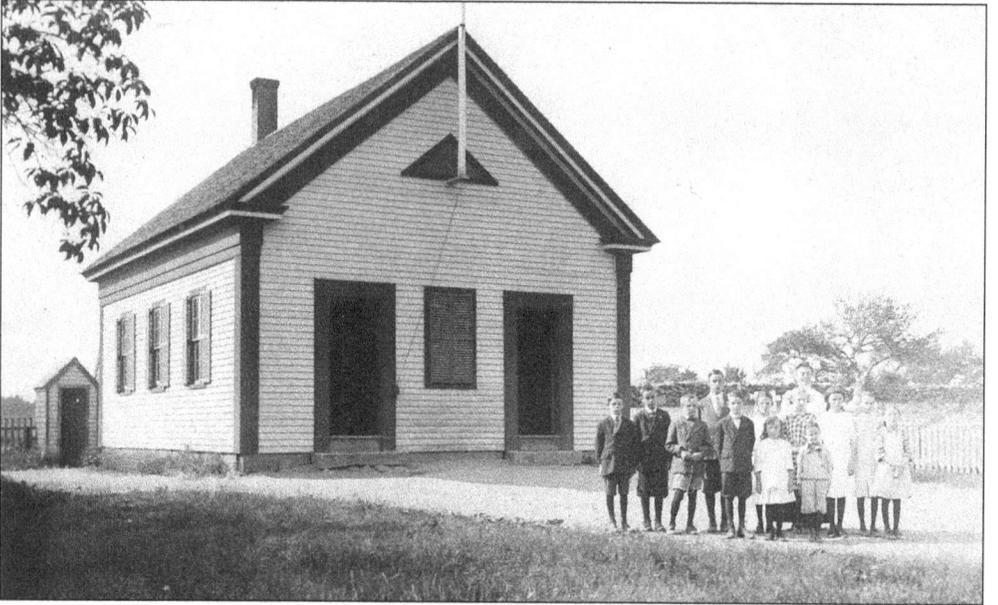

Built in 1853 for an appropriation of $650, the district school No. 7 was located on Taylor Street near Elm Street in East Pembroke. An 1880 census of scholars lists such familiar Pembroke names as Taylor, Ford, Simmons, Church, Barrows, Sherman, and Baker, among others. The building is still used today as the East Pembroke Community Club.

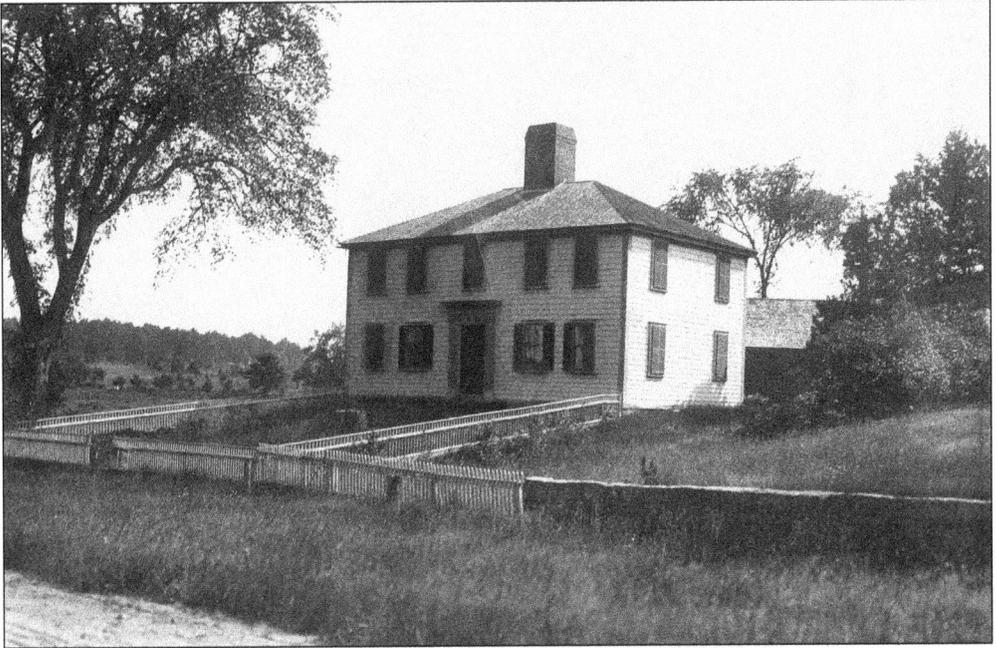

This home on Elm Street was built in 1719 by Isaac Hatch, shortly after his marriage to Lavina Allen. Both were born in Pembroke in 1796. They raised five children in the home. One of their children, George Francis Hatch, was the benefactor of Pembroke's first high school, the George Francis Hatch School in Pembroke Center.

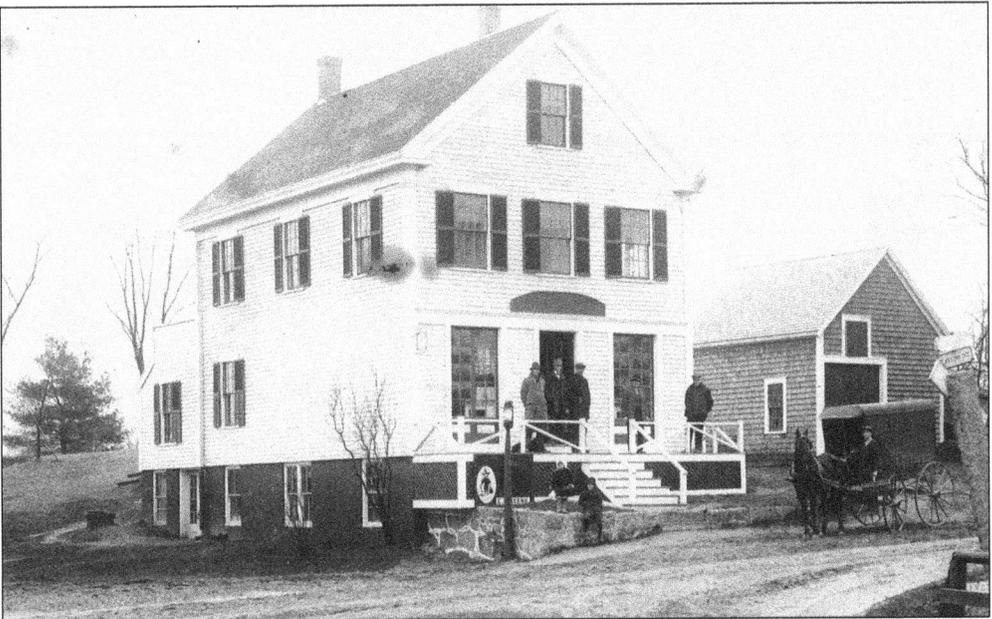

This building was most likely built by Andrew Poole around 1860. Poole was a shoemaker in the 1850s, but by 1860, he called himself a "trader," and by 1870, he was a "country merchandiser." It had living quarters in the basement and a dance hall on the upper floor. In 1900, Poole's wife Sarah was postmistress. Chester Keene purchased the place in 1915, and it became known as Keene's Store.

The Pine Grove Cemetery is located on a quiet knoll off Elm Street and Spring Street in East Pembroke. The cemetery was incorporated in 1857. One of the earliest interments is that of Nathaniel Keen, who died in 1813 at the age of four. (Courtesy of John Proctor.)

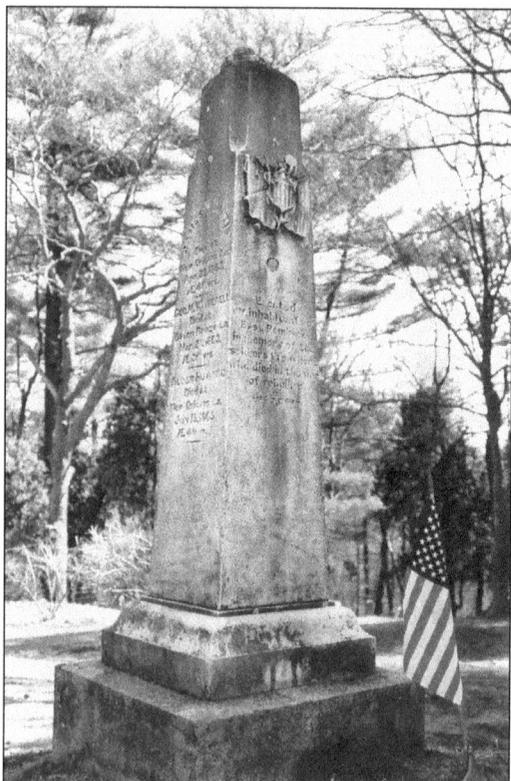

One of the earliest Civil War monuments in Massachusetts was erected in Pine Grove Cemetery in 1867. Honored are James Curtis, John Jones, Alden Howard, Edwin Taylor, George Whiting, Philip Chandler, Lucius Chandler, Martin Witherell, Josiah Bourne, Theodore Rost, Thomas Ingalls, William Nash, Eugene Paine, William Gaskins, and Abraham Gast. (Courtesy of John Proctor.)

Five

FOSTERVILLE

The Fosterville neighborhood is the only Pembroke neighborhood that did not have its own one-room schoolhouse. Children from the area generally attended the Bryantville School. Fosterville is believed to have received its name from the family of David H. Foster and his wife Deborah (Howland) Foster. David was born in Pembroke in 1799 and was a shipwright and a farmer. He lived on Mattakeesett Street near Bryantville before building and moving to his farm at the intersection of Mattakeesett Street and Phillips Road, near Maquan Street. This is the area that became known as Fosterville.

David and Deborah had seven sons who attended the district school in Bryantville. The youngest son, John, took care of his parents' farm, as David was busy with ship carpentry and Deborah was in poor health. Of the seven sons, it was John who eventually took over the family farm. He began purchasing tracts of timbered land and harvesting them. In 1874, he bought a sawmill to which he added a gristmill and box factory. He also owned a cooperage shop for making cranberry barrels. He owned several local cranberry bogs. His obituary stated that he donated a drinking fountain in Fosterville, but it is unclear as to its whereabouts.

The Fosterville neighborhood has always been rural. The only enduring commercial structure was the Abington-Rockland pumping station built in 1886 on Great Sandy Bottom Pond. The location of the neighborhood, at the confluence of Oldam Pond, Furnace Pond, and Great Sandy Bottom Pond, made it conducive for growing cranberries, which need large amounts of water to thrive. The important use of the land for agriculture did not allow for the kind of residential development found in other neighborhoods in Pembroke, which is probably the reason why it never had its own schoolhouse.

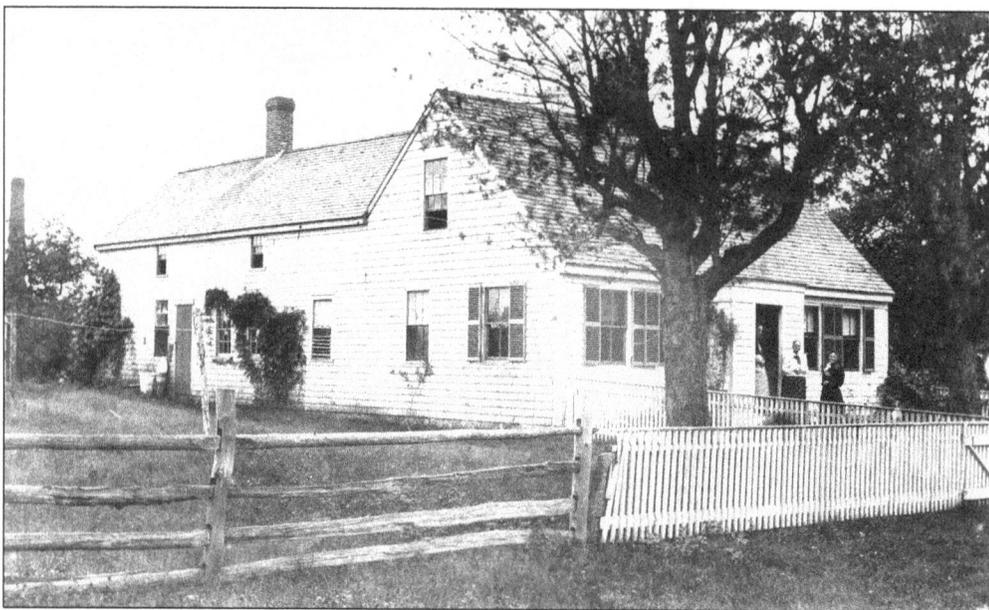

This home is known as the David Foster Place and is located at the intersection of Mattakeesett Street and Phillips Road, near Maquan Street. It was built sometime between about 1830 and 1840. David H. Foster was a shipwright and farmer. He was born in 1799 and died in Pembroke in 1880. The Fosterville neighborhood takes its name from the family.

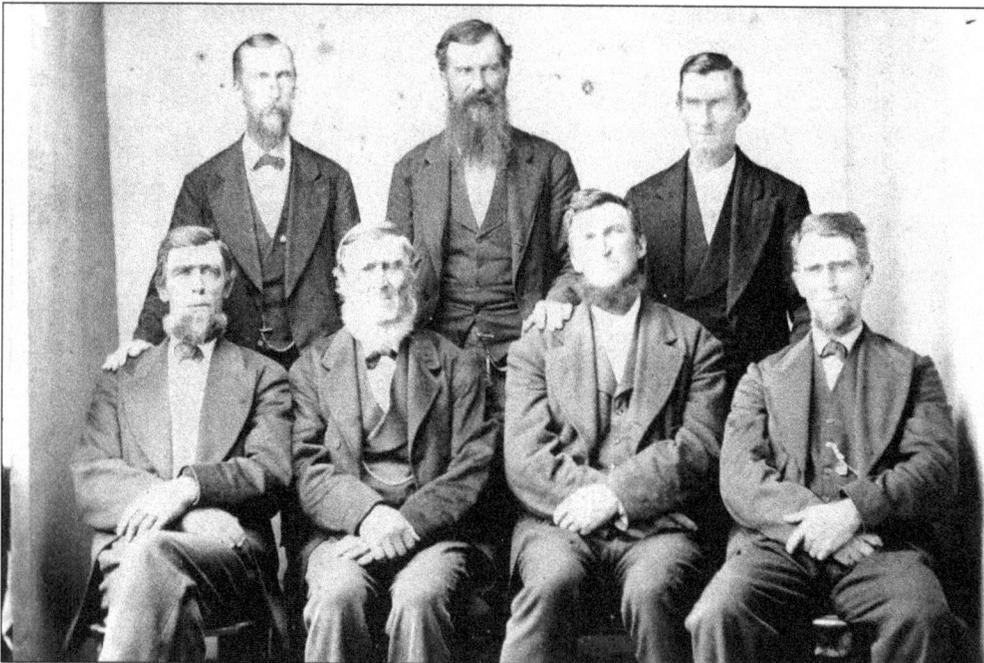

David H. and Deborah (Howland) Foster had seven sons. This picture, in no special order, shows, Horace James Foster, Otis Foster, Hiram Foster, John Foster, Jarius Howland Foster, Jared Perkins Foster, and Charles Foster The neighborhood of Fosterville probably took its name from this large family. A great-great-granddaughter of David H. and Deborah stated that John Foster invented cranberry juice and sold it in two local drugstores.

70

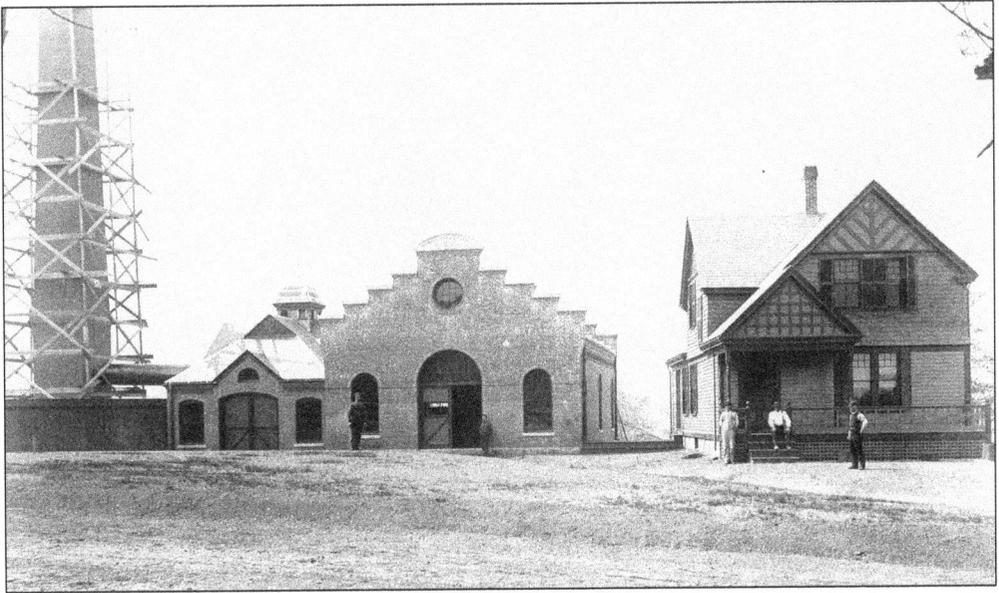

For over 100 years, Big Sandy Pond (also known as the Great Sandy Bottom Pond) has provided the towns of Abington and Rockland with a clean freshwater supply. The picture above shows the construction of the smokestack at the Abington-Rockland pumping station on Big Sandy Pond in the year 1886. This smokestack is visible in most of the scenes of Fosterville. The picture below shows Big Sandy Pond in the foreground and was taken from a spot on the Fosterville section of Mattakeesett Street. While this old building is no longer used, it is still standing next to the modern pumping station. The house, however, is gone.

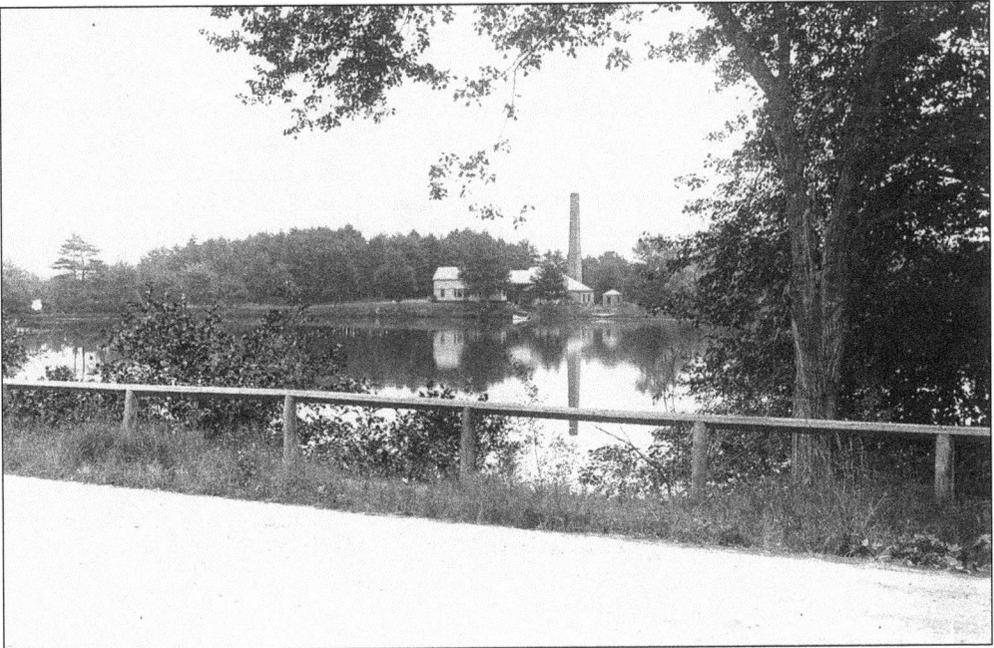

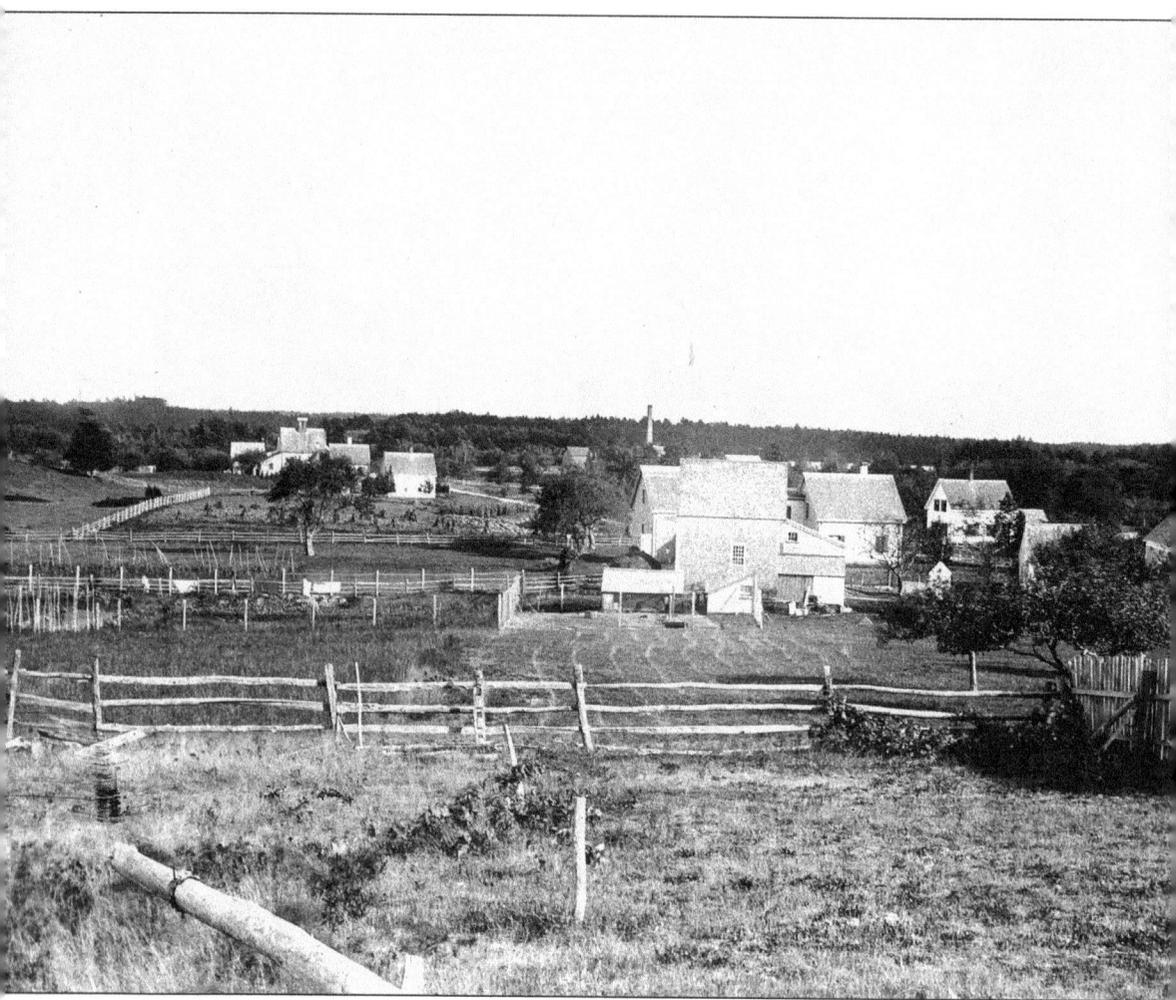

This view of the Fosterville neighborhood was taken from a high ridge off Mattakeesett Street, near Fair View Road. It shows the truly rural character of Pembroke prior to 1900. The smokestack at the Abington-Rockland pumping station is the identifiable feature near the center of the picture. The homes seem to be all of a similar style, which may indicate that they were all built around the same time period, probably after 1831. Prior to that time, the only homes in the Fosterville area were those of Luther Howland, Asa Taylor, John Fish, and, farther down the road, Thomas Drake.

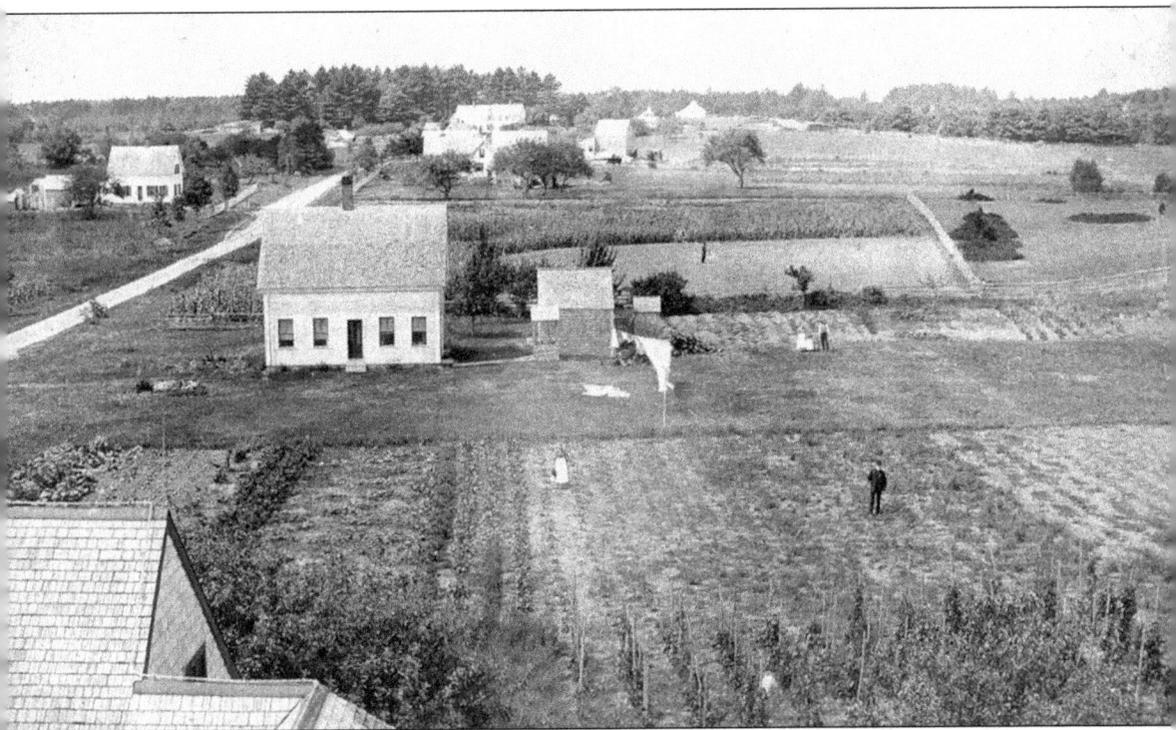

This is another view of Fosterville, looking down Maquan Street toward Hanson. It was taken in 1887 from the cupola of the barn owned by George B. Lewis and his wife, Helen, probably by their son George Edward Lewis. In later years, George Edward Lewis became a local photographer of some note and the publisher of the *Bryantville News*. It is interesting to note the wonderful gardens and farmland where trees now stand. It appears that the people standing on the ground are either posing for the picture or at least curious as to why anyone would be on the cupola.

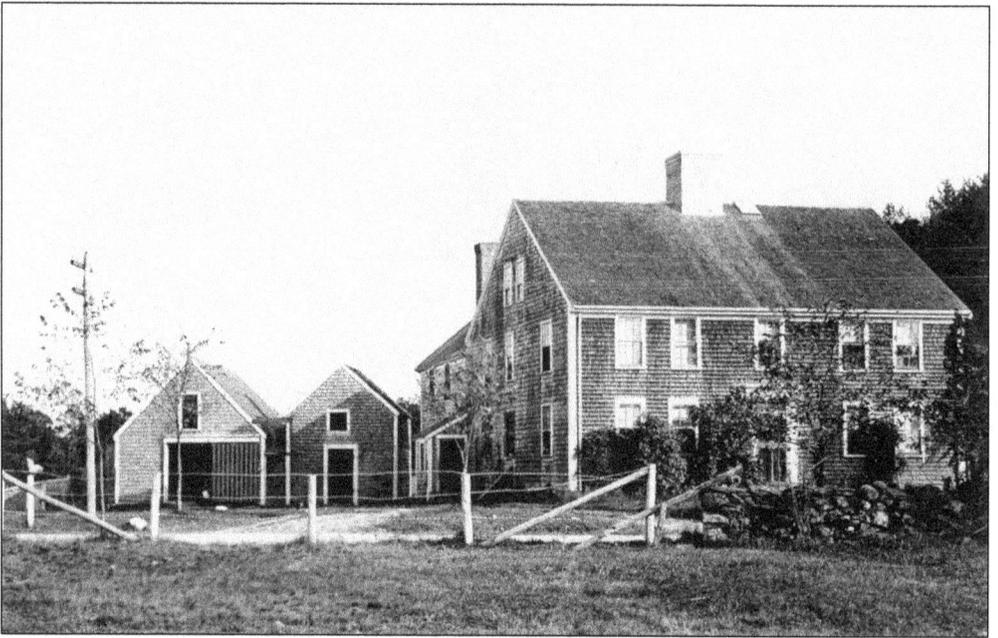

Pembroke's almshouse, or poor farm (above), was located on Mattakeesett Street between Fosterville and Bryantville. Originally the Parris farm, it was purchased in 1823 for less than $3,500 including stock, utensils, and so on. Isaac Stetson and his wife were chosen as overseers of the poorhouse for a fee of $200 per year and were expected to keep the costs of running the establishment to a minimum. Working the surrounding land and fields (below) helped to defray the costs and make the poorhouse as self-sustaining as possible. The residents of the poorhouse were not allowed to leave the premises without the permission of the overseer, and the highly specific rules were strictly enforced.

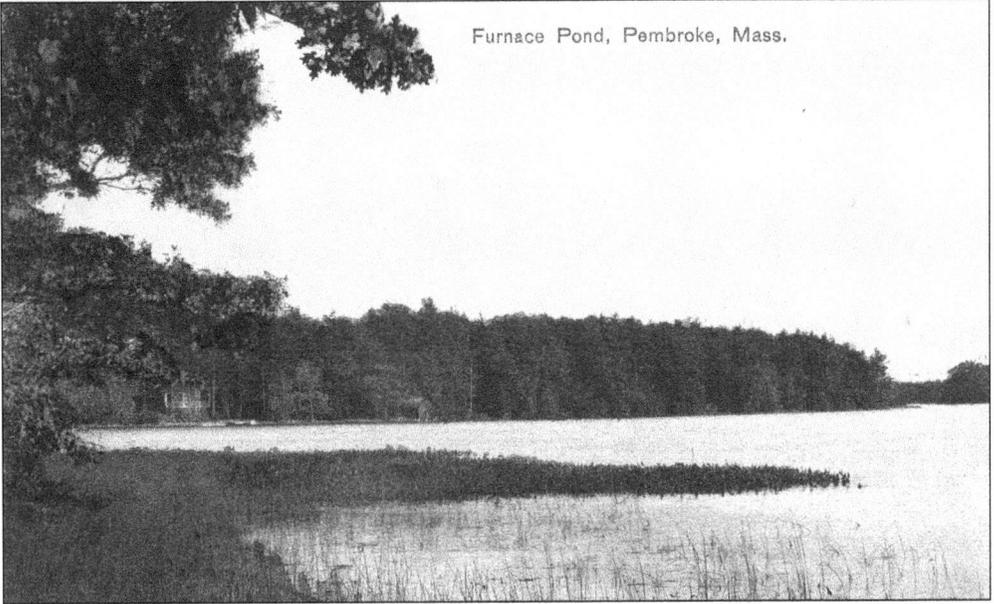

Furnace Pond, Pembroke, Mass.

Furnace Pond was known to the Native Americans as Herring Pond. Locations with names like Sachem's Point and Grave of the Kings speak to the importance of the place. Queen Patience, or Sunny Eye as she was also known, lived on land that projected into the pond. Presumably the name was changed sometime after 1702, when the Barker family established an iron furnace near the outlet of the Herring Brook.

This scene shows Big Sandy Pond, or Great Sandy Bottom Pond, with Furnace Pond in the distance. The picture was probably taken from the Fosterville side. Although still almost as rural an area as it was when this shot was taken, it is unlikely that this picture showing both ponds could be taken today.

This is the site of the Gorham Mill. It was situated on Gorham Mill Pond, near the outlet of Furnace Pond. Today it would be found between Cranberry Road and Mill Pond Road. While the records are unclear, it was most likely a sawmill. The Gorham Mill Pond today is mainly a swamp.

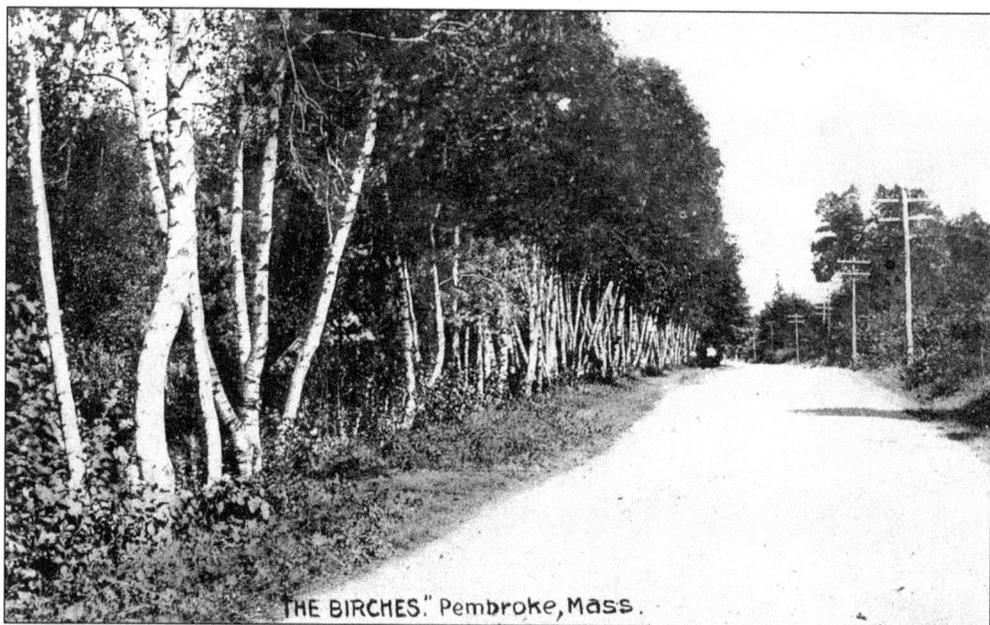

"THE BIRCHES." Pembroke, Mass.

On a stretch of what is known today as Mattakeesett Street, between Furnace Pond and Oldham (also known as Monument) Pond, stood a large stand of birches. This area was known historically as Indian Bridge. It was also called Indian Fields, because of the planting of these lands by the Massachusetts Native Americans from a very early time.

Six

HIGH STREET

One of the main roads from Plymouth to Boston used during the Colonial period and known as the Bay Path had its beginnings as the Massachusetts Path. It was the main trail used by the Massachusetts Native Americans, who controlled this area prior to European settlement. The path ran between Neponset and Mattakeesett (the Native American name for the Pembroke area meaning "place of much fish"). The Pembroke section of this thoroughfare began at the Duxbury line on High Street and continued down High Street to the Herring Run. Here it turned up Center Street to Oldham Street, down Oldham Street to West Elm Street, and on to the Hanover line and beyond.

Because of the significant travel along this early thoroughfare, it is not surprising that a settlement sprang up on High Street. Stagecoach travel was grueling, and passengers needed a place to stop, rest, and perhaps get food and drink. There needed to be places to change horses and fix broken coaches. These needs brought Brimstone Tavern and a blacksmith shop, and they brought the people to do the work. The residents needed a school to educate their children, so school district No. 4 was established, serving the High Street neighborhood. A general store provided provisions for the residents, and eventually a Mechanic's Hall was moved from Hanover and used first as an academy, and then as a wheelwright shop, a carriage shop, and a dance hall. Many of these operations occurred in close proximity to the Pembroke and Duxbury town line, so that residents from both Pembroke and West Duxbury could take full advantage of what was offered. The High Street Methodist Church, although located in Duxbury, served the spiritual needs of many from both towns.

With the growth in population and buildings, a fire station became a necessity. The Mechanic's Hall, by that time empty, became the High Street Fire Station.

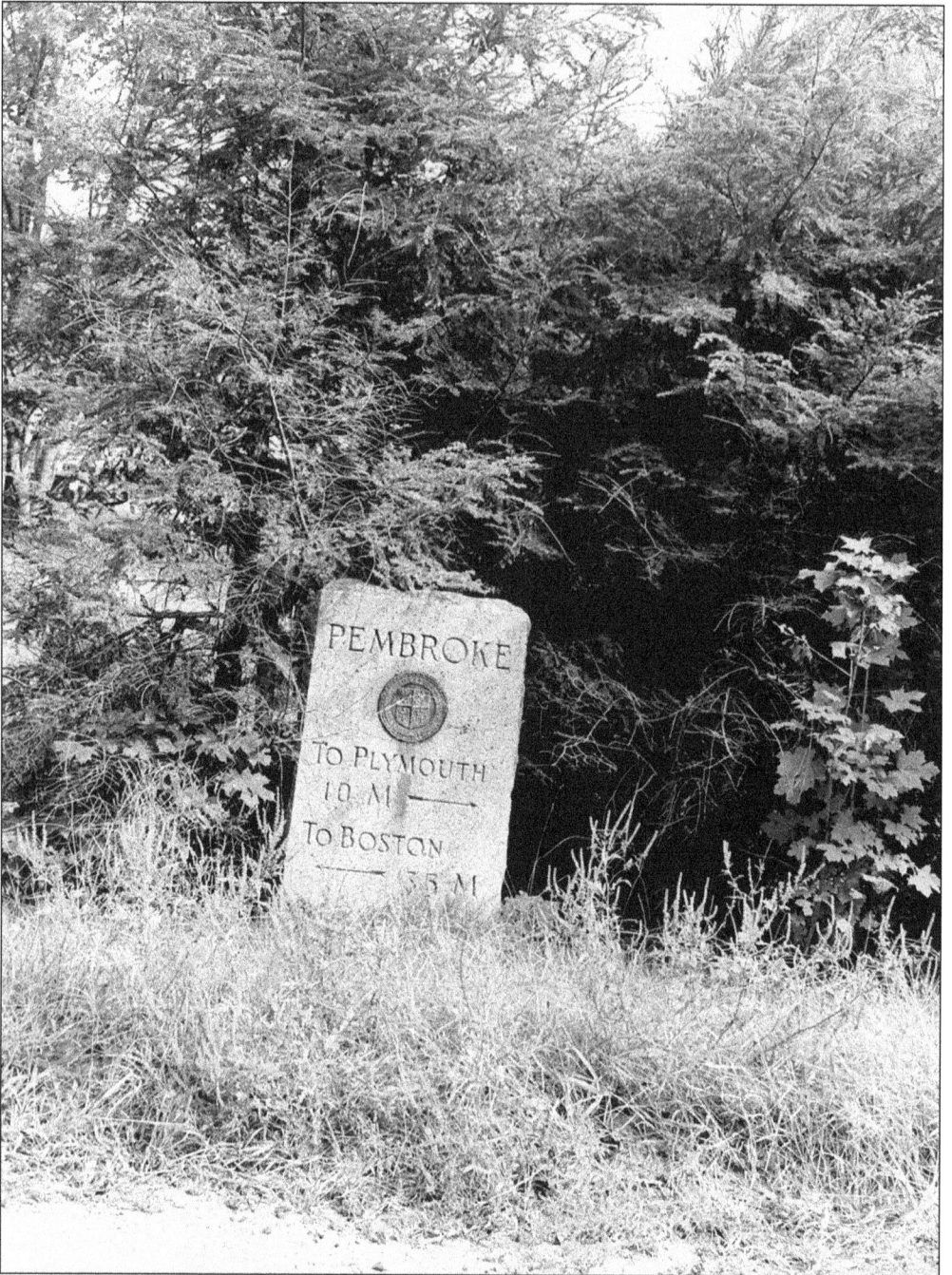

One of the main stagecoach routes from Plymouth to Boston, important especially during the Colonial period, was known as the Bay Path. The Pembroke section of this thoroughfare began at the Duxbury line on High Street and continued to the Herring Run, where it turned left up Center Street then turned right onto Oldham Street, down Oldham Street where it turned right onto West Elm Street, and on to the Hanover line at Luddam's Ford. This mile marker is located on High Street as it enters Pembroke. There is also a marker on the Duxbury side of the town line.

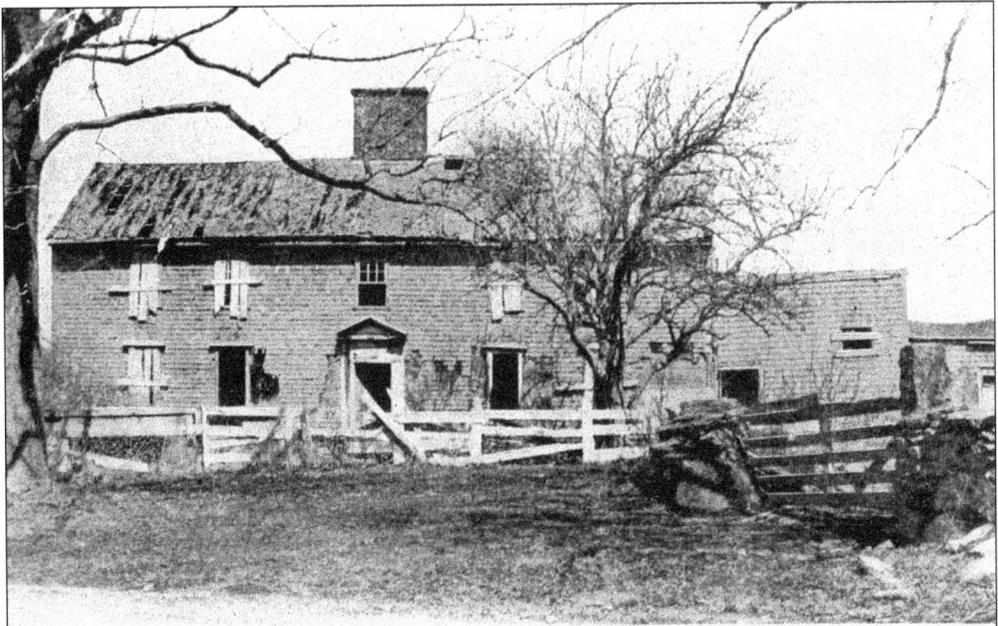

THE OLD BARKER PLACE, PEMBROKE, MASS. Copyrighted 1902, by Geo. E. Lewis, Bryantville, Mass.

The Barker Garrison, a homestead that was fortified for military use and protection purposes in case of Native American attack, was built prior to 1650 by Robert Barker Sr., considered the first settler in the Pembroke area. Located at the corner of Barker and High Streets, it remained in the Barker family until it eventually fell into disrepair and was torn down in 1894.

In 1912, a bicentennial celebration was held in Pembroke. Of course, part of the celebration included events relating to one of Pembroke's earliest families, the Barkers. An exhibition of artifacts from the old garrison house was prominently displayed, including portraits of the garrison's last Barker family owners, Peleg and Abigail (Loring) Barker.

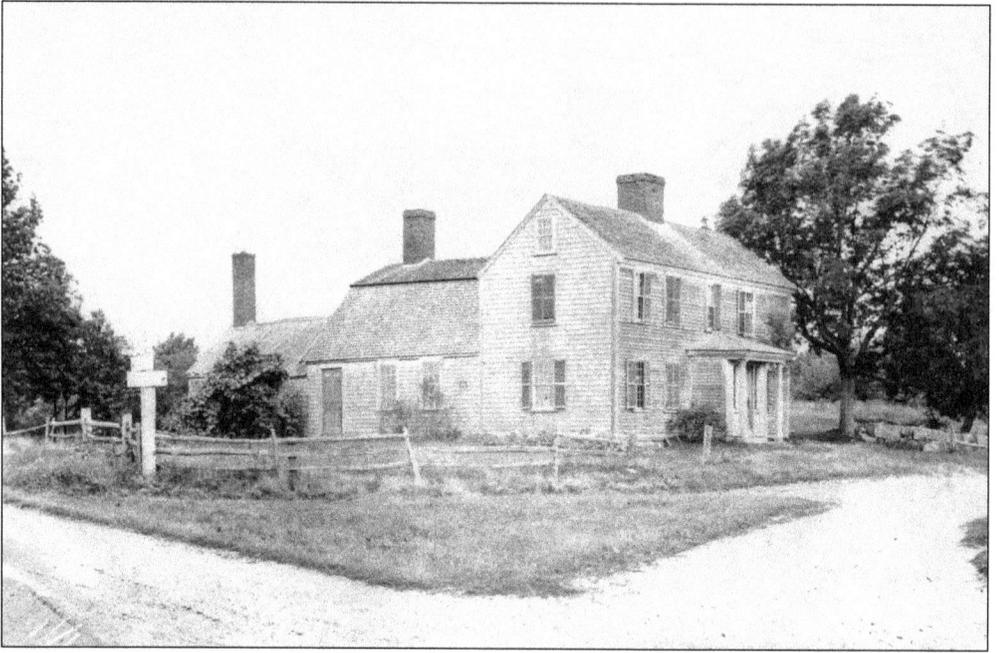

Brimstone Tavern was located at the corner of High and Old Washington Streets along the Bay Path, a main stagecoach route from Plymouth to Boston. Here horses were changed for fresh ones, and travelers could enjoy a drink or meal. It was a large two-and-one-half-story structure consisting of 10 or 11 rooms and was one of the oldest buildings on High Street, until it burned in 1937.

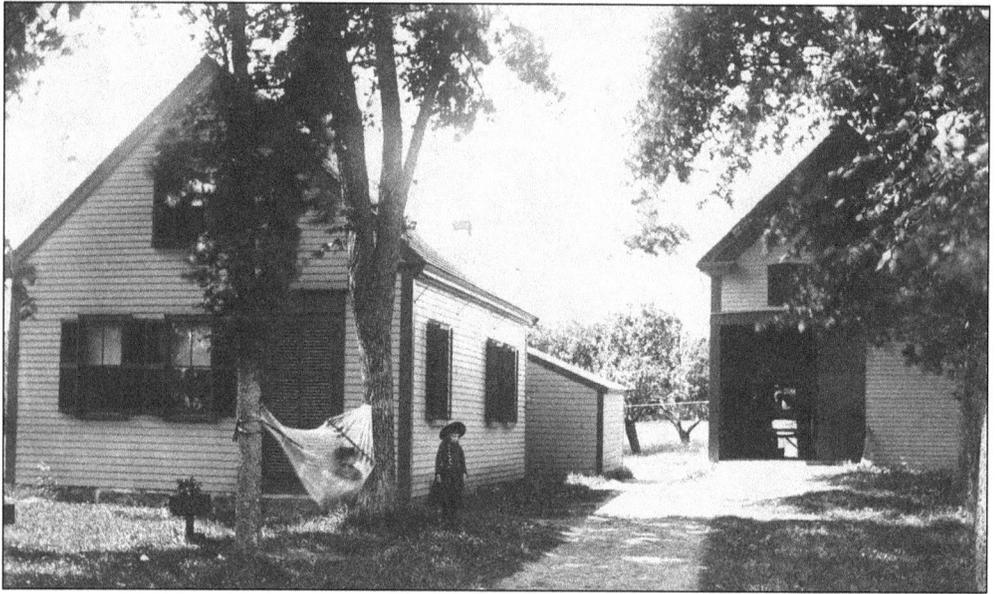

It is thought that this house was built in the 1840s either by Isaac Loring or Peleg Barker. The ell on the home was moved from West Duxbury and is significantly older than the house itself. The kitchen was built with gunstock posts and beams held together with large wooden pegs. The home was in Barker and Loring family hands until the 1930s.

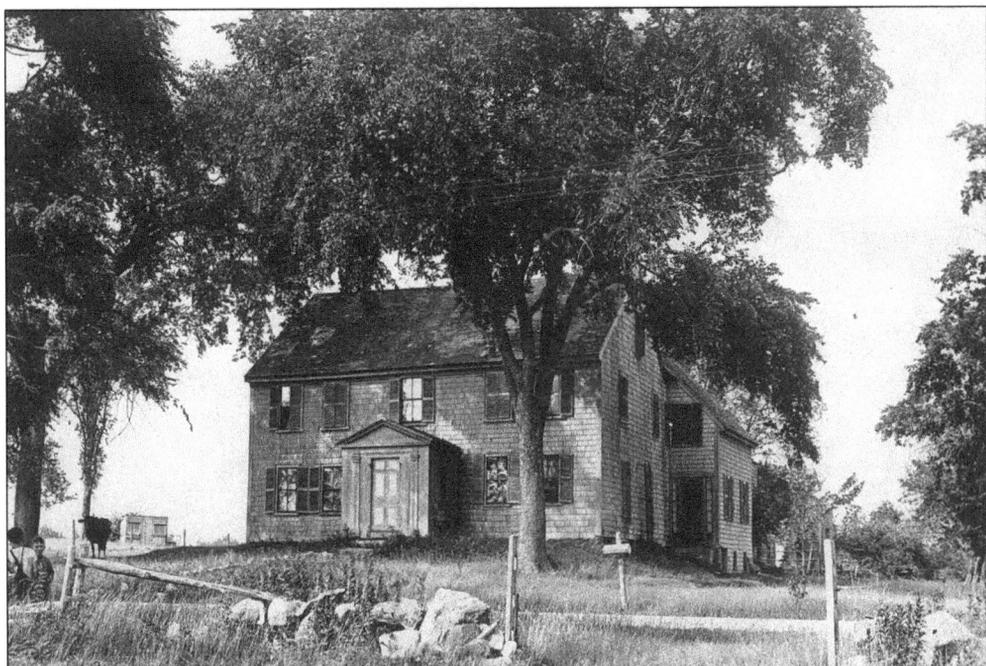

This home on High Street was owned by Samuel Brown and his wife, Maria. Samuel was the son of Smith and Lydia (Gould) Brown. The Browns were Quakers. The small family burial plot, not far from the home, contains the remains of Samuel and Maria and their children Lydia, Sarah, Elizabeth, and Moses.

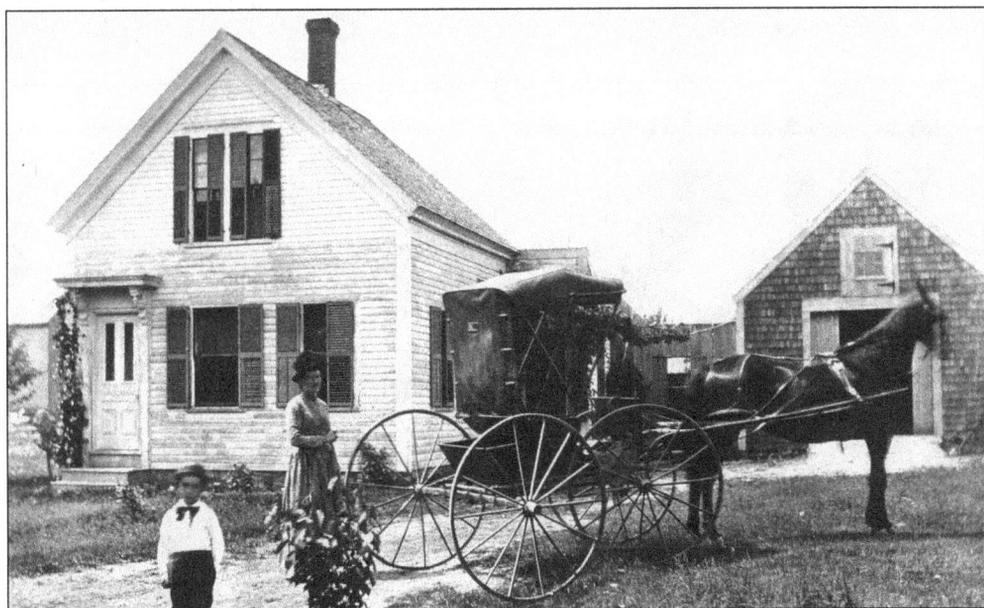

Briefly the Hammond family lived in this home on High Street. William and Effie Hammond were born in Paris, Maine. Their son Horatio was born in Pembroke in 1885. A daughter, born in Marshfield in 1890, died in Pembroke in 1891. The family moved back to Maine before 1900. William, listed as a farmer, may have been an itinerant farmer, which would explain his frequent moves.

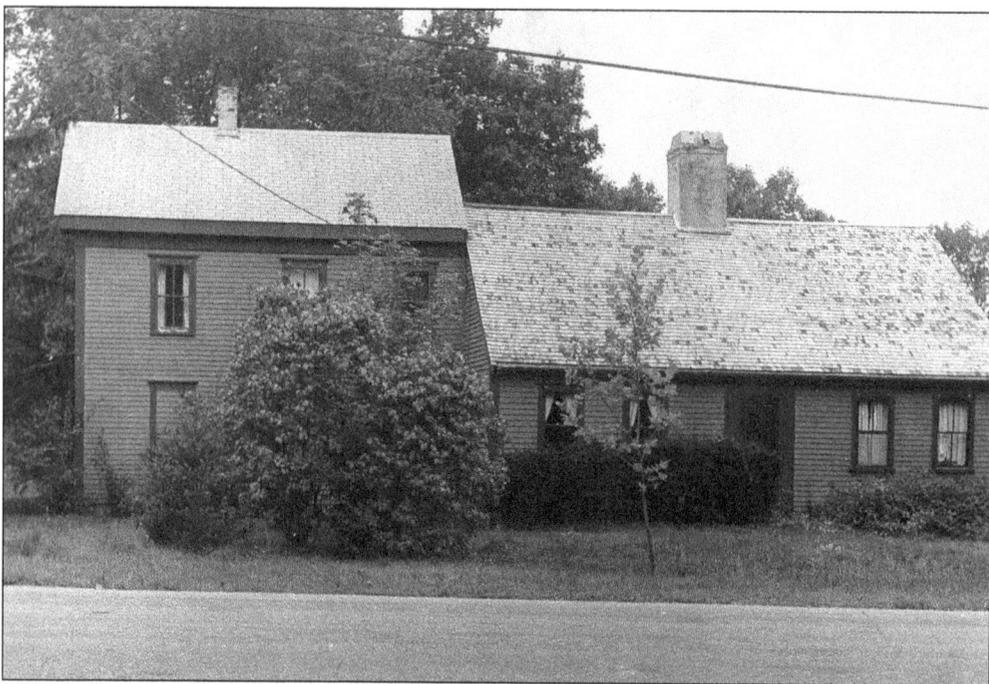

The Keen (also spelled Keene) Homestead was built around 1750, based on construction practices of the period, by Asa Keen. Asa married Zilpha Hatch in 1762, so it could have been built then. Their son Asa married Abigail Barstow in 1791, making it probable that the first Asa built the home. Asa and Abigail passed the home to son Abel, who passed it to his son Francis. It left the Keen family about 1916.

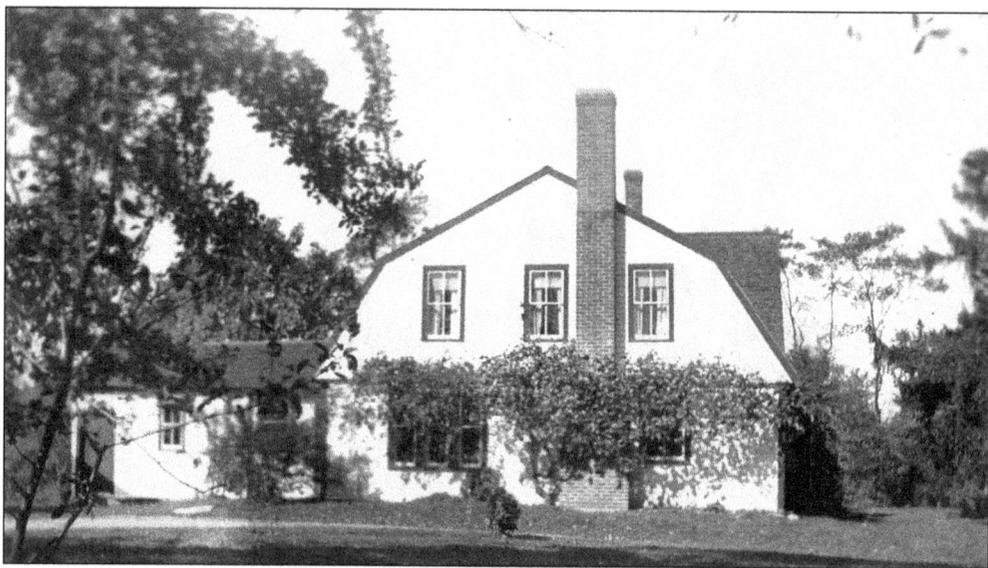

The list of owners of this property reads like a who's who of Pembroke. Families with names like Howland, Bates, and Stetson, among others, are found on its deeds. It is thought that the house on the site today is not the original, but that the first house burned and was replaced sometime near the beginning of the 19th century. It was known as "the brick house on High Street."

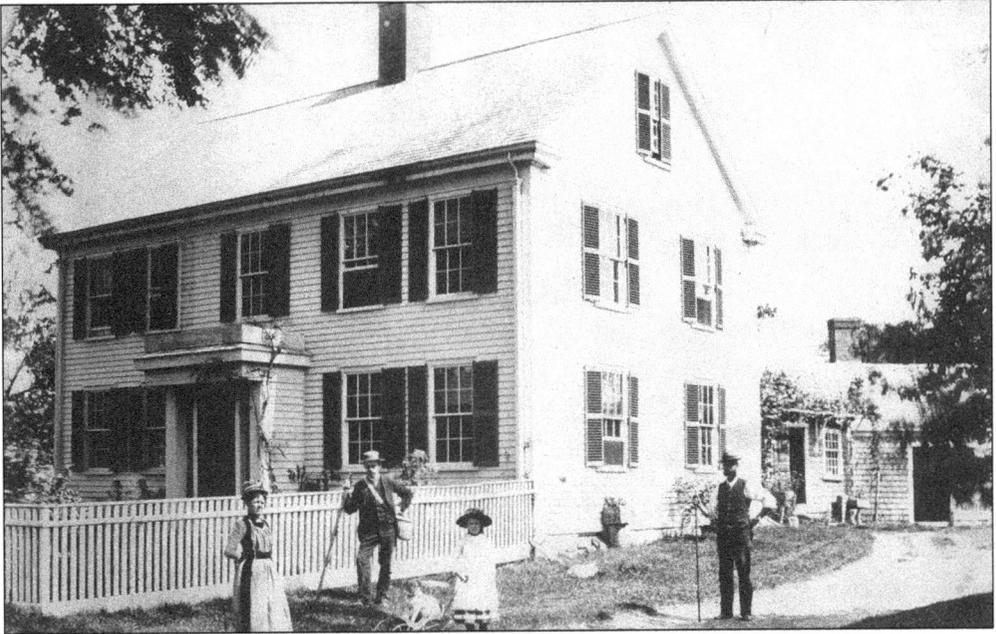

This house on High Street is thought to have been built between 1702 and 1727 by the Loring family. Wadsworth Chandler, who was born in 1849 in Duxbury and married Delia Cushman of Pembroke, eventually purchased the home where they raised their daughter Rowena, who was born in 1882. This picture shows Wadsworth, Delia, and Rowena with a cousin surnamed Cushing.

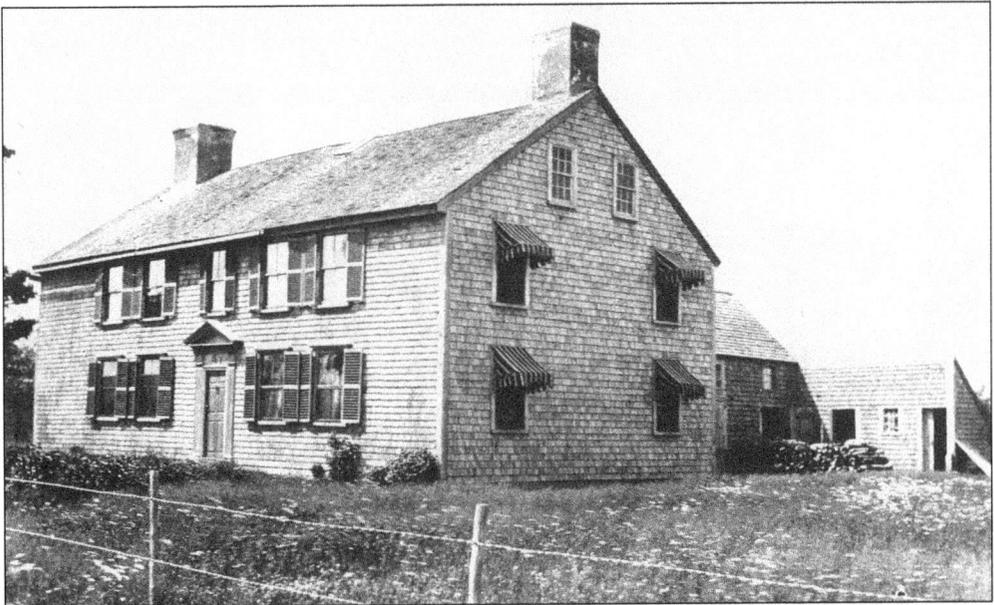

This High Street home was built about 1702 by Thomas Loring III on a grant of 100 acres given to him in 1699, when Pembroke was part of Duxbury. The house was built with end chimneys, low ceilings, and gunstock beams. It appears to have been built in two stages, first by Thomas Loring and later by his son Nathaniel, who inherited the home in 1717.

Mechanic's Hall, now the High Street Fire Station, was moved from Hanover in 1865 and used as an academy. A third story was added and used as a dance hall. The second floor became a carriage shop, and the first floor was a wheelwright shop. Empty for a number of years after 1900, it was purchased by the High Street Hall Association and eventually by High Street area firemen.

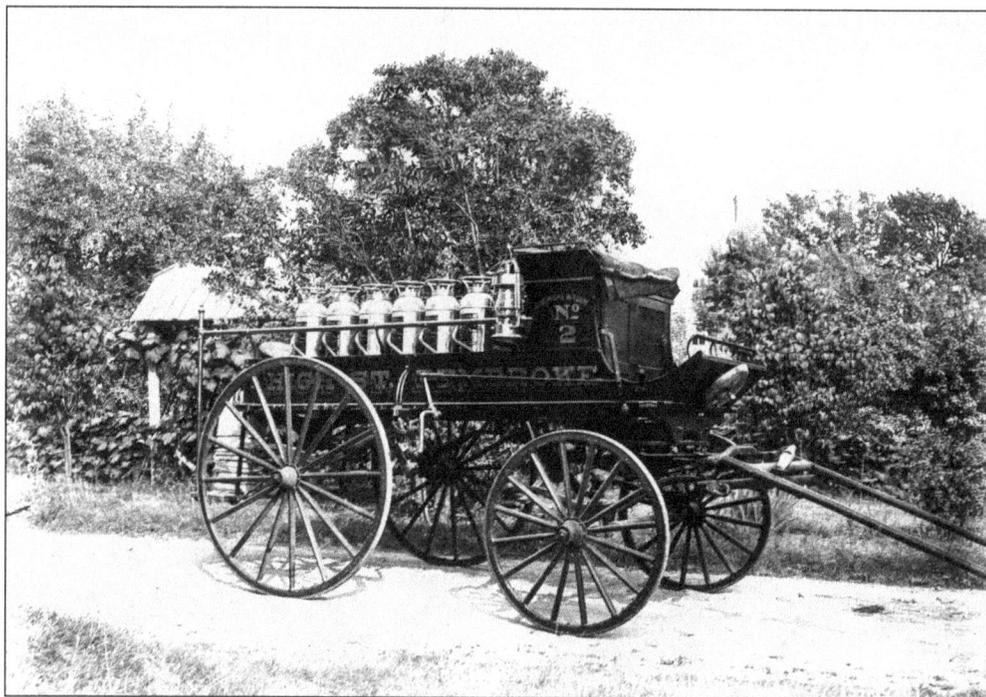

Just prior to the start of the 20th century, Pembroke's fire equipment consisted of six hand fire extinguishers. In 1903, this two-horse wagon, designed by J. J. Shepherd and Horatio Daub, carried 12 extinguishers, axes, pails, brooms, and a tank of water. This one belonged to the High Street station, but each station had a similar wagon.

The Lydia Drake homestead, on High Street, was donated to the town for use as a library by longtime schoolteacher Lydia Drake after her death in 1937. The house was built around 1861, as a small five-room cottage with an unfinished upper story. The "Old Pine Room" was originally a shop in which Drake's father worked at his shoe repair trade.

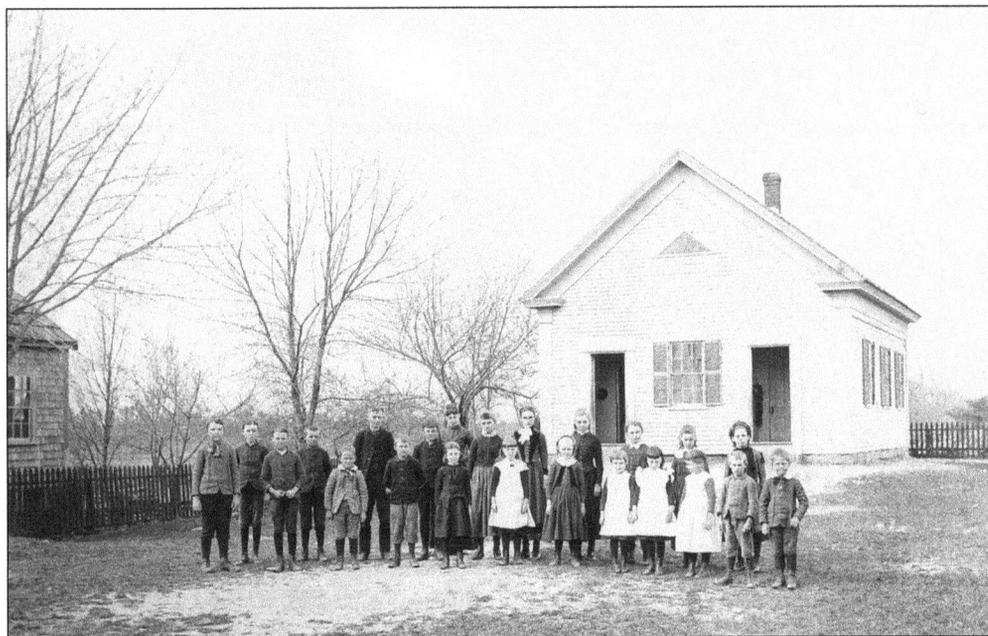

Pembroke's district school No. 4 was located on High Street. A typical one-room schoolhouse, it accommodated grades one through eight. This picture, taken in 1890, shows the entire student body and their teacher, Henrietta Collamore. Drake, of library fame, also taught at this school, which was conveniently located next door to her home.

Hiram Randall (at left) was born in Pembroke in 1817, the son of Isaac and Joanna (Keene) Randall. In 1838, he married Cordelia Simmons (below), the daughter of Martin and Nabby Simmons of Duxbury. Around 1840, he began carrying the mail by horse and coach to and from North Abington. He continued this practice, six days a week, for almost 40 years. The couple raised two daughters, Caroline Alma and Sarah, who married Isaac Howland in 1866. It was Isaac who took over the business from Hiram and ran it until 1900, when his son Hiram took over and ran the business for another 40 years.

This home was originally owned by Barker Delano and his wife Abigail Cook, who were married in Pembroke in 1828. Barker appears as property owner on an 1831 map of Pembroke. Hiram Randall and his wife, Cordelia, purchased the home from Joseph Loring. Originally a cape, Hiram enlarged and added to the building, giving it two separate cellars.

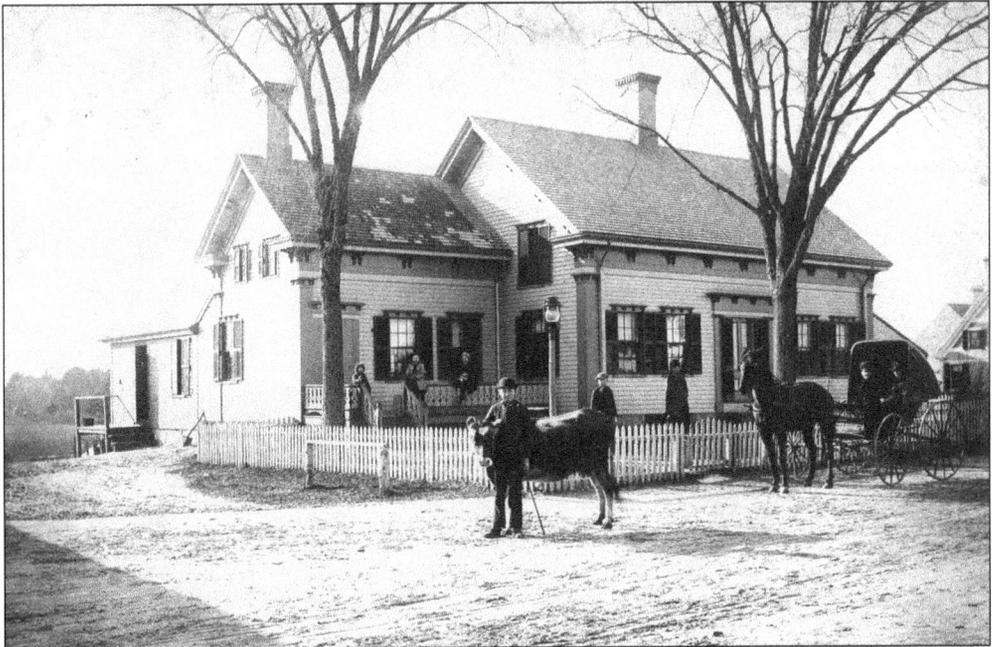

This house was probably built by Hiram Randall (the mail delivery contractor) for his daughter Sarah in honor of her marriage to Isaac Howland in 1866. Isaac and Sarah raised six children here. Shown are, from left to right, (on the porch) Mabel Simmons, Ethel Howland, and Rowena Chandler; (on the lawn) Ray Howland, Carrie Randall, and Hiram Howland with the cow; and Jim Blake, Annie Howland White, and Mabel Howland Merritt in the buggy.

Isaac Newton Howland was born in Abington in 1838. Between 1850 and 1860, his family moved to Pembroke. Their home was next to the family of Hiram and Cordelia Randall, and Isaac was employed by Hiram as a stagecoach driver/teamster. In 1866, Isaac married Hiram's daughter Sarah, and upon the death of Hiram, Isaac took over the operation of Hiram's mail coach line and Randall's Express Company of Boston.

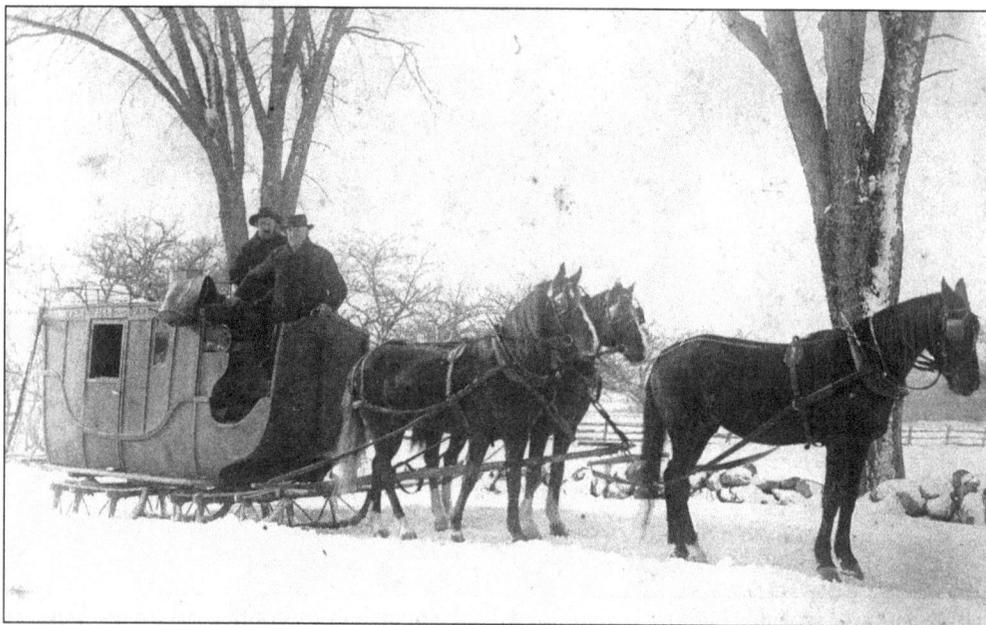

This picture, from the winter of 1886, was taken on Washington Street near the Briggs Burial Ground. The driver is Isaac Newton Howland, and the passenger is Will Delano. Showing how important a good team of horses was, they are also named—the lead horse is Peter, followed by John and Sam.

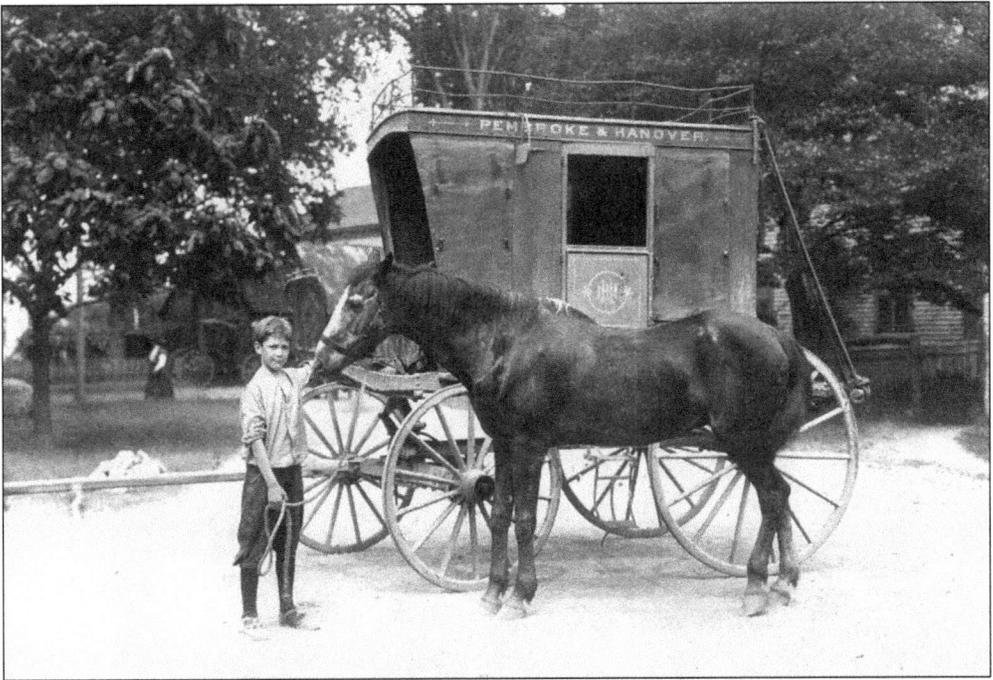

Hiram Randall was born in Pembroke in 1817. In the 1840s, he began carrying the mail six days a week, by horse and coach to and from the North Abington rail depot. By 1867, the Hanover depot was established, cutting Hiram's traveling distance considerably. In 1883, Hiram's son-in-law Isaac Howland took over the route. In 1900, Isaac was replaced by his son Hiram Howland, who is pictured here.

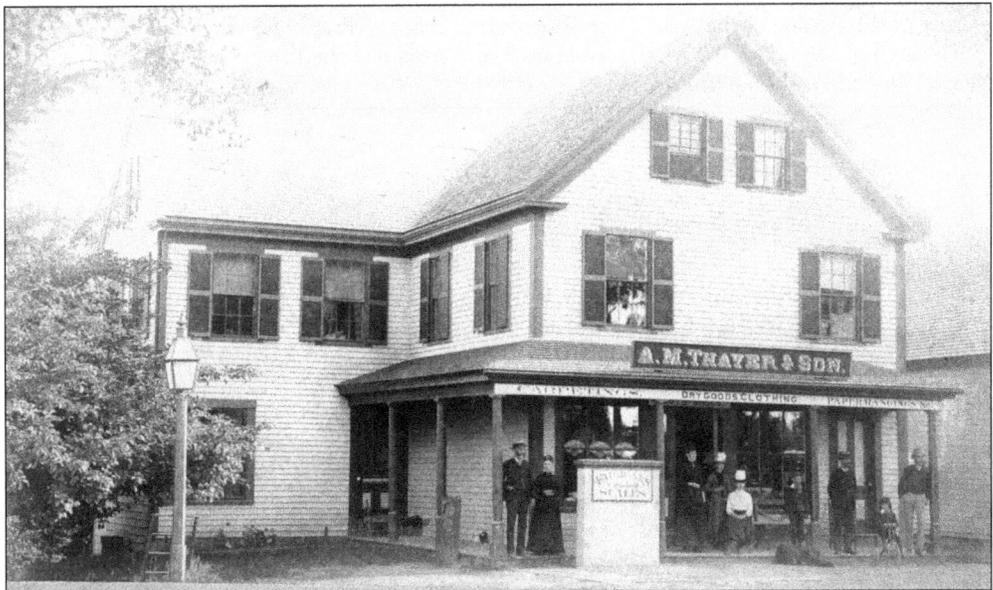

The A. M. Thayer and Son store was located near the Pembroke and Duxbury line on High Street. It was typical of the general merchandise stores of the period. This picture was probably taken in the 1880s. The store served the needs of the High Street neighborhood on both sides of the line for many years.

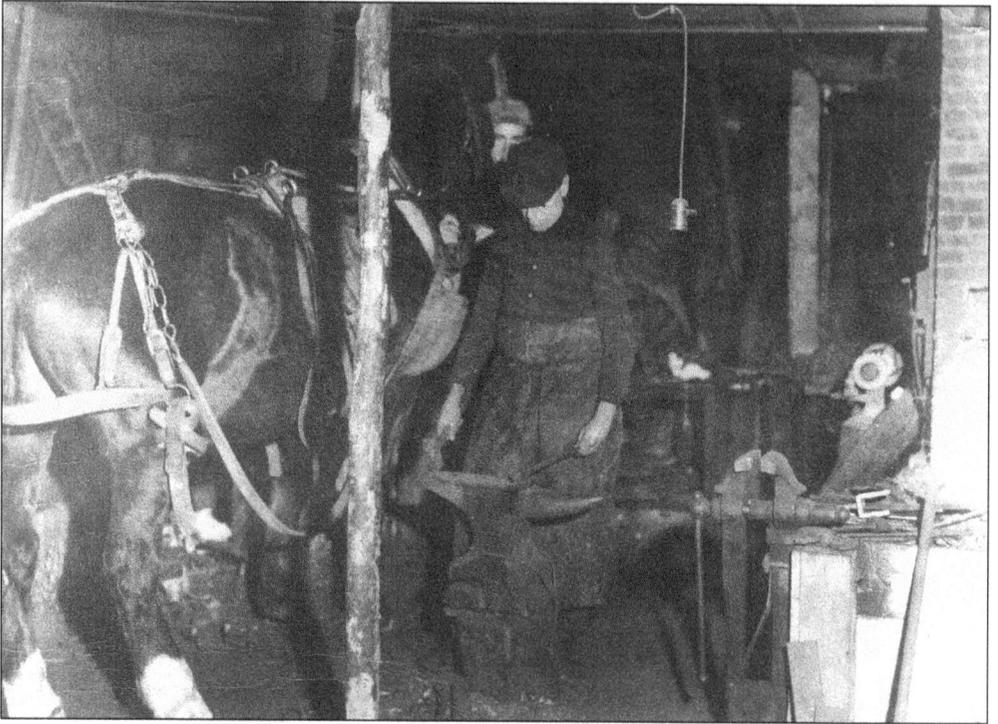

Over the years, the blacksmith shop located on High Street (above) had a number of smithies. Men with the names of Merritt, Washburn, and Winslow labored over their hot iron forges to create the wheels, bolts, horseshoes, and other implements necessary for daily life in a largely rural farming community. They could also repair almost anything made of iron. Below is a picture of the outside of the blacksmith shop during Francis (Frank) Merritt's tenure. The shop was located to the left of the Methodist church and straddled the Pembroke and Duxbury line. Merritt died in Pembroke in 1907.

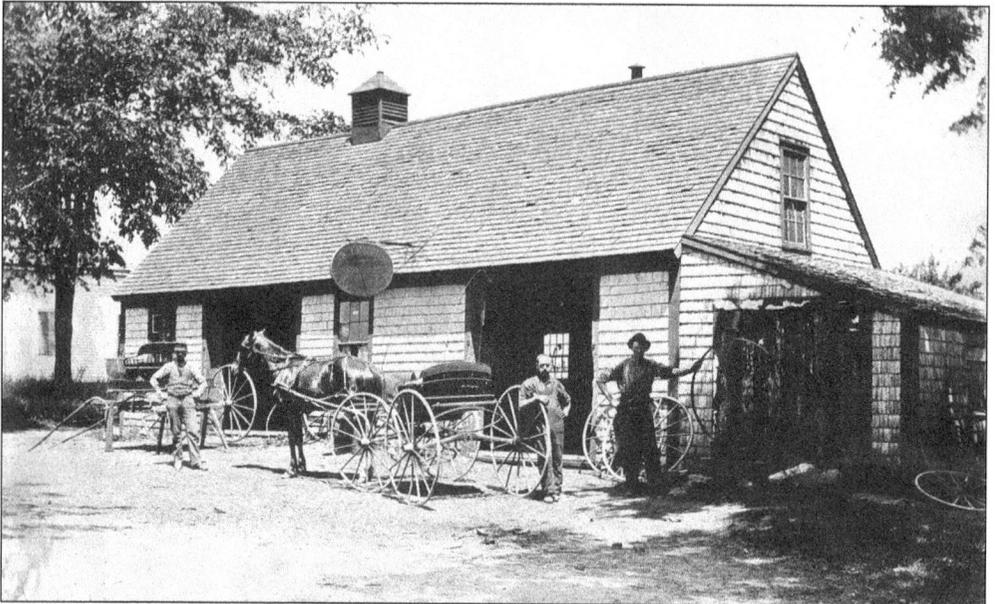

This was the home of Frank and Lydia (Cole) Merritt. Frank's High Street blacksmith shop was located between the house and the Methodist church. Their only child, Sarah, married Duxbury mariner George Lewis. Because George was so often at sea, Sarah always lived with her parents in the home. Her daughter Edith died at the age of 12 of a heart condition while George was away.

When this picture was taken, around 1880, this was the home of John and Sophronia Ann (Glover) Prouty. The couple came to Pembroke, and John went to work as a stage driver for Hiram Randall. They had one child who died in infancy. John died in Pembroke in 1902, and his wife died in the Taunton Insane Hospital in 1909. The family is buried in the Sachem Lodge Cemetery.

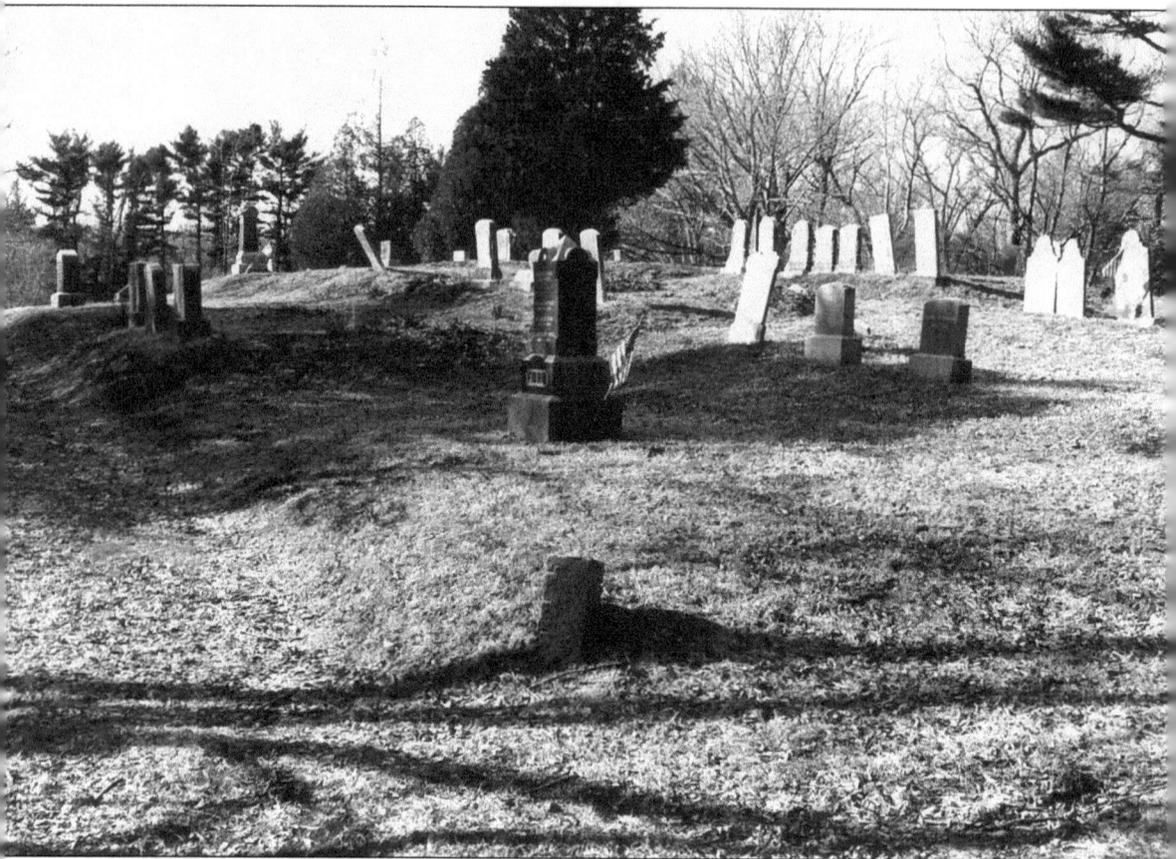

The Sachem Lodge Cemetery on High Street has also been called the Loring Cemetery or the High Street Cemetery. It is located on what was once known as Hall's Hill, probably after Horace and Gracey Hall, who owned the property in that area and are buried in the cemetery. It was first owned by a private corporation and later turned over to the Town of Pembroke. The oldest memorial is that of Capt. Daniel Pierce, who died in Richmond, Virginia, in 1799 at the age of 31 years. There are about 300 stones in the now seldom used cemetery. (Courtesy of John Proctor.)

Seven

NORTH PEMBROKE

For close to three centuries, the North River, which separates the towns of Marshfield and Pembroke from Scituate, Norwell, and Hanover, was a cradle of New England shipbuilding. When the North River is looked at today, it is hard to imagine majestic merchant ships sailing through these narrow, marshy waters. Over the centuries, storms and man's increasing demand for water have dramatically changed the character of the river, making it narrower and more winding, so that today it is used almost exclusively by canoes and rowboats, leaving little evidence behind of the once thriving shipbuilding industry that once graced its banks.

During this shipbuilding period, which lasted roughly from 1678 to 1871, the North River afforded excellent access to the sea. A second factor that caused shipbuilders to come to inland towns such as Pembroke was the abundance of white oak and other hardwood trees, which could be made into excellent shipbuilding timber. A third factor was the existence of an iron furnace located on Furnace Pond that could provide nails, spikes, and other hardware, including anchors.

Perhaps because of its close proximity to the North River and the wealthy shipbuilding families, the area of North Pembroke became a haven for those in the area who wished to spend their hard-earned money or credit on store-bought and/or manufactured items. In addition, there were those necessities that had to be purchased by the average citizen, such as shoes, harnesses for horses, metalware, and the like.

The beehive of activity brought about by the North River led to jobs, which led to population growth. There were actually two district schools located in the North Pembroke area. District school No. 3 was moved several times but eventually was located on Schoosett Street. District school No. 8 was located on Washington Street.

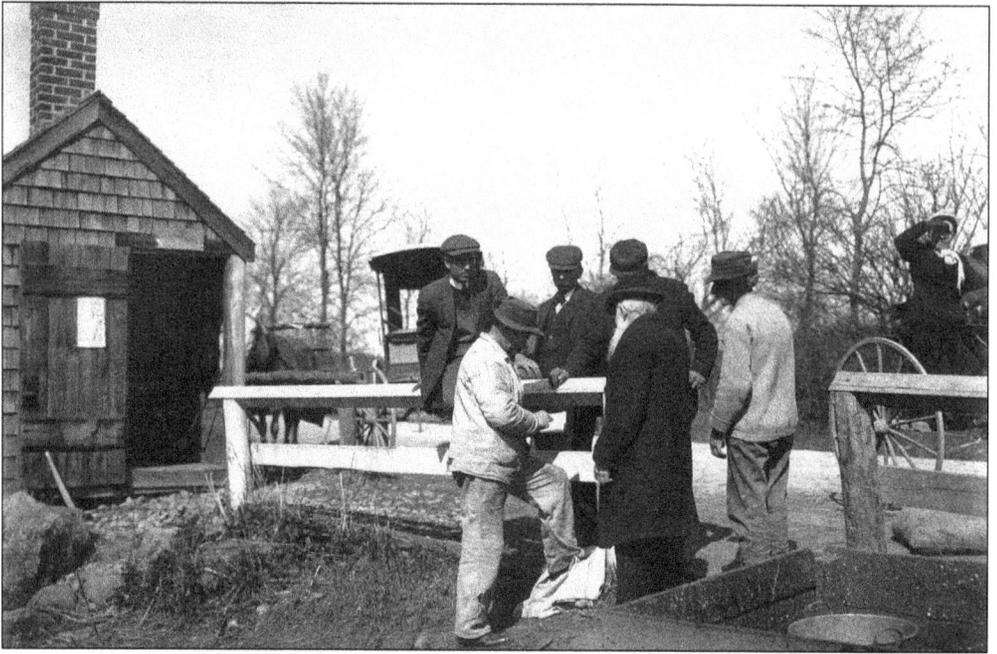

Since the first Native Americans settled in the Pembroke area, the herring (actually alewives) have been an important food source for local residents. Each spring, as warmer weather approached, Pembroke residents gathered at the Herring Run (above) to observe and collect their individual herring quota under the watchful eyes of the herring superintendents (below). The amount of fish that each resident could take was carefully regulated. Pictured below are John LeFurgey (second from left), Lemuel LeFurgey, and, holding the nets, Richard Strang and Arthur Ford. One of the Snow boys (Arthur or Willard) watches the process. Although catching the fish is no longer permitted, residents still come to the Herring Run at Tommy Reading Park to view this annual rite of spring.

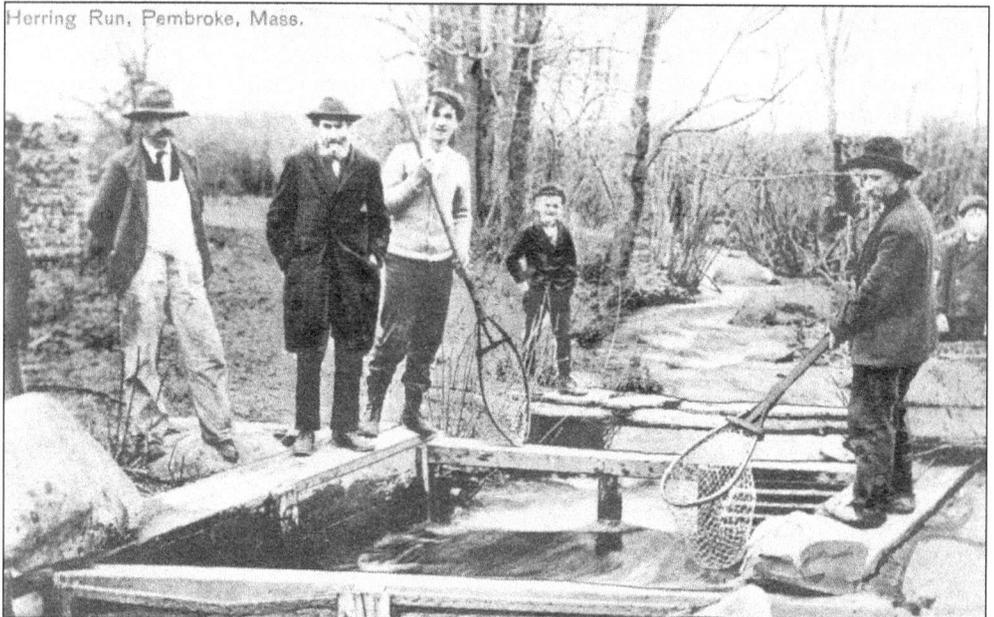

Herring Run, Pembroke, Mass.

Legend says that the Indian Rock, located at the Herring Run in Tommy Reading Park, was a frequent gathering place for the Native Americans from Mattakeesett and surrounding areas. A hurricane many years ago toppled a tree near the rock and revealed, in its root system, stone chippings, the result of natives crafting spear points and other tools for their daily lives.

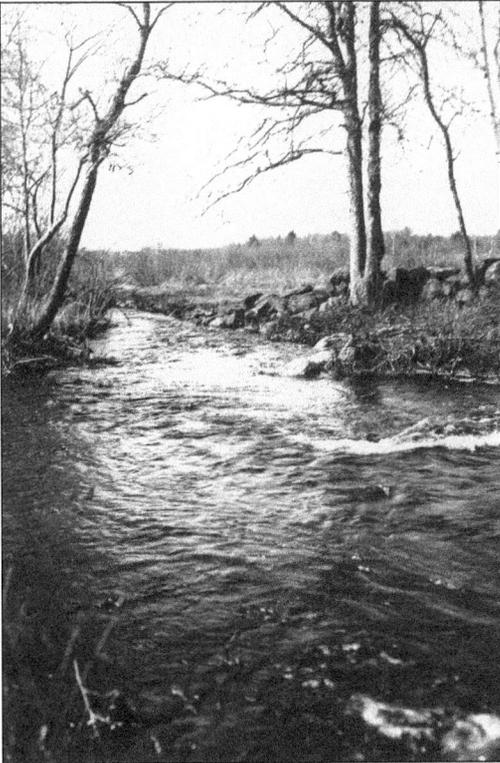

Each spring, runoff from melting snow and spring rains causes the Herring Brook at Tommy Reading Park to flow over its banks. Normally little more than a meandering brook, this picture shows the stream as it flows toward the Great Cedar Swamp. Before long, thousands of herring fight their way against the current toward the ponds where they are hatched, to spawn and die.

Greetings From Pembroke, Mass.

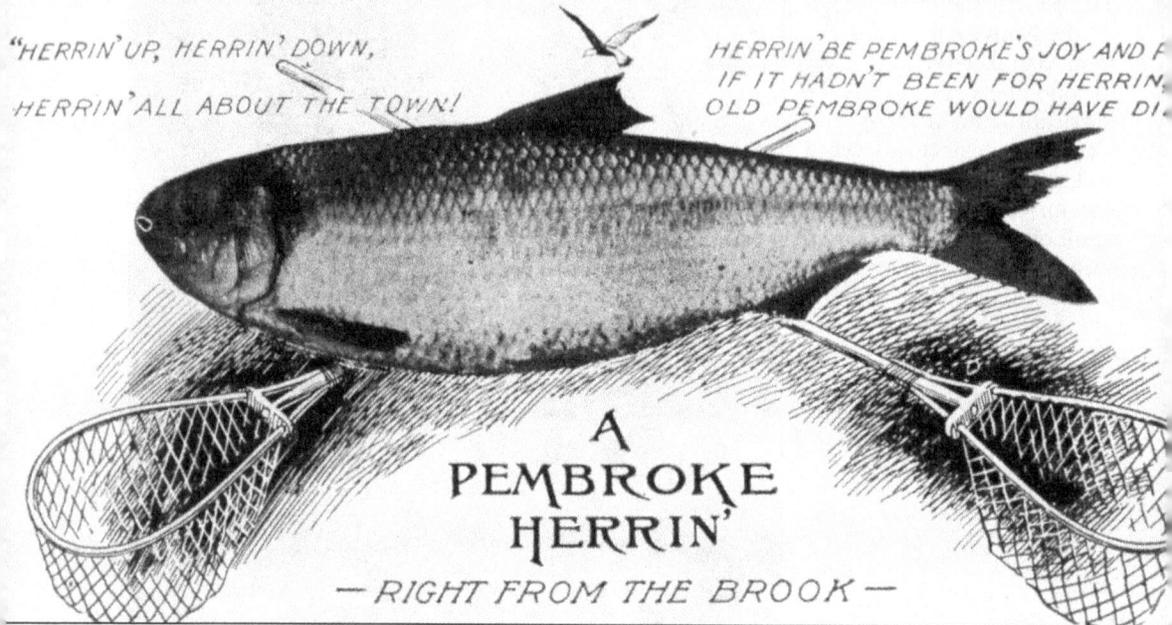

"HERRIN' UP, HERRIN' DOWN,

HERRIN' ALL ABOUT THE TOWN!

HERRIN' BE PEMBROKE'S JOY AND F
IF IT HADN'T BEEN FOR HERRIN,
OLD PEMBROKE WOULD HAVE DI.

A
PEMBROKE
HERRIN'

— RIGHT FROM THE BROOK —

The importance of the herring to the Native Americans and the European settlers of Pembroke is clearly illustrated by this postcard, printed by Bryantville photographer/publisher George Edward Lewis. After the European settlement of Mattakeesett and the establishment of the town in 1712, the quantity of herring that could be taken from the brook was carefully regulated by Pembroke's town fathers and the herring superintendents. Although called herring, the fish are actually alewives, which are related to herring but slightly smaller. They are grayish green in color and have silvery sides and underbelly. While they can reach up to 15 inches in length, most of Pembroke's fish are traditionally smaller and weigh in at about one pound.

The records are confusing as to the builder of this Barker Street house, but it is thought that it was built in 1786 by Harris Hatch. The land was originally part of the Barker land grant, and by the 1830s, the home was owned by a descendant of Robert Barker Sr., also named Robert Barker. By 1905, after ownership by several generations of Barkers, the home passed out of the family.

The Squire Keene Mansion on Barker Street was built on land sold by the Barkers to John Keene in 1699. Keene sold the property to his son Josiah, who built his home there in 1749. Josiah was elected to the general court in 1757 and held that position off and on until 1772, when Pembroke residents petitioned to have his seat denied to him because of what they believed was an unfair election.

Samuel Webb was born in 1754 probably in Scituate. He married Betty Baker of Pembroke in 1782 in Pembroke. It is believed that he built this home on Barker Street about 1810. Samuel died in 1839, and Betty in 1843. The house was later owned by Ichabod Loring, who was born in Pembroke in 1807 and died here in 1884, and his wife Elizabeth, who died in Pembroke in 1896.

Kenelm Ford was born in 1830 in Pembroke, the son of Joseph and Pamelia Ford. In 1858, he married Mary Abbie Samson of Kingston. The couple settled in North Pembroke, where they raised six children. Kenelm was a brick mason for his entire life. He died in Pembroke in 1909.

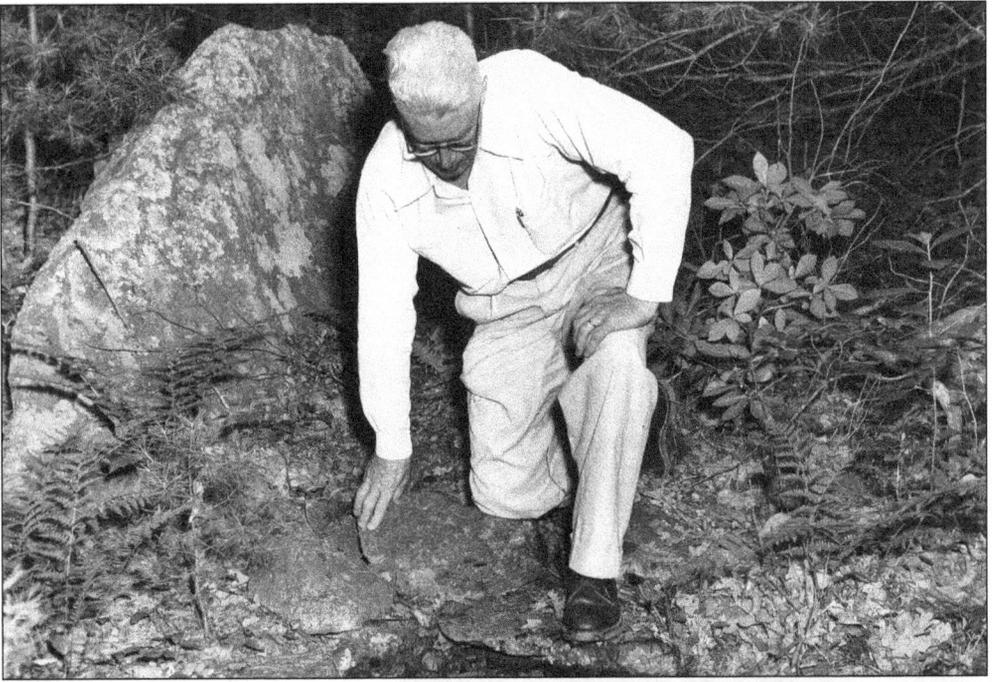

Granville Thayer (above), of the Pembroke Historical Society, is kneeling over Peter's Well, located on a small lot on Fairwood Drive. Legend says this may have been the site of a Huguenot settlement in 1617. Nearby, it is said, are the ruins of the house foundation amid the remains of an early orchard of hightop sweetings (below), an apple variety peculiar to Huguenot orchards. Old maps of Pembroke call this area Wallis Orchard. This is said to be the spot where the Huguenot family of Wallis settled. The whole family except for Wallis himself was wiped out in a Native American attack. He supposedly lived out his life here. In 1756, French neutrals, driven out of Acadia, settled among the American colonists. Pembroke took in the family of Pierre Pelerine, called Peter by his neighbors, who moved into the abandoned homestead.

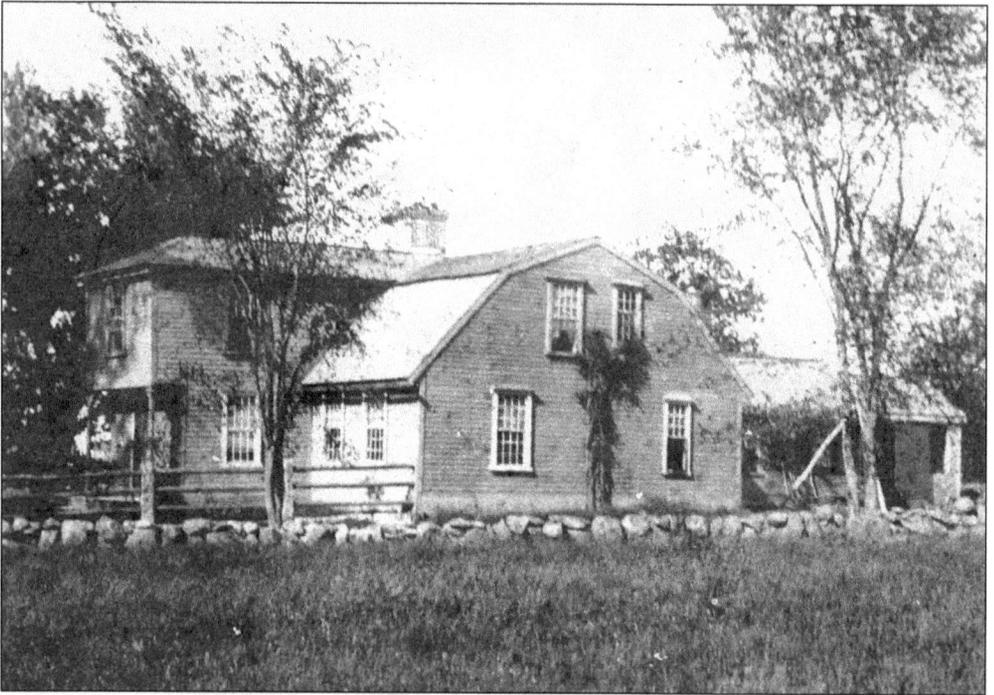

It is thought that the Adah Hall House property was a part of a land grant given by Miles Standish to Pembroke's first settler, Robert Barker Sr. Barker gave a portion of his land to his oldest son, Robert Jr., who built the house on Barker Street about 1685. Quaker converts, the Barkers held gatherings of the Quaker Society at this house prior to the building of the present Quaker Meeting House. The picture above shows the house as it appeared about 1900, before it was purchased by Adah Hall and restored to its original state. Below is the way the house originally looked and appears today.

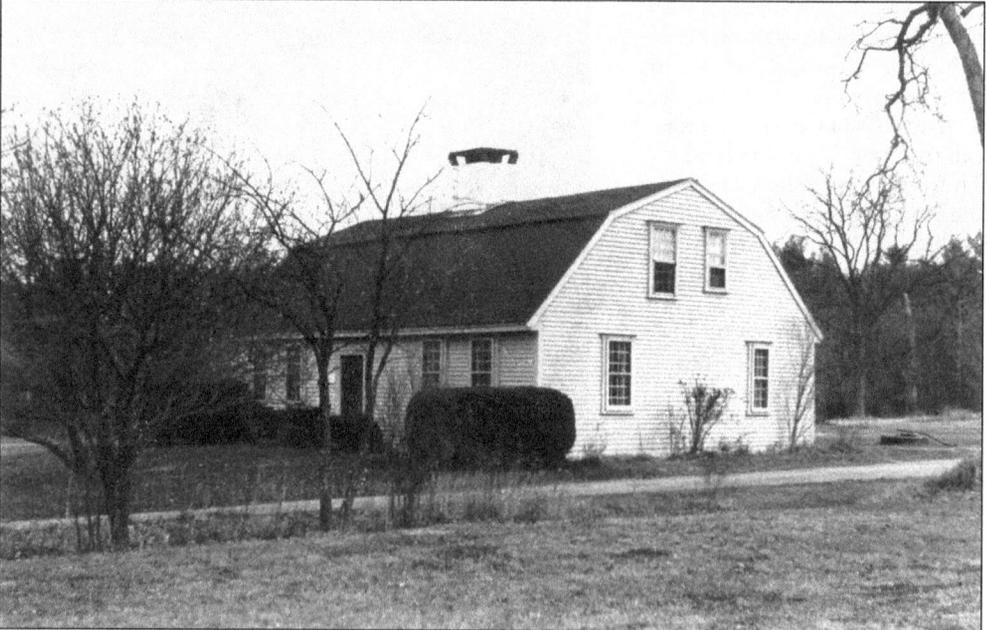

Calvin Shepherd, born in Pembroke in 1785, married Mary Branch Byram in 1807. In 1810, he was operating the cotton factory on Pudding Brook, which in 1824 he converted into a sawmill and wooden box factory. The business was turned over to his son-in-law James Horace West. Shepherd died in 1867. A devout Quaker, Shepherd, his wife, and several children are buried in the Quaker Meeting House Cemetery.

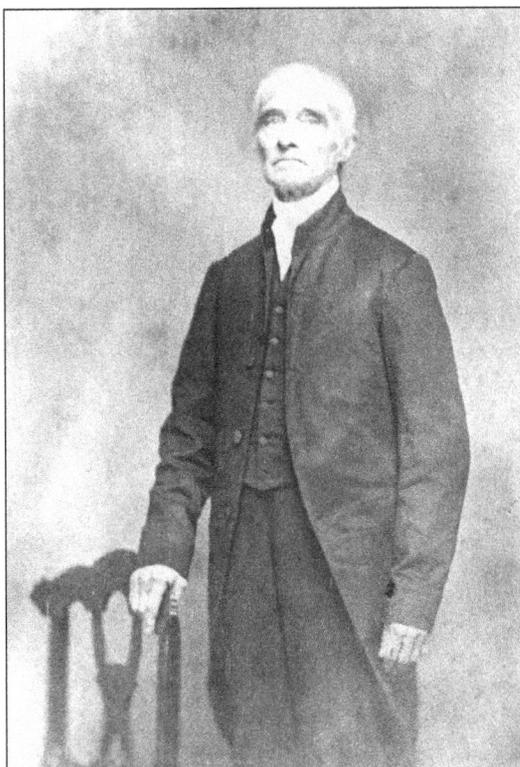

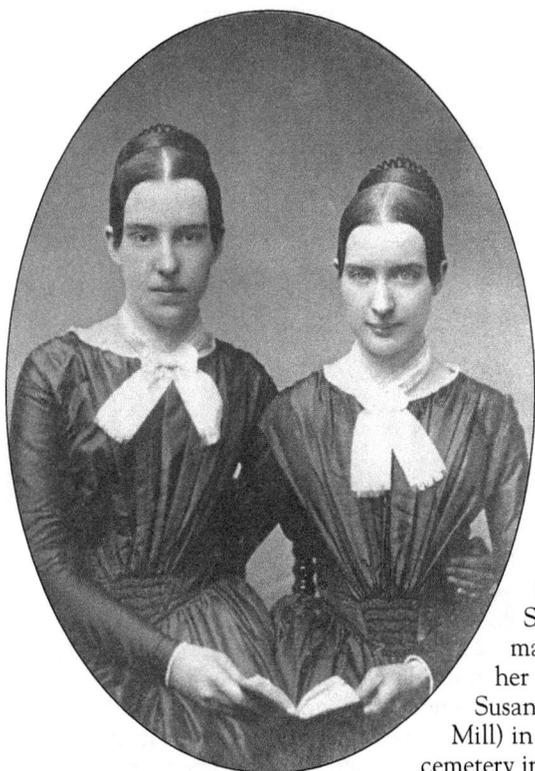

Here are two of the daughters of Calvin and Mary Shepherd. Mary Green Shepherd (left) was born in 1827 in Pembroke, and Susan Shepherd was born here in 1831. Mary married James Horace West (who took over her father's box factory business) in 1851, and Susan married Lemuel LeFurgey (of the LeFurgey Mill) in 1861. The families are buried in the Quaker cemetery in Pembroke.

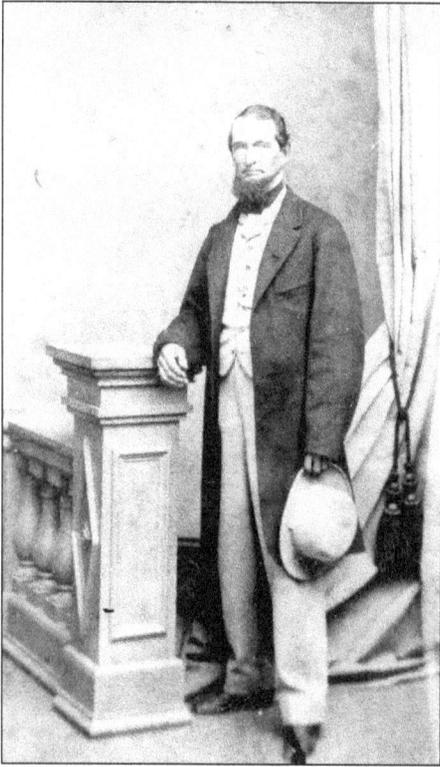

Nathan T. Shepherd was the eldest child of Calvin and Mary (Byram) Shepherd. He was born in 1811 in Pembroke and married Ruth Ann Shove in 1833, also in Pembroke. The couple raised seven children. Nathan worked in his father's box factory for most of his life. He died in 1885, and his wife died in 1896.

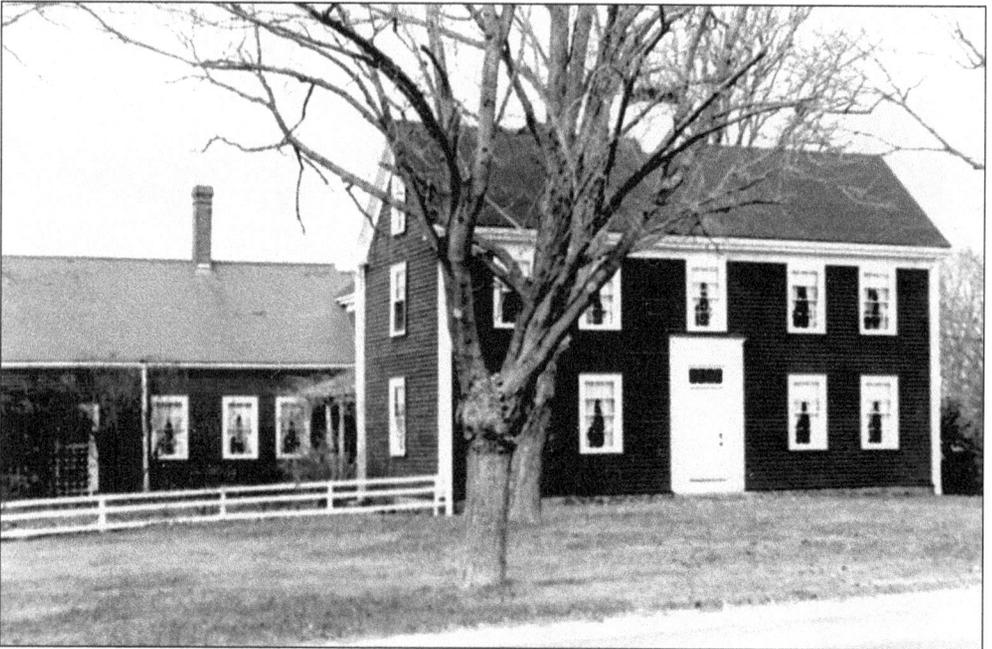

Built in 1777 by Israel Turner, Willowbrook Farm on Barker Street was originally located on Pleasant Street near the Pudding Brook. It was also known as Factory Farm in the 19th century, because it was then owned by Calvin Shepherd, who also owned the box factory. In 1877, Susan Shepherd LeFurgey, Calvin's daughter, bought the home and moved it to its present location.

Joseph Rogers Shepherd was born in 1820 in Pembroke, the son of Calvin and Mary. He was married to Phebe Wing Shove, who died of consumption. He then married Huldah Turner and had three children. He worked all his life in the box factory started by his father and later owned by his brother-in-law James Horace West. He died in Pembroke in 1914.

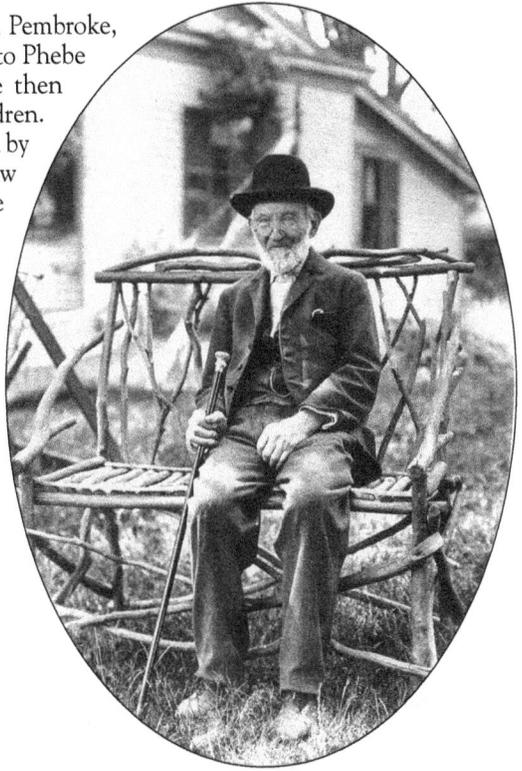

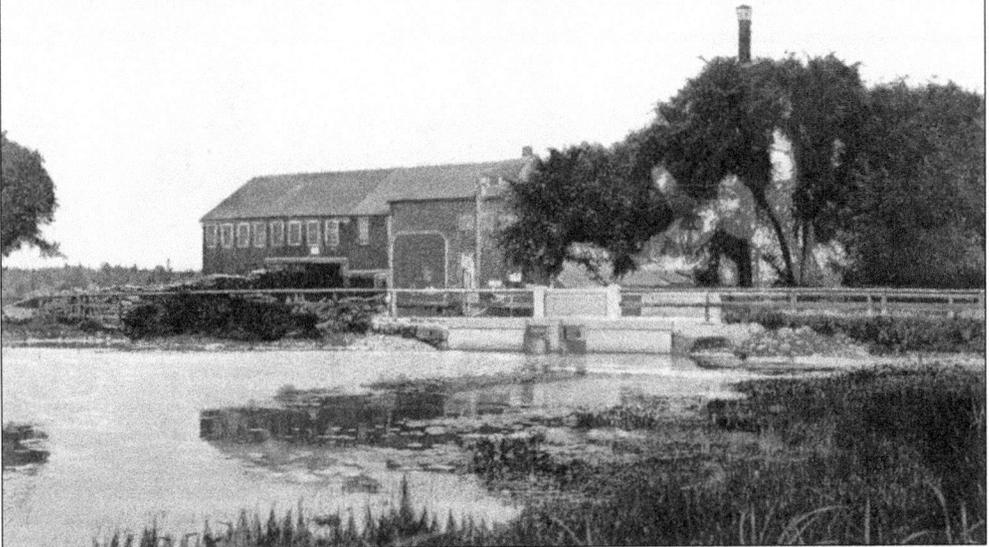

West's Mill, North Pembroke, Mass.

In 1810, Calvin Shepherd ran a cotton mill on Pudding Brook near the intersection of Washington Street and Barker Street. About 1824, he converted his mill into a sawmill and also manufactured wooden boxes there. Calvin eventually turned the mill over to his son-in-law James Horace West. Descendants of the family ran the business for a number of generations.

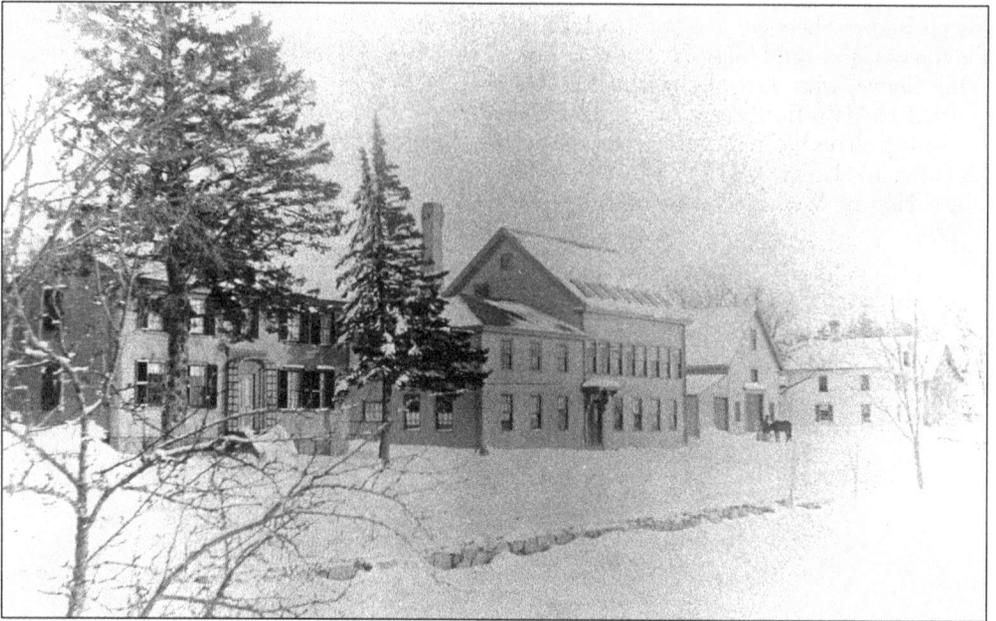

The Arnold Shoe Shop (above) was located on Washington Street, to the right of King's Highway Inn. It was owned by Francis (Frank) Preston Arnold, who was born in Abington in 1836, the son of Jonathan and Mary (Damon) Arnold. Like his father, Frank went into the shoe industry as a stitcher and later was the owner of the Arnold shop. The picture below shows a substantial expansion of the shop, which by this time was known as a shoe manufacturing business. It employed as many as 100 people. Frank had taken his nephew Moses Arnold of North Abington as an associate. All in all, the business operated from about 1880 until about 1910. Around 1914, the building burned and was torn down.

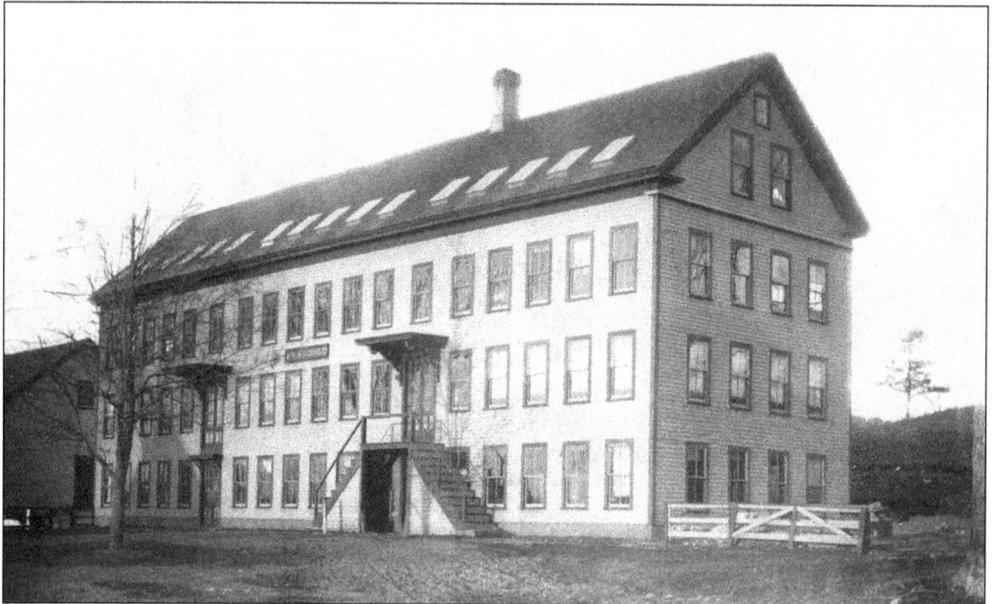

This home on Barker Street, built in 1837, was a replacement for an earlier house, destroyed by Thomas Turner. The earlier home, first owned by Samuel Barker, was purchased about 1761 by an ancestor of Turner, also named Thomas Turner, whose wife, Joanna, on her wedding day planted buttonwood trees that graced the property for many years. In 1932, the home passed out of the hands of Turner descendants.

The William Cushing House stood at the corner of Washington and Water Streets, the site of today's North Pembroke Post Office, and dated from the 1770s. William Cushing was born in 1749, the son of Nehemiah and Sarah Cushing. In 1777, he married Abigail Turner. They had one child, William, born in 1780.

The Simmons Store was located at the corner of Washington Street and Water Street (the site of the present post office) and was built in 1873. The store was constructed with a large dance floor upstairs. Daniel Simmons operated the business and served as the North Pembroke postmaster in this building for many years.

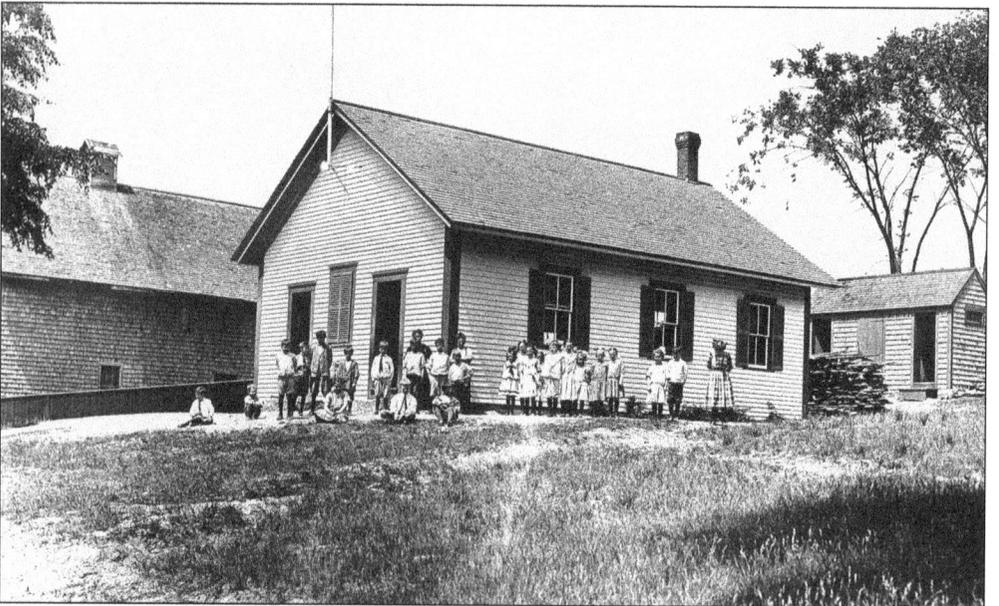

North Pembroke district school No. 8 was built in 1848 to replace an earlier structure located next to the Briggs-Barker Burial Ground on Washington Street. Around 1848, schoolchildren playing at recess accidently unearthed a body. The townspeople voted to move the school one quarter of a mile south to its present site. It was used as a schoolhouse until 1924, when it was sold.

WASHINGTON STREET, NORTH PEMBROKE, MASS.
No. 38. Pub. by Geo. Edw. Lewis, Bryantville, Mass.

The King's Highway Inn is still located at its original spot on Washington Street, known prior to the American Revolution as the King's Highway. A frequent stagecoach stop for travelers between Boston and Plymouth, it was built on a tract of land given to Francis Barker by his father, Robert Barker Sr., about 1660. A hammered copper plate bearing that date was uncovered during a restoration.

The Briggs Cemetery, located on a hill on Washington Street, was named for the descendants of Seth Briggs (1721–1802) and bears the family name. Descendants of the Barker family are buried here along with famed architect Alexander Parris; shipwrecked sailor Moses Smith of Pembroke, who died off the North Carolina coast in 1861; and North River shipbuilder Ichabod Thomas.

This view of Washington Street was probably taken from the Briggs Family Cemetery hill. In the foreground on the right is the hexagonal house, before the barn was built. Beyond that, on the same side of the street, is the house once owned by Alexander Parris and Nathaniel Smith. In the distance, on the left, is the Collamore house.

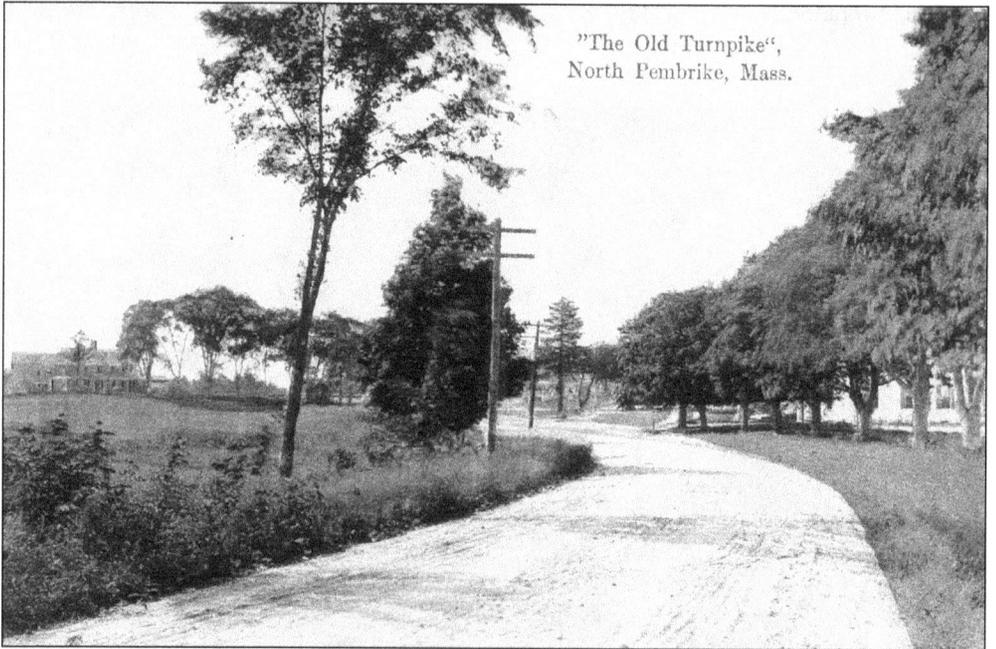

"The Old Turnpike",
North Pembrike, Mass.

Identified as the "Old Turnpike" on this postcard by George Edward Lewis, this stretch of Route 53 in North Pembroke is approaching the intersection of Route 139. The Anthony Collamore House is in the distance on the left. Note the farmlands where trees and houses now stand. This picture, taken at the beginning of the 20th century, is a perfect depiction of the rural character of Pembroke.

In 1852, Luther Briggs Jr. of the Briggs shipbuilding family purchased a tract of land next to that of his uncle Alexander Parris. The hexagonal house is believed to have been built by Briggs about that time, but no proof has been found. It is one of a number of hexagonal and octagonal houses built throughout the country.

Built in 1850 by disgruntled members of First Church at the church's change from Trinitarianism to Unitarianism beliefs, Bethel Chapel, according to a covenant in the deed, was to be used only by followers of the Evangelical-Trinitarian Church, which today is nonexistent. After much effort by the Pembroke Historical Commission, the building is now owned by the Town of Pembroke.

Located on Washington Street, the property known as the Dr. Anthony Collamore Estate (above) was actually purchased by Dr. Anthony Collamore in 1809. In 1713, the house was built by Thomas Barker on a land grant given to him by his father, Francis Barker. Dr. Collamore practiced medicine in the area for many years before turning the practice over to his nephew Francis Collamore. Henry Collamore, Esq., son of Francis, owned the home until about 1900, when the home passed out of the Collamore family. Florina Collamore (at left) was born in 1862, the daughter of Dr. Francis Collamore and his wife, Priscilla (Mann) Collamore. She never married and lived with her parents, caring for her father after the death of her mother in 1903. She worked as an insurance agent after the death of her father in 1910.

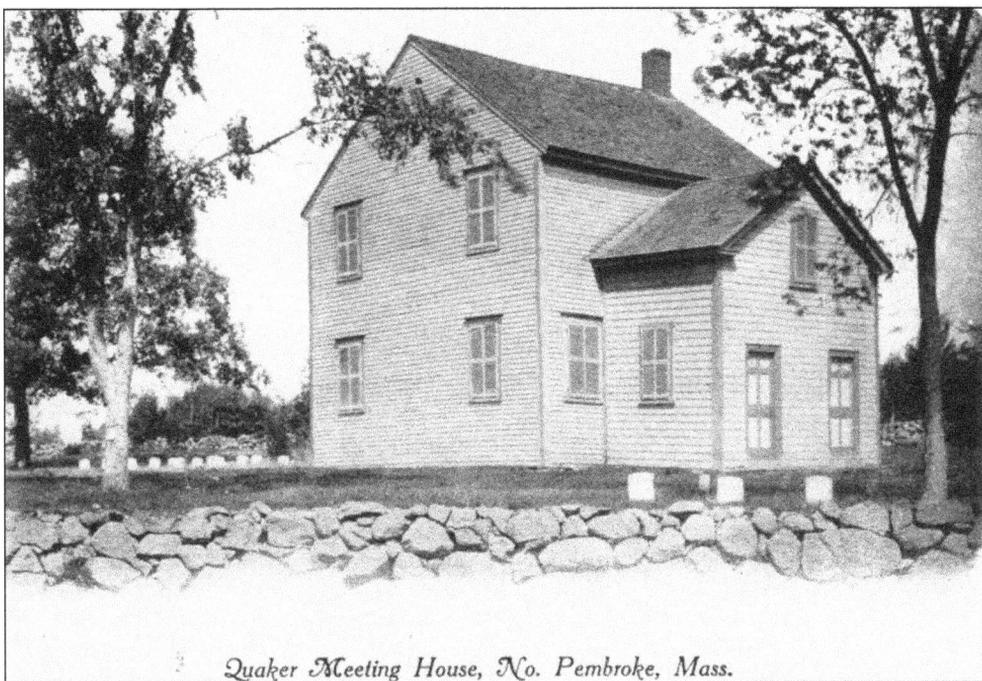

Quaker Meeting House, No. Pembroke, Mass.

The Quaker Meeting House (above) was thought to have been built in Scituate and moved to its present location, a practice fairly common in the 18th century. More recently, local historians believe that the building was built on the site by Robert Barker Jr., a Quaker convert, prior to 1718 and as early as 1706. The interior picture (below) of the meetinghouse shows one side of the space. Quaker men and women were separated during the meetings, and each had separate entrances. One can only wonder whether it was the men or the women who had the side closest to the only source of heat in cold weather—the fireplace or wood stove.

The North River Bridge spans the river between Pembroke and Hanover. The picture above shows the old bridge, built in 1829 at Washington Street and replaced in 1904. The picture below shows the 1904 replacement. The North River was an extremely vital part of early Pembroke history. The bridge afforded easier access to goods and services on both sides of the river. A bronze marker denotes one of the most prolific industries ever in Pembroke—shipbuilding. According to the plaque, between 1678 and 1871 over 1,000 vessels of between 30 and 470 tons were built on the shores of this important South Shore waterway.

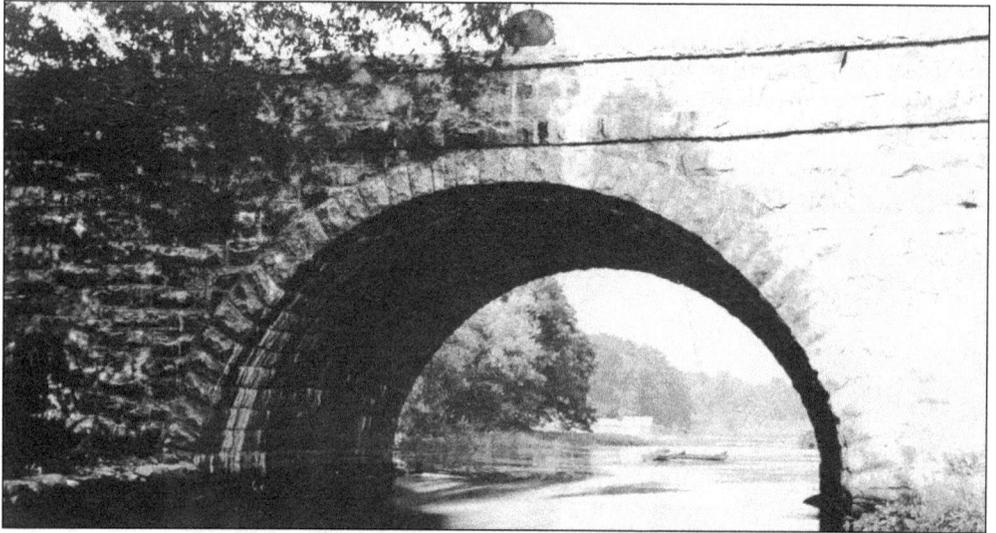

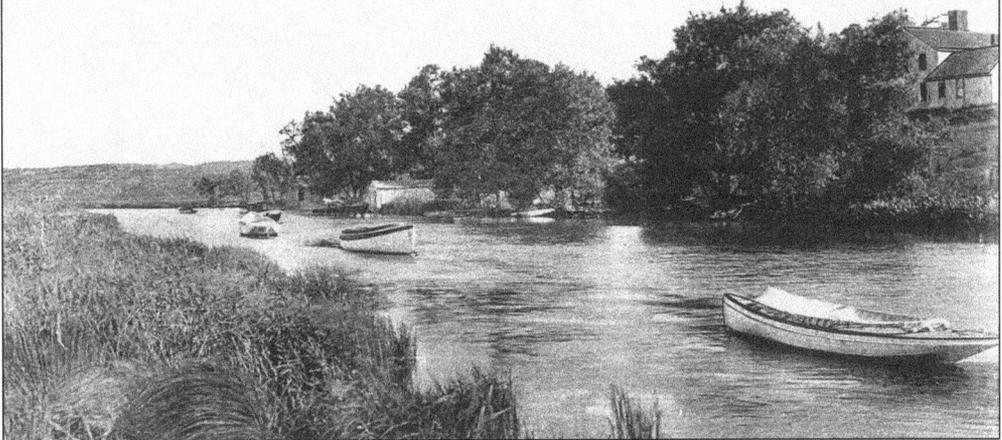

This location on the Pembroke side of the North River was the site of the Brick Kiln Shipyard. It is widely believed that the Boston Tea Party ship *Beaver* was built by Ichabod Thomas at this yard. The *Bedford*, the first ship flying the American flag in Europe, and the *Maria*, which sailed for 90 years, were also built here. Thomas built at this yard from 1766 to 1788.

Countless generations of Pembroke residents have enjoyed lazy summer days boating, canoeing, and fishing on the North River. Once bustling with sounds of shipbuilding, the shores of this major South Shore waterway became much more popular for recreation after the last ship was completed on its banks in 1871.

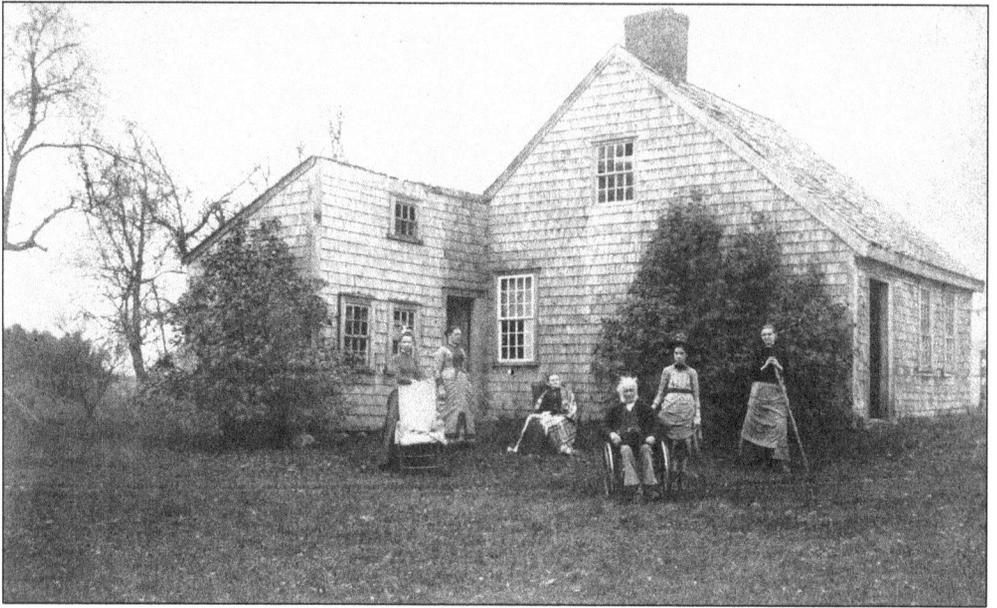

This home, now gone, located at the end of Brick Kiln Lane, was the home of Alden Briggs Jr. It is thought that this is the Briggs family. In 1899, William Ferdinand Macy, a respected painter of marine scenes, and his wife, Anne, a writer once hailed as "poet lauriat of the South Shore," bought the house. After the deaths of William and Anne, the home passed to their son Theodore.

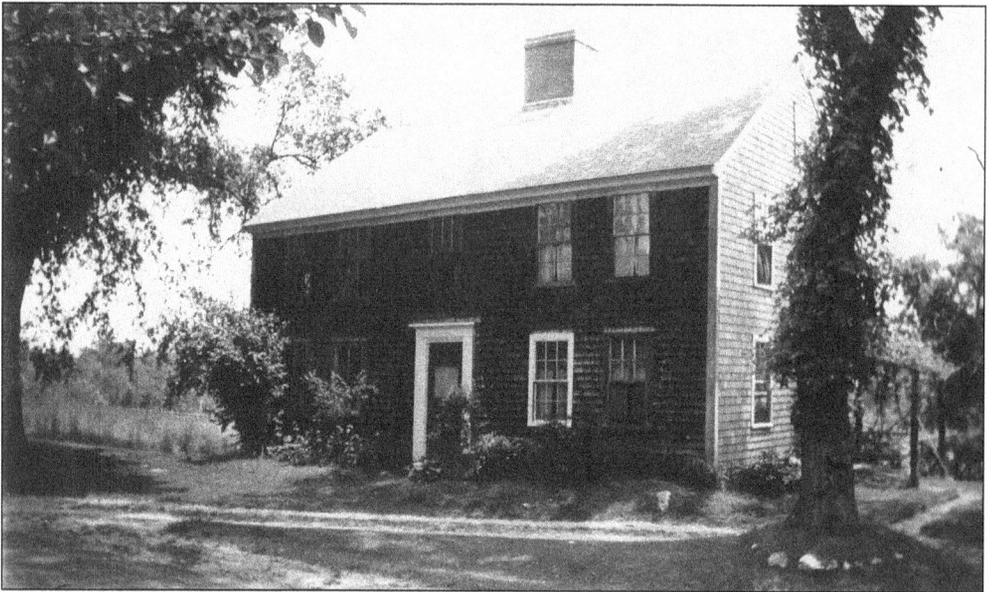

It is thought that this home on Water Street was built by Seth Hatch Jr. around 1776. Seth was born in Pembroke in 1755, the son of Seth Sr. and Mary (Turner) Hatch. Seth Jr. married Mary Hatch in 1779. A number of these family members are buried in the small Hatch Cemetery located across the street from this home.

According to Gus Westerling, former owner, antique dealer, and member of the Pembroke Historical Society, in 1730, Capt. Job Turner built this classic Cape Cod home. The house has wide pine panels that make up the walls in the dining room and parts of other rooms; low, broad-beamed ceilings; and unusually wide floor boards. This picture shows Westerling standing outside the home located on Washington Street.

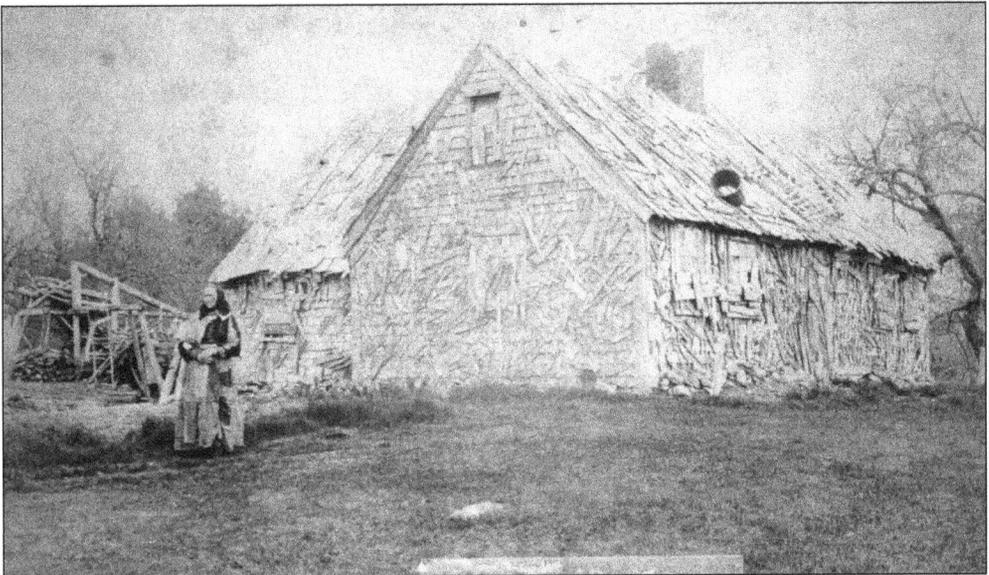

Marcia Bates was born in the 1830s to Oren and Abigail Bates. In 1854, she married John Parry, a shoemaker who died in 1893. This picture, taken about 1900, shows Marcia outside her Washington Street house. Neighbors remembered her as a woman who wore many layers of clothing. Others have noted that this picture speaks as much to her poverty in widowhood as it does to her eccentricities.

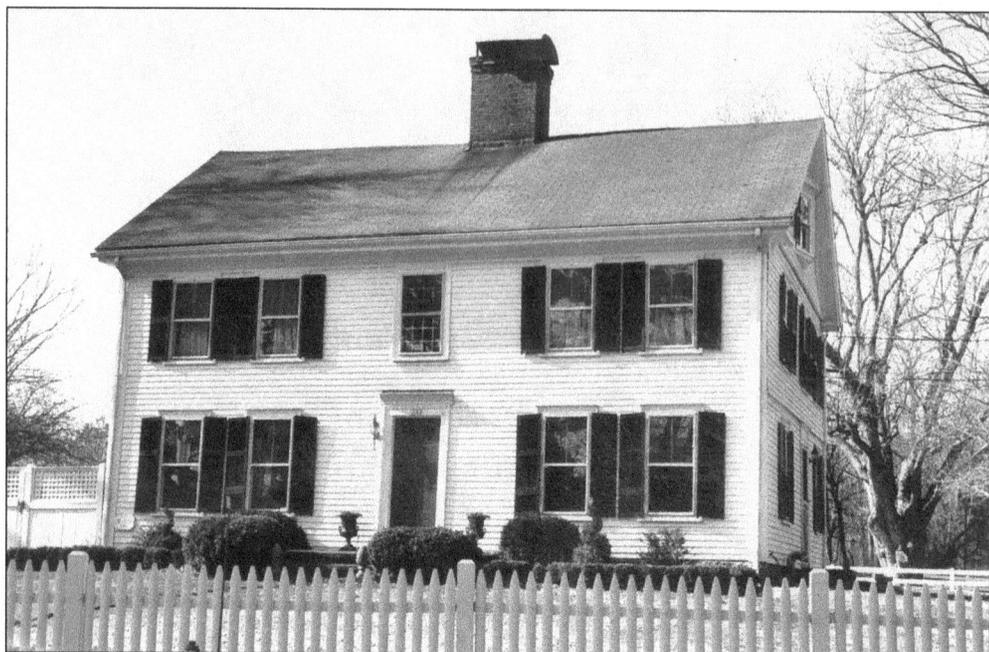

John Magoun came from Scotland to Massachusetts about 1655. He first settled in Hingham and came to the Pembroke area (which was part of Scituate) in about 1665. He purchased a tract of land, it is believed, from Robert and Lucy Barker and in 1666 built a home, which is still standing on Water Street, across from the Luther Magoun Cemetery. This home is considered the oldest building in Pembroke. (Courtesy of John Proctor.)

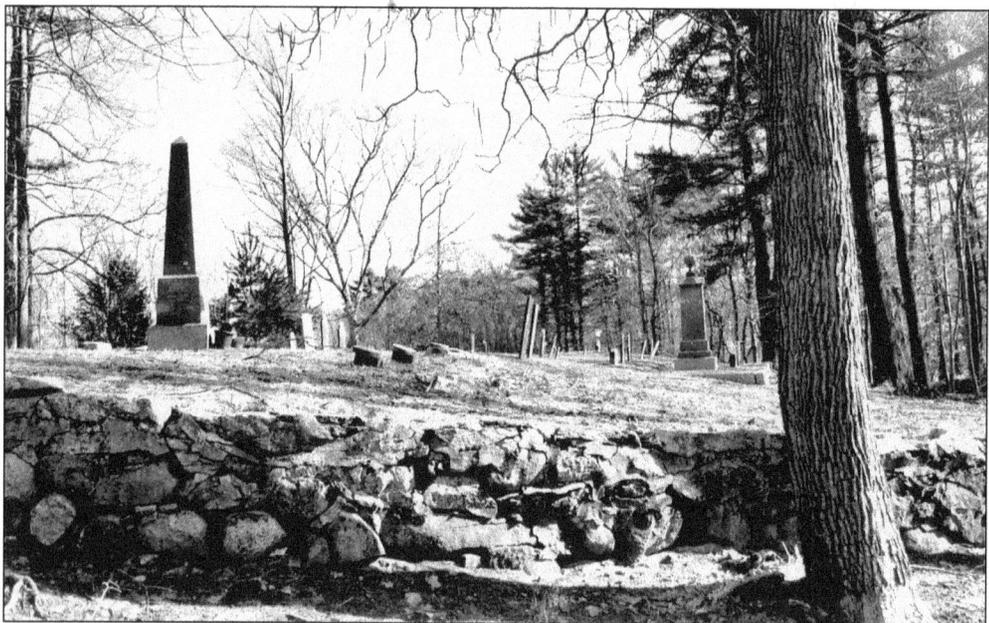

The Luther Magoun Cemetery is located at the corner of Route 139 and Water Street and is also known as the Two Mile Cemetery. One of the earliest graves is that of Hannah Magoun, the wife of Elias Magoun, who died in 1707. The cemetery is across the street from the John Magoun Homestead, home to some of the cemetery's residents. (Courtesy of John Proctor.)

Eight

WEST ELM STREET

The West Elm Street neighborhood also had the advantage of being part of the Bay Path route from Boston to Plymouth.

Besides the lovely old homes that line this historic thoroughfare, there is another remnant, still visible, left from this period. It is a bridge that crosses the Swamp Brook and is located in a field off West Elm Street. It is believed that the Massachusetts Indians used two paths through this part of Pembroke—the so-called Summer and Winter Paths. The stone bridge is situated on what would have been the Summer Path. The Winter Path ran across the higher ground.

Although it is not known exactly when this stone bridge was built, historic maps and other records, as well as a certain amount of informed speculation, indicate that the bridge was probably used as a foot and horse-and-cart path prior to 1682. It remained an important link in the local transportation network until about 1830. At this time, old maps of Pembroke indicate that the course of West Elm Street was altered and straightened to its present location and that the original path and the old stone bridge fell out of service.

Unlike the High Street neighborhood, West Elm Street never had business development to the same extent. It was, however, close to Luddams Ford and the mills that provided the jobs that helped the neighborhood grow. And again, the significant population caused the neighborhood to need its own school district known as district school No. 1 or the Cedar Swamp School (also known as the 'Round the Swamp School, because one had to go around the swamp to get there).

Families with the names of Josselyn, Chamberlain, Mann, Oldham, Torrey, Sturtevant, and Dwelley built their homes here, and many of their houses remain. Streets have been named after some, giving testament to their influence in the town.

This view of West Elm Street was taken about 1880. It illustrates the bucolic character of the town. Although today the area is quite wooded, the importance of farming to this community, especially in the 19th century, is clearly evident. It stood alongside milling, shipbuilding, and shoe manufacturing as important occupations for Pembroke's residents.

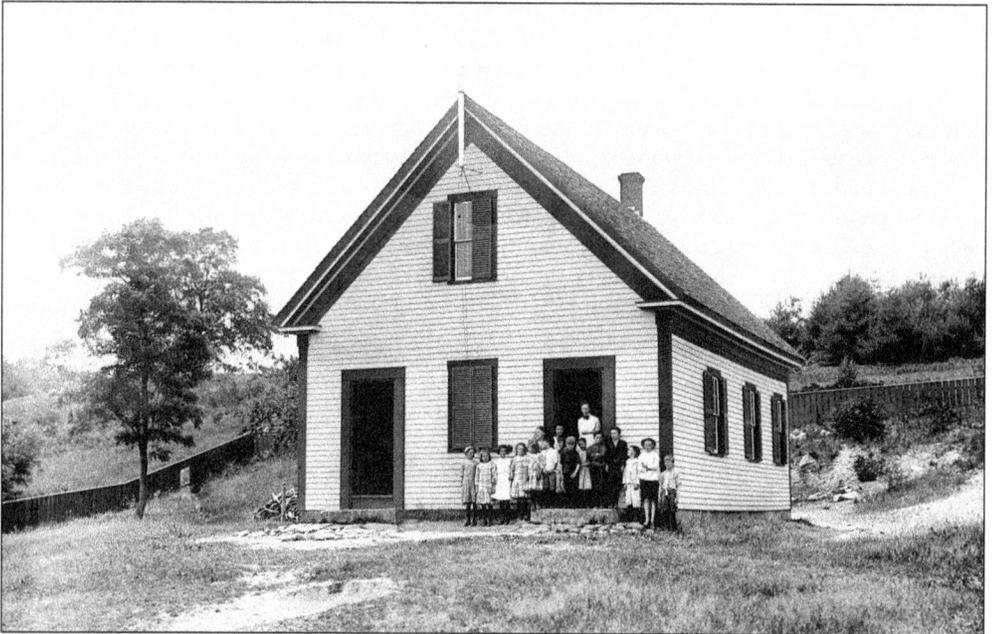

The district No. 1 school was located on West Elm Street. It was also known as the Swamp School or 'Round the Swamp School because one had to travel around the swamp (the Great Cedar Swamp) to get to it. It was eventually moved and now is the back part or meeting room for the Pembroke Historical Society.

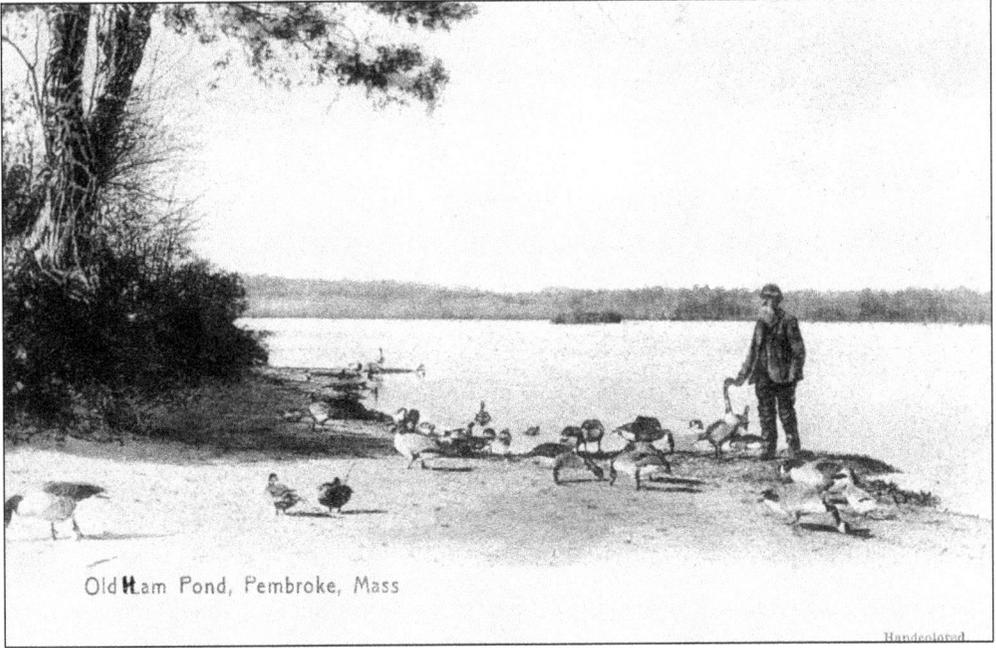

Old Ham Pond, Pembroke, Mass

Handcolored

Oldham Pond (above), located between Oldham Street and Mattakeesett Street on the western edge of Pembroke, covers just over 154 acres. It is the largest of the town's six major ponds, second only in size to Silver Lake. The name comes from the families of Isaac and Thomas Oldham. Isaac built his home on the pond's north shore on land given to him by his brother Thomas in 1695. The pond's Monument Island (below) is fraught with Native American legend concerning the final resting place of Wampatuck, whose death, it was said, caused the formation of the island, and it stands as a monument to the Native American leader's bravery in battle.

The Island in Oldham Pond Pembroke, Mass.

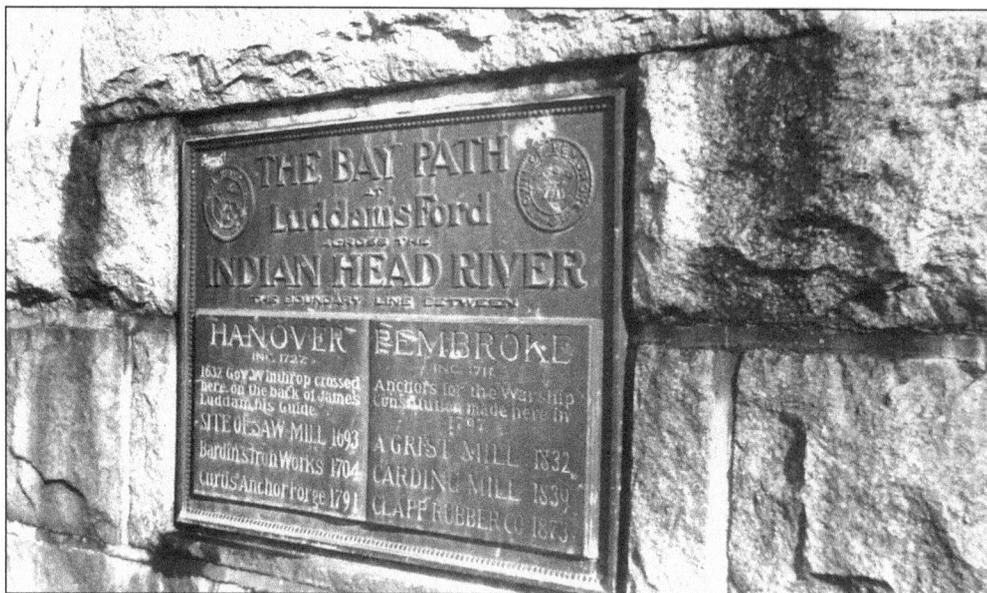

The Bay Path, one of the main routes from Plymouth to Boston, ran over West Elm Street. Here at the boundary between Pembroke and Hanover, on the Indian River, is Luddam's Ford, the spot where it is said that in 1632 Gov. John Winthrop crossed the river on the back of his guide James Luddam. This marker (above) is located on the bridge that spans the river. Near this site, on the Pembroke side (below), was located a sawmill in 1693, an ironworks in 1704, and the Curtis Anchor Works in 1791 where, in 1797, the anchor for the USS *Constitution* was made. Also here was a gristmill in 1832, a carding mill in 1839, and the Clapp Rubber Company in 1873. This marker is located on the bridge that spans the river.

Records indicate that this home on West Elm Street was built by George Dwelley in 1826, the same year he married Hope (Curtis) Cushing. He had destroyed the original house on the site that had been built between 1715 and 1720 by Hudson Bishop. George was the son of Jedediah and Lydia (Soule) Dwelley. He was a farmer, and he died in Pembroke in 1862.

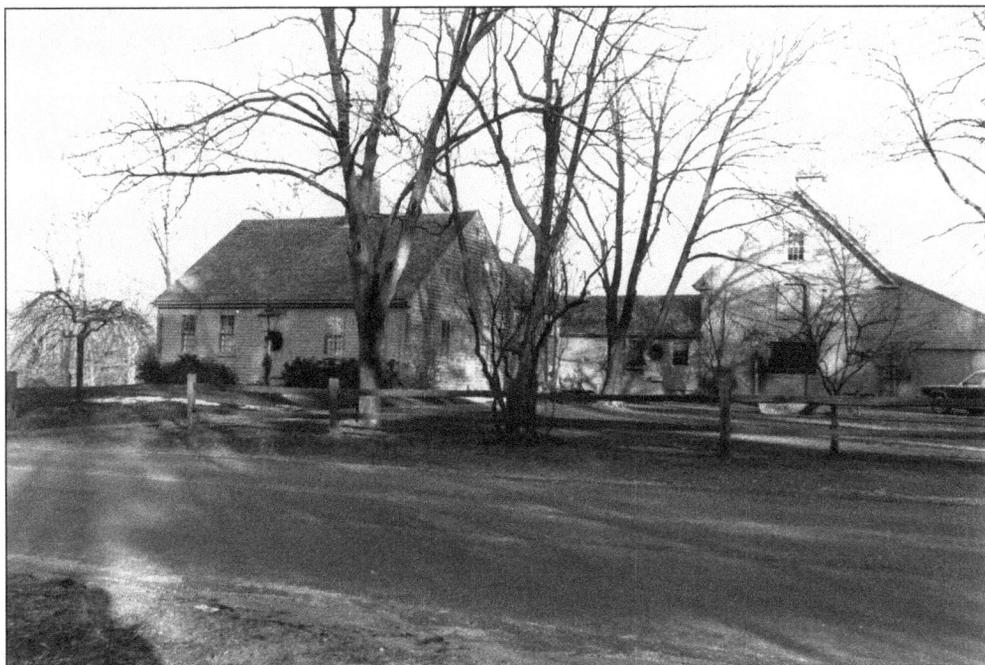

This home may have been built as early as 1701, based on dates marked on the central fireplace and second-floor joists and beams. The house is known historically as the Henry Josselyn Place. Henry was the father of Joseph and Thomas Josselyn, who operated the ironworks at Luddam's Ford.

In 1834, Jonathan Mann, who was born in Pembroke in 1808, married Elizabeth Sears. As was the custom of the time, he probably built this house on West Elm Street about that time. He was the son of David Mann Jr. and Rebecca (Oldham) Mann. Jonathan was a farmer and died in Pembroke in 1894.

This house on Old West Elm Street is known as the William Warren Josselyn home. William Warren Josselyn was born in Pembroke in 1801 and married Abigail Barstow in 1822. Their son William Barstow Josselyn is said to have been one of 23 who left Boston on the ship *Roanoke* for California, sailing around the horn. Arriving in San Francisco on December 31, 1849, they just barely qualified to be called forty-niners.

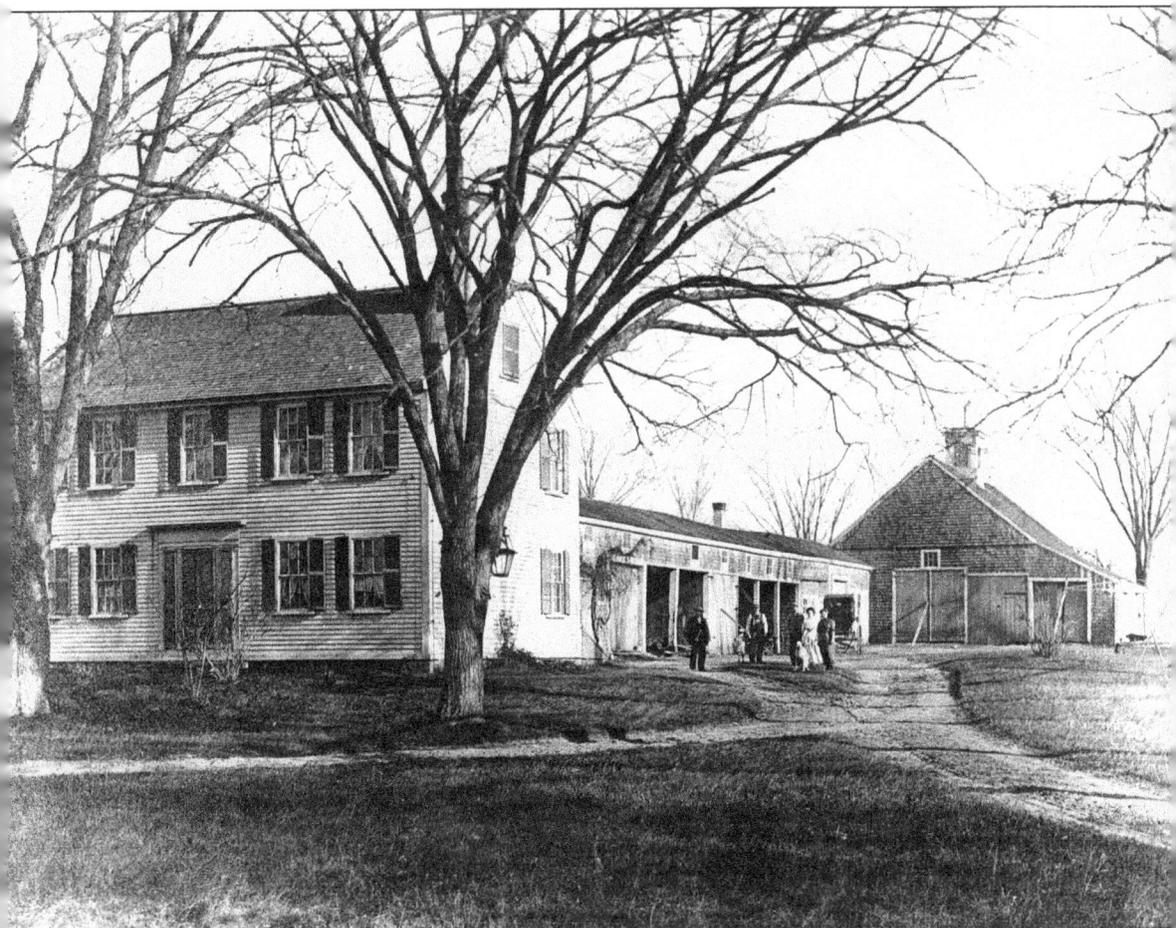

This house was built, according to some, by Josiah Smith, the son of the second minister of First Church in Pembroke, Thomas, and his wife, Judith (Miller) Smith. Josiah was born in 1738 and was a graduate of Harvard College. He studied and eventually practiced law. He was a member of the Massachusetts House of Representatives, the Massachusetts Senate, and was Massachusetts state treasurer. From 1801 to 1803, he was elected as a Republican to the Seventh Congress of the United States. He contracted smallpox while in New York and returned home to Pembroke, where he died. The house was known historically as the Aurora Oldham Farm, after another resident, who owned the place probably about 1824, after his marriage to Jane Smith of Hanover. Aurora was born in Pembroke in 1799, the son of David and Deborah (Barker) Oldham. Jane and Aurora had six children.

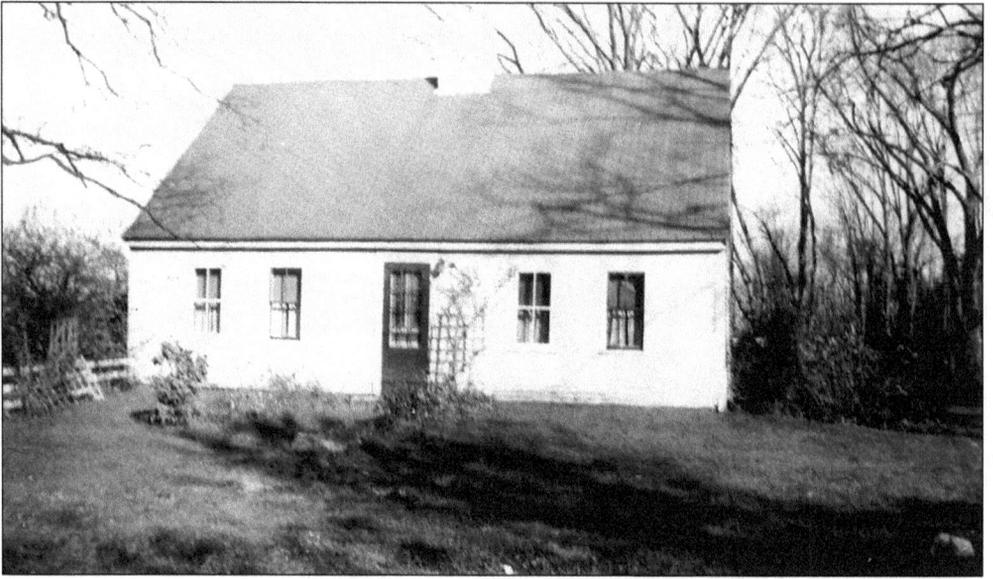

This West Elm Street home (above) is thought to have been built about 1709 or earlier and is known historically as the Jonathan Josselyn House. Not much is known about the earliest residents of the house, or even the builder, but one owner was Capt. Freedom Chamberlain, who was in the home in 1767. He was an officer in the American Revolution. After the war, he became disenchanted with the idea of liberation, along with some other members of the First Church in Pembroke. This angered many Pembroke residents, and the section of West Elm Street where Chamberlain lived became known for a time as "Heathen Street." Jonathan Josselyn actually lived in the home around 1798. The Josselyns were blacksmiths and ironsmiths. For many years, an old orchard (below) was behind and around the home.

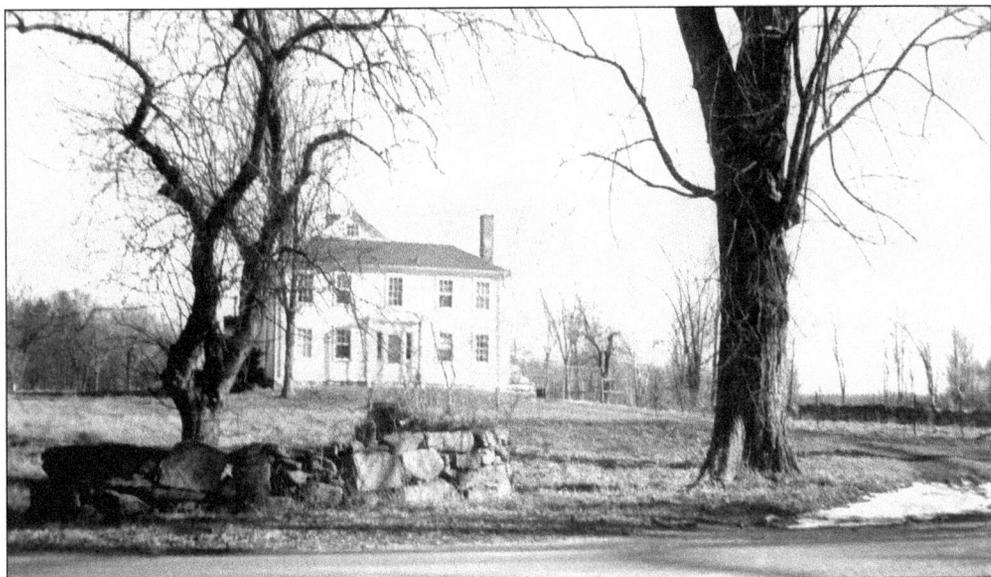

Known historically as the Levi Sturtevant House, this house on West Elm Street was built by Freedom and Deborah (Turner) Chamberlain. Freedom Sr. gave the house to his son Freedom Jr. and Priscilla (Josselyn) Chamberlain. Prior to 1802, Freedom Jr. and Priscilla sold the house to Levi Sturtevant, who had married Freedom Jr.'s sister Mary. Levi was an anchorsmith who lived in the house until he died in 1858.

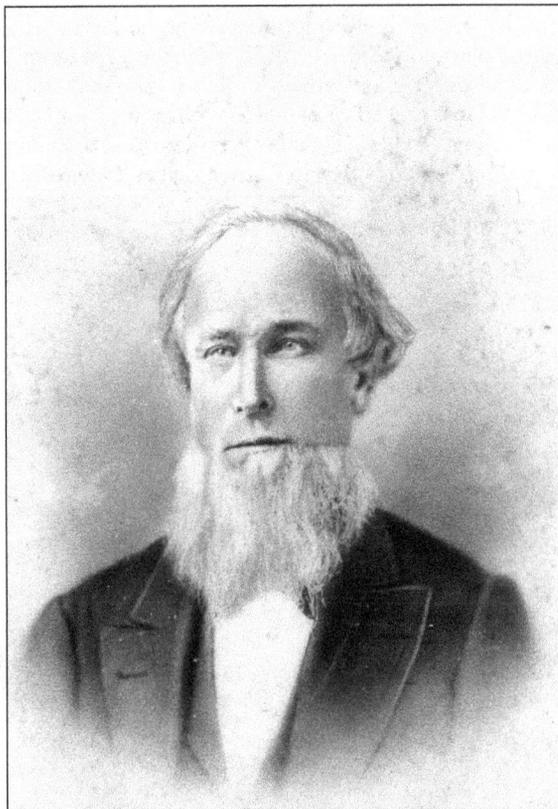

George Gilbert Bonney was probably born in Pembroke in 1836. He was a descendant of James Bonney, who was in Pembroke as early as 1702. In 1858, he married Catherine Vinal of Hanover. He moved to Dedham between 1860 and 1870 and eventually to Westwood, probably due, like his father, to his lifelong occupation as an iron molder. He died in Westwood in 1906 as a result of an accident.

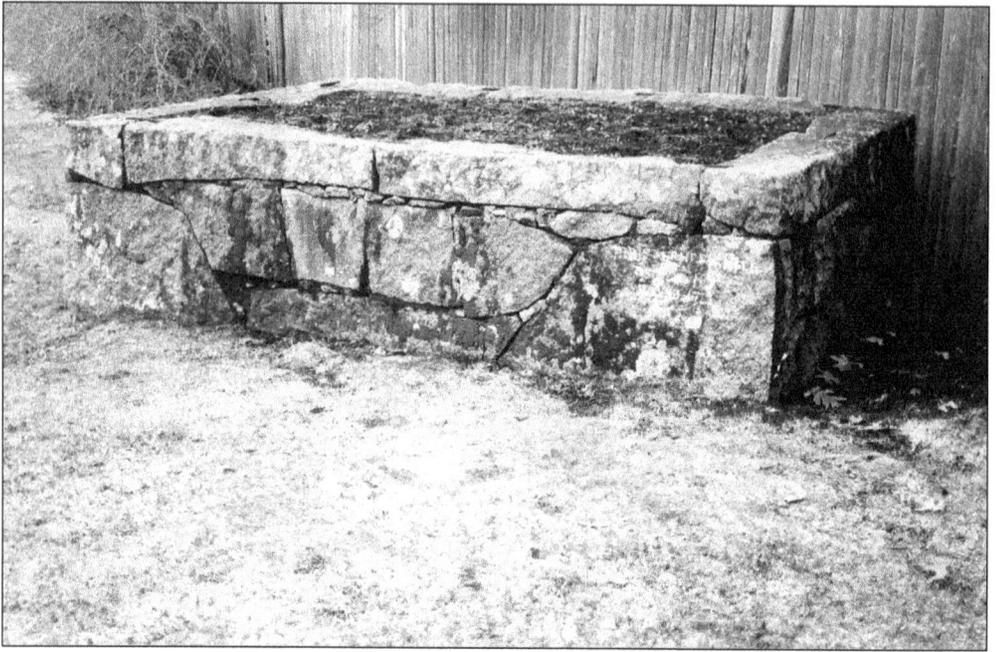

Behind a home on West Elm Street is a small patch of land surrounded by granite blocks (above). Carved in one block is the name Christopher Smith with the dates December 22, 1757, and July 10, 1781 (below). Smith was the son of the Reverend Thomas and Judith (Miller) Smith. During the Revolutionary War, he served in Capt. Thomas Turner's militia, responding to the alarm on April 19, 1775, and Capt. Freedom Chamberlain's company that marched on Dorchester Heights. Later he "followed the sea" and died aboard a prison ship at Halifax, Nova Scotia. He is probably not buried within these walls. He died far from home when travel was long and arduous. Had his remains been returned to Pembroke, being the son of a minister, surely he would have been buried in Center Cemetery with his family. (Courtesy of John Proctor.)

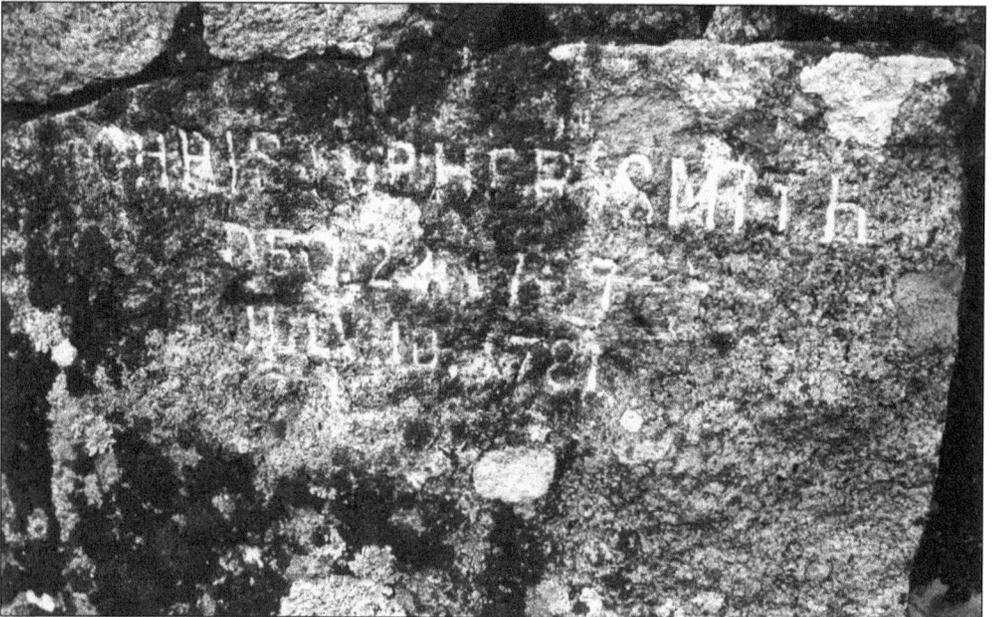

BIBLIOGRAPHY

Lewis, George Edward. *Old Pembroke*. Bryantville, Massachusetts: George Edward Lewis, 1912.

Litchfield, Henry Wheatland. *Ancient Landmarks of Pembroke*. Bryantville: George Edward Lewis, 1910.

Littlefield, Cyril O. *The Herrin' Are Running*. Pembroke, Massachusetts: Pembroke Historical Society, 1978.

New England Historic Genealogical Society. *Vital Records of Pembroke, MA to 1850*. Boston: F. H. Gilson Company, 1911.

Pembroke 250th Anniversary Committee. *Town of Pembroke 250th Anniversary 1712 to 1962*. North Abington, Massachusetts: Sanderson Brothers, 1962.

Pembroke 275th Anniversary Committee. *Pembroke-Evolution of a New England Township 1712-1987* Pembroke: Claremont Press, 1987.

Pembroke Bicentennial Committee. *Pembroke Revisited*. Pembroke: Pembroke Bicentennial Committee, 1962.

Pembroke Historical Commission. *Inventory of Historic Properties*. Pembroke: Pembroke Historical Commission.

Pembroke Historical Society. Old House Files, Family Files, Miscellaneous Files.

Quill, Ed. *Pembroke 2000*. Pembroke: Ric Sivigny, Desktop Publishing, 2000.

Secretary of the Commonwealth of Massachusetts. *Massachusetts Soldiers and Sailors of the Revolutionary War*. Boston: Wright and Foster Printing Company, 1906.

Smith, Susan A. *A Memorial of Rev. Thomas Smith*. Plymouth, Massachusetts: Avery and Doten Book and Job Printers, 1895.

Visit us at
arcadiapublishing.com

www.ingramcontent.com/pod-product-compliance
Lightning Source LLC
Chambersburg PA
CBHW050714110426
42813CB00007B/2177